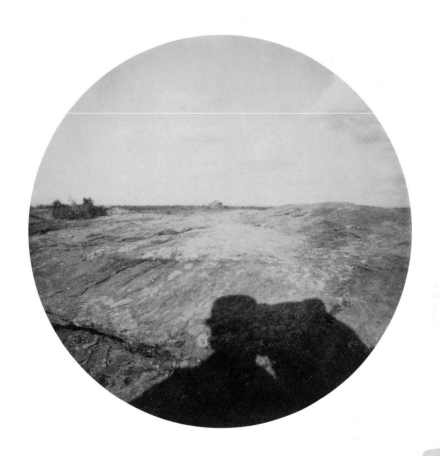

anonymous

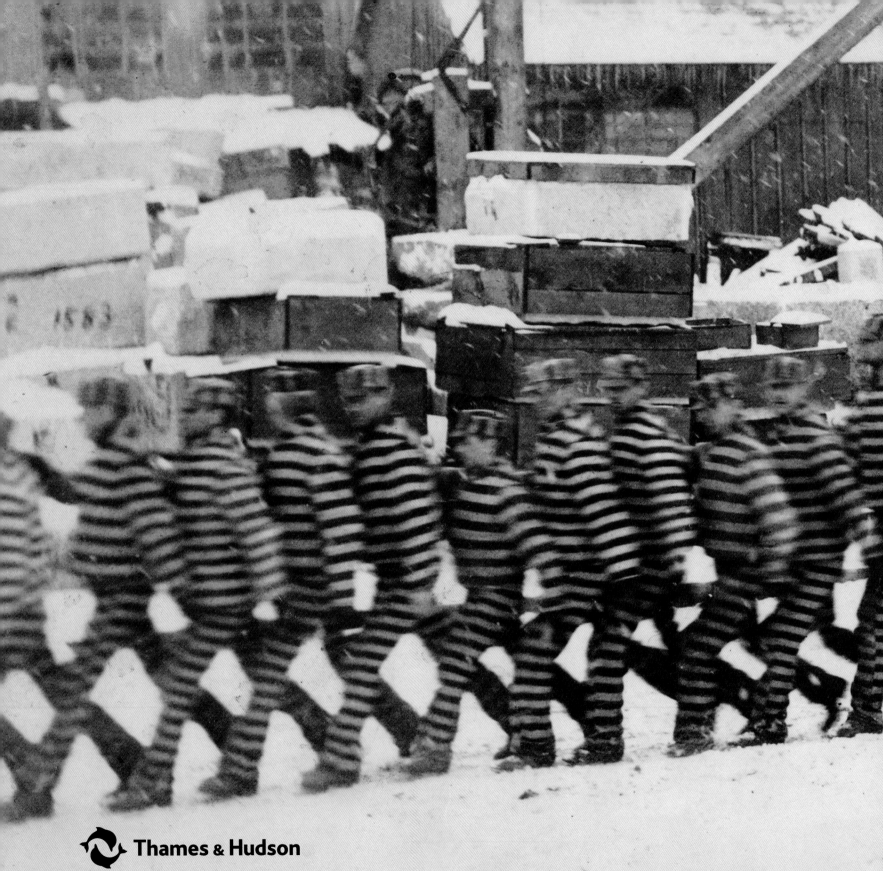

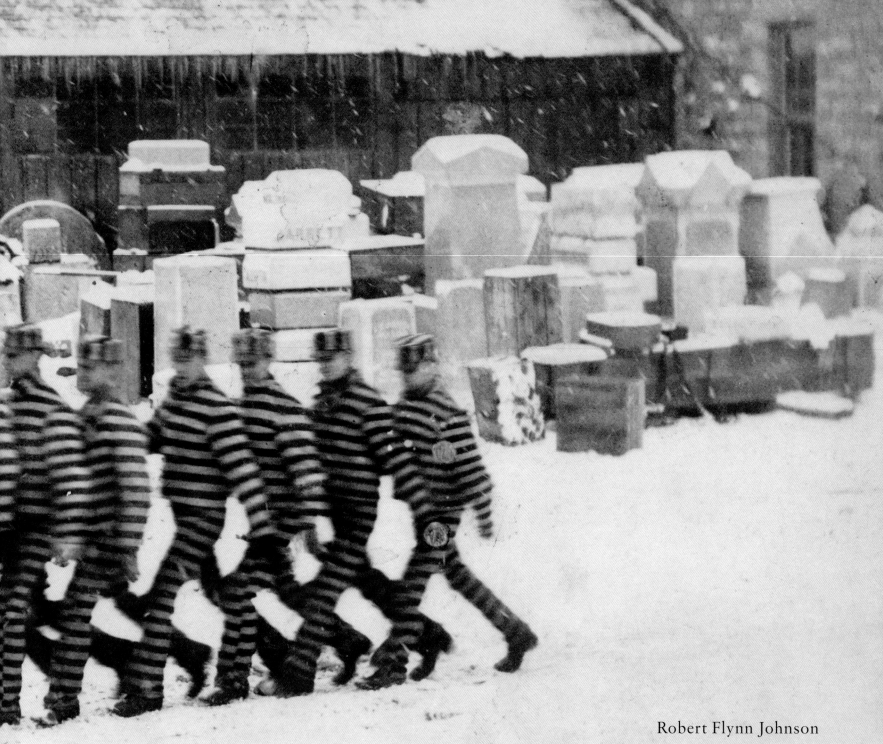

Robert Flynn Johnson

with an introduction by William Boyd

anonymous

enigmatic images from unknown photographers

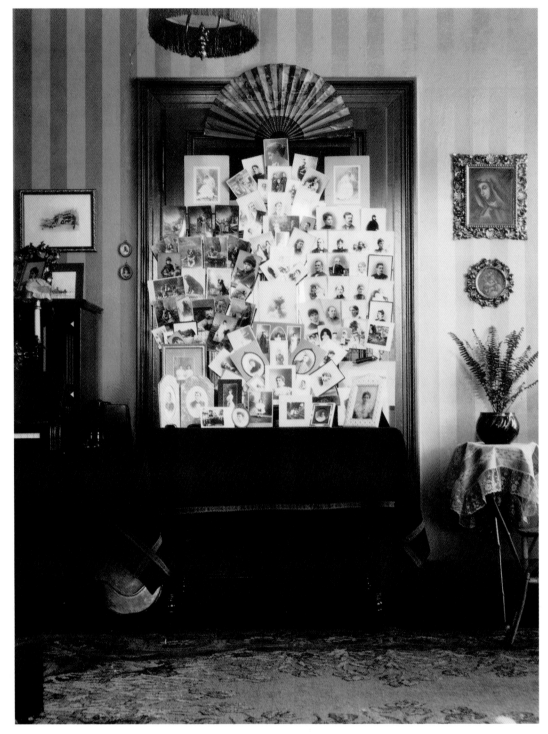

First published in the United Kingdom in 2004 by Thames & Hudson Ltd,
181A High Holborn, London WC1V 7QX

www.thamesandhudson.com

© 2004 Robert Flynn Johnson
Introduction © 2004 William Boyd

First paperback edition 2005

British Library Cataloguing-in-Publication Data
A catalogue record for this book is available from the British Library

ISBN-13: 978-0-500-28576-3
ISBN-10: 0-500-28576-4

Printed and bound in Germany by Steidl

contents

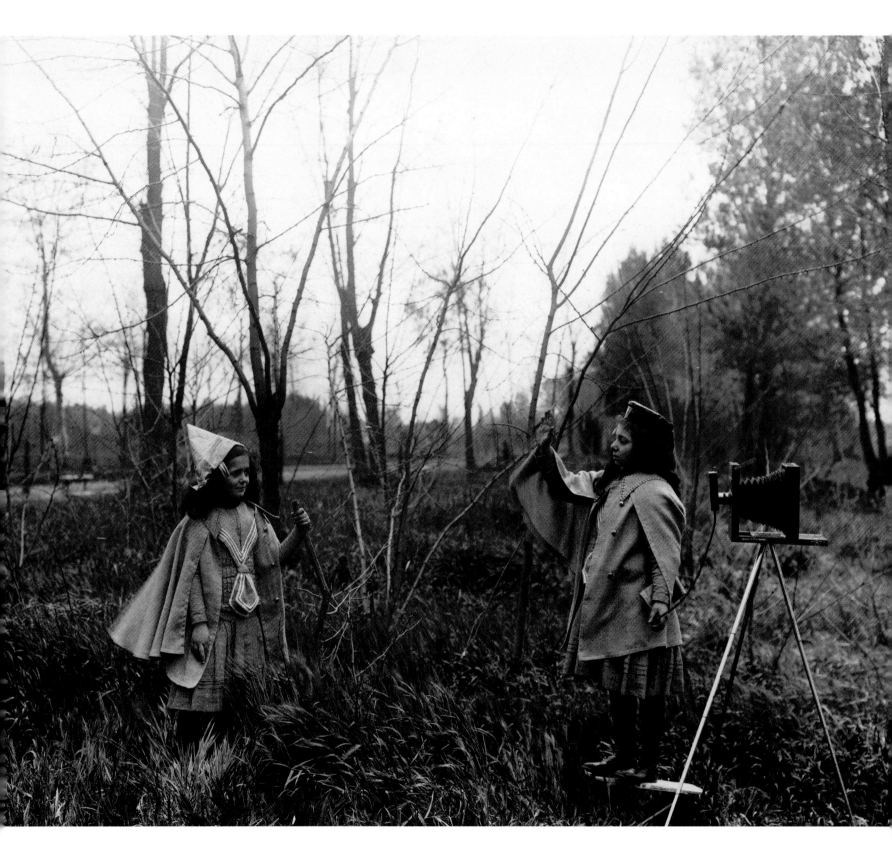

William Boyd thirteen ways of looking at a photograph

I know noble accents

And lucid, inescapable rhythms;

But I know, too,

That the blackbird is involved

In what I know.

Wallace Stevens, *Thirteen Ways of Looking at a Blackbird*

We go to photography for images of reality, but images that are more immediately real than the more contingently intimate, adroit and nuanced versions that other art forms provide. This is both photography's blessing and its curse: it appears to bear irrefutable witness to the nature and content of our world yet it is achieved mechanically. In theory, anyone with a camera can do it: hence its ambiguously freighted appellation – the 'artless art'.

The first photographic image I purchased was in 1967 when I was 15. I bought – for 5 pounds (a vast sum to me then) – one sheet from the 1965 Pirelli calendar (the month was November) owned by a boy at my school. It was only the exorbitant price I offered that made him part with it and the picture was pinned for many months on the wall above my desk until it was lost in some end-of-term packing fiasco. Doubtless there was some now-forgotten adolescent sexual fascination that drove my determination to buy this picture but this does not explain why, over the thirty-six years since I first saw it, I have been able to summon this image to mind effortlessly. A young blonde sunglassed woman, in a white t-shirt embroidered with a small anchor, sits at a café table in some seaside location. She has a cigarette in her mouth and is caught by the photographer in the very act of lighting it (from a book of matches), her lips are slightly pursed to hold the cigarette steady, the match is flaring at the cigarette's tip. I had no idea who this woman was and I had no interest in the name of the photographer. But something about that image made me covet it and urged me to spend so much money to make it mine. Even though I lost it some months later its place is secure in the small but select image-bank in my memory. For the first time in my life a photograph had worked on me. Why? What happens on these occasions? How can a seemingly run-of-the-mill image stir one so?

That photograph was to all intents and purposes anonymous and, the more you come to think about it, in photography anonymity is the norm. When you consider the thousands – perhaps the tens of thousands – of photographic images each one of us encounters in a given year the vast majority – 99 per cent I would venture – is anonymous. In newspapers, magazines, colour supplements, advertisements, in-store promotions, posters, manuals, part works, CD covers, mail shots, travel brochures, textbooks, knitting catalogues, and so on, the photographer's by-line – if by chance there is one – is irrelevant. When it comes to the way we consume photographs we are like sperm whales, jaws wide, cruising through an ocean of swarming images, unreflectingly scooping up those that our eyes alight on.

The only times we are consciously aware of the authorship of a photograph, I would argue, are when we contemplate the photographs we ourselves have taken (or those of friends and family) or when we go deliberately to the photographer's monograph or exhibition. The signed image – the appropriated, the owned image – is by far the rarest in this pullulating world of pictures.

Therefore to isolate and pointedly categorize the anonymous, as *Anonymous* does here, is to postulate something both unusual and intriguing. In our 21st-century world of millions upon millions of anonymous images what does the selection of a couple of hundred or so enshrined in a beautifully produced book say both about our response to the photograph and the practice of photography, and, perhaps more importantly, to its status as an art?

The anonymous photograph, thus selected and presented, makes us ask, with new concentration, what it is about a photograph that elevates it above the casual and banal. What criteria do we bring to our evaluation of a photograph, what makes one memorable, another not?

What, in short, makes a photograph good? We have become so accustomed to *not* seeing photographs, through their omnipresence, that now here is a chance to try and determine (without 'the bubble reputation') why some images move and enthral and remain in our memories – like paintings, like pieces of music.

It's for this reason that I've appropriated the title of Wallace Stevens' famous poem, 'Thirteen Ways of Looking at a Blackbird'. Looking at anonymous photographs and trying to analyze them, without a famous name attached, has the effect of sifting out a variety of responses to the photographic image. It seems to me that we look at photographs in ways that are far more varied and multifarious than the ways we look at other works of art. Sometimes these different responses complement each other, sometimes they cancel each other out, but when the photographer's name is absent (and thus the photo's historical-cultural-biographical context) we can, with better precision, more exactly investigate what assumptions and prejudices we bring to the photograph and how the photograph works on us.

Therefore I've tried to isolate, for harmonic poetic neatness, thirteen different ways we look at photographs. Perhaps there are more: perhaps some of my categories overlap somewhat, but I think the exercise – the thought-experiment – is valid because at the end of the process, if I am right, then what conclusions we draw about the anonymous photograph will bear intriguingly on the so-called 'artless art' of photography itself.

Aide-memoire Is this not why most of us take photographs? We use a camera to provide a visual analogue of a potential memory. We take photographs of places, people, pets, cars, houses, and so on, to store away. How many photographs are kept in boxes and not displayed in frames or mounted in albums (or, in this digital age, on hard discs)? Many of these anonymous photographs in this book inevitably fall into this category: here a little boy is snapped in front of a car (p. 37); there, a housewife on a lounger looks up from her newspaper (p. 9). Photographs of pets are of interest only to the owner (and possibly win the prize for the most boring photographs ever). The memory referent in these and other examples is lost to us now but in so many cases this must have been the motivation: the photograph functions simply as a way of recalling, a way of summoning up the past.

Reportage This is the public face of the previous private category, in a sense. Often these images – of wars, of natural disasters, of historic events, of famous people, of gathered crowds – provide some of the most memorable images in the history of photography. Here the photograph is testimony, often of a shocking and harrowing order. The decapitations on pages 190 and 191 function in exactly this way.

Occasionally the horror gives way to more disturbing responses. The picture of the decapitated head (p. 198) moves beyond the initial shock of the image to something more surreal and unsettling. The juxtaposition of crashed car, empty country road and the victim's head, seemingly carefully placed fifteen feet away from the body, looks like a scene from a Buñuel film. The camera is fortuitously present – or else, especially in combat zones, the photographer chooses to go where most of us would dare not. The great war photographers – Robert Capa, Don McCullin, Philip Jones Griffiths, Larry Burrows – come to mind.

Work of art Sometimes the photograph tries to replicate the classic tropes of painting or sculpture. Think of the nude, the still life, the portrait. Here the photograph presents itself as a quasi-painting, a pseudo canvas – with mixed results, in my opinion. Photos such as these – a corn cob (p. 170) or a vase of roses (p. 173) – seem vaguely ashamed of their mechanical reproductive nature and, by copying a genre, try to buy some aesthetic respectability. What's the point of these images, one wonders (*pace* Mapplethorpe)? Only rarely can they outshine their equivalents in the plastic arts.

Topography This category is related to the former, where the photograph tries to reproduce the effect of painted landscape, or a refulgent sunset. Or else the photograph is taken to register some natural phenomenon – mountain ranges, canyons, gorges, cataracts. As a means of recording a topographical situation the precision of photography is unrivalled. But is anyone as moved by the image of a photographed landscape as they are of a painted one?

Erotica and pornography This is perhaps a field that photography can claim as its own, having vanquished all rivals except, perhaps, the cartoon. The massive proliferation of sexual images (soft and hard) in our world exhibits something of the sheer range of photography's power and effect – the gamut is extensive, the nuances of erotica are manifold. The naked women flourishing their suspender belts and baring their plump buttocks is frank titillation (p. 103). The before-and-after images of three women, clothed and unclothed (p. 110, p. 111), make, perhaps guilelessly, a more intriguing social point. But the picture of a man and a prostitute in a darkened room (p. 114) with the shadow of a blind fanning over the cut-out pinups on the wall is interested purely in creating a fine photograph. Any erotic subtext is nugatory.

Advertisement Subjects of erotic or pornographic images are selling their sexual *frisson*, such as it may be. But this category of photograph – the advertisement – is as ubiquitous as porn. These are photos that are programmed to function wholly as a form of allurement, as bait, as

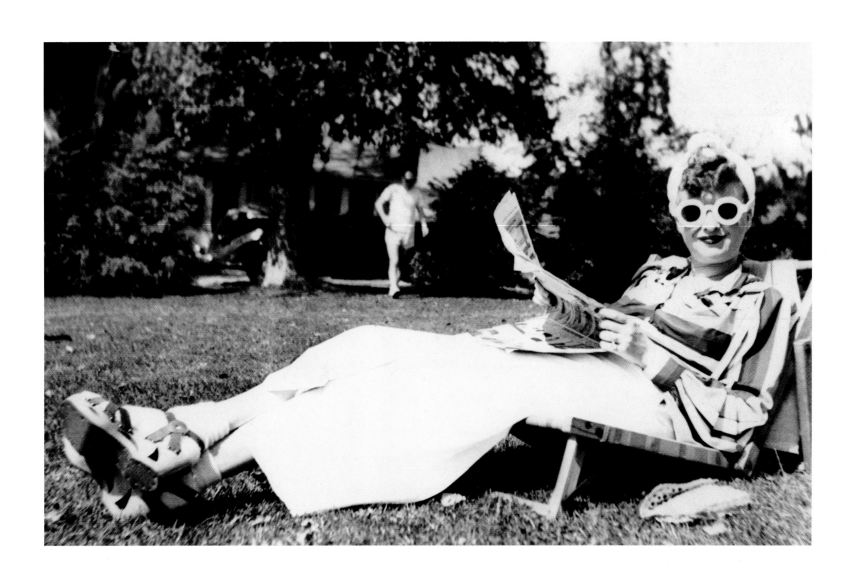

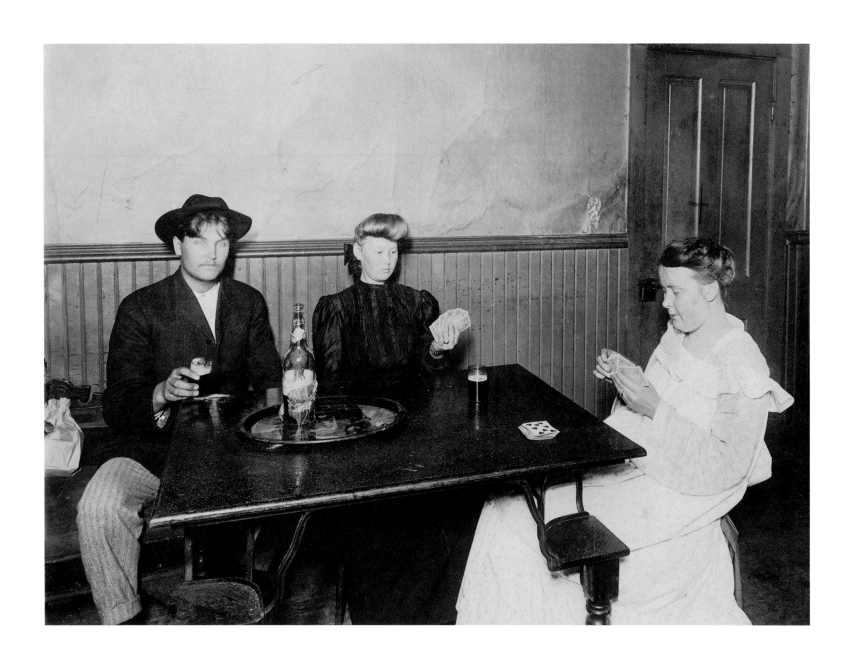

temptation. It is something photography does extremely well – better than any other form of image, conceivably. The whole huge world of fashion photography, for example, can be subsumed in this category.

Abstract image Here is another sub-class that links with painting but in which photography has carved out a niche for itself. Something photographed in extreme close up, for example, loses its quiddity and becomes near or wholly abstract. Two pairs of spectacles or the pistons and driving wheels of a locomotive are presented arrangements of shape and mass. A strange angle, or extreme cropping can produce the same effect. The photograph functions simply and purely, being judged, like an abstract painting, in terms of form, pattern, texture and composition.

Literature Again and again we are tempted to 'read' a photograph, as if it were part of a narrative or a short story. This is particularly the case in anonymous photographs as we have so little to go on. Who are these masked women in their identical dresses? (p. 163). Or the odd trio in the bar (almost like a Brassaï) – the two card-playing women and the young man with the glass and bottle (p. 10). Is he with them? Perhaps he's the true subject of the photograph. Does he know the photographer? (He's looking into the lens.) We want to supply a 'story' to the image. We want to find a narrative frame – or a series of frames – into which we can slot this image, and, as we bring our deduced or inferred narrative to the picture, attempt to understand it. This is a potent impulse in all photography and again it comes to the foreground when the image is anonymous. Walker Evans said: 'Fine photography is literature, and it should be.'

Text Why are there so many photographs of signs? There is a whole subdivision, throughout the history of photography, that concerns itself with the photography of writing or printed signs, running from an image like the photograph of a diner (p. 151) where its signs are what

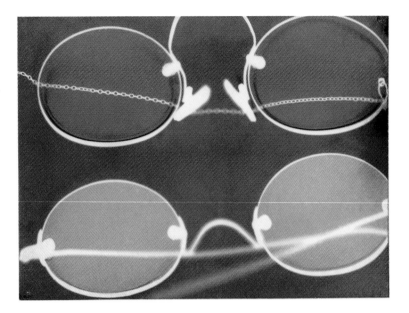

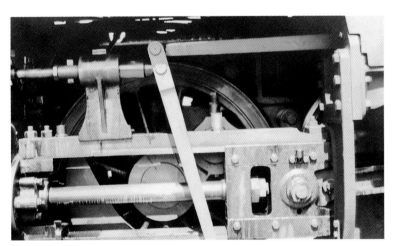

attracts – 'Bohemian Lunch Café' – to the sophisticated work of someone such as Lee Friedlander. I find it hard fully to comprehend this impulse but it is clearly near-universal and one the anonymous photographer is equally prone to adopt (p. 147, p. 150). The entrance to a town, the hand-painted advertisement, the comic misspelling or the absent letter – something about words seems to provoke the desire to photograph them, as if the verbal joke needs to be visibly enshrined.

Autobiography Every photograph, if we knew enough about the circumstances of its taking, will contain some biographical information about the photographer. A photograph such as that of the little black boy with the dummy in his mouth and the toy rifle in his hand (p. 12) is a form of biographical signifier of the man or woman who took the picture. This is a wonderful photograph (very Diane Arbus in its calm eeriness) but is the juxtaposition of symbols deliberate or a result of chance? Is this child the photographer's son? What's trying to be conveyed here about the photographer's attitude to innocence and experience? Can we move on from there to ask if every photograph, therefore, is an unconscious fragment of the photographer's autobiography? Will all the photographs a person takes in his or her life be as much a record of that individual as anything written down?

Composition One could argue this is a sub-class of the 'work of art' category but I feel that the traditional fine-art concept and rules of composition particularly apply to photography. Many of the most memorable photographs, in my opinion, are also beautifully composed. The picture of two Nazi storm troopers hand in hand with their

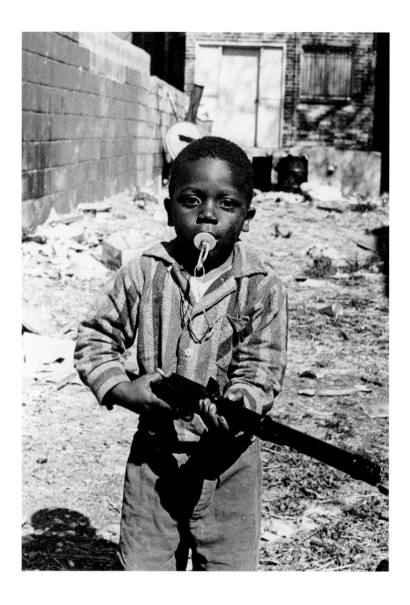

identically uniformed toddlers (p. 57) is, apart from anything else, a perfect composition: it could almost be a Cartier-Bresson. The photograph of two boys fishing (p. 47) works precisely because of the inadvertent mirror-imaging of their pose. Of course the classical elements of composition – balance or asymmetry, grouping of forms, the placing of light and dark etc. – apply to a photograph as well. But I find in a well-composed black and white photograph – and perhaps this is something to do with a combination of depth of field and the photo's monochrome nature – an element that is absent from painting. One is more intensely aware of composition in black and white photographs. I think, for example, that this idea of composition is behind the unanalyzable appeal of some of Cartier-Bresson's photographs. Why are they so tenaciously memorable? It's not simply a question of subject matter: the ones I remember best also tend to be the best composed.

A means to an end/tool Photography cannot be separated from its pragmatic advantages. The huge sub-class of anonymous photography as pedagogical illustration (in textbooks and encyclopaedias for instance) bears this out. There are interesting ramifications, however: a photograph, for example, of James Dean's wrecked Porsche will fall under the category of 'reportage'. A similar photograph, but taken by the insurance loss adjuster investigating the accident, will have an entirely different import. Crime scene photographs (p. 194 and p. 196 make one think of Weegee) also vacillate between these two designations, at once helping to solve the crime but also with their own curious aesthetic effect. Or, to put it another way, once the pragmatic task of the photograph has been satisfied it may transmogrify into something else. The professional photographer's polaroid is an exemplary instance. As someone who has been photographed many times by professional photographers, I often find the most pleasing image is the one they discard after the shoot. Professional accessory eliding into serendipitous portrait.

Snapshot The photographer Nan Goldin has gone on record claiming that the snapshot is one of the highest forms of photography. I would like to go one step further and say that in the snapshot we distil the very essence of photography and find in this concept an explanation of this artless art's idiosyncratic and enduring power. All photographs and all the types of photographs that are outlined above borrow from or share in the nature of the snapshot to a greater or lesser degree. For what distinguishes photography from all the other visual arts is its particularly intense relation to time. That mechanically retrieved image is the record of a split second of the world's history. A photograph is a stop-time device and this is what it makes every photograph, however sophisticated, however humdrum, unique. And because our mortality and own lives

are so bound up with the sense of our time passing – or with the sense of our lives heading on remorselessly to their end – then the artificial ability to stop time yourself with your own photographs, or to witness time stopped in the photographs of others, is profoundly, atavistically appealing. I would argue that it is this feature of photography (and not, for example, Roland Barthes' concept of the *punctum*, the 'detail') that explains the individual response to the strange enticement of an individual photograph. Look at the photo on page 126, one of the great images in this collection (it could have been taken by Jacques-Henri Lartigue). A group of wealthy, well-dressed people, holding umbrellas high against the rain, dash across a wet road through advancing traffic. The women's feet are blurred in their hurry, defying the speed of the camera shutter. The ambience is all energy and momentary alarm. The composition of the group is near perfect: look at the diagonal swerve of the tyre track imprinted on the glossy tarmac (and how it draws us back into the picture); note the vertical shafts of the umbrellas beginning to cant forward in the direction of the rush. Yet what, finally, 'makes' this photograph – why it *works*, I would claim – is the women's feet frozen in the air in mid-dash. This is the pure element of snapshot (our rosebud, our blackbird): we see it plain – time is halted, time stands still.

I think this same notion underscores the allure of the November image in the 1965 Pirelli calendar for my 15-year-old self (and thereafter: I have it now – again – in a Pirelli album). There are agreeable associations in the picture – of sea, of sun, of summer – and the girl is pretty enough, in a very 1960s way, but – crucially – the image is unposed, candid, snapped. Time has stopped: that match will forever flare, her lips will be forever slightly pursed.

This crucial, elemental aspect of photography could not be better enshrined than in the image on this page. In the middle distance a man, silhouetted against the sky, leaps from one towering column of rock to another. The unknown photographer captures him in mid-air, in mid-leap, poised above the significant abyss. This is a great and memorable photograph. All sorts of potential readings and interpretations crowd around it – was it a dare? What was the man trying to prove? Who was this leap designed to impress? How dangerous was it? We will never know, the facts of the photograph are lost to us: and because we can never know therefore all explanations are equally valid. But that moment of time has been recorded and held and the symbolic resonance around the split-second happenstance of its taking is rich. It could stand as a synecdoche for all photography. The great photographs – anonymous or otherwise, the photographs we love and remember – must have a snapshot of the human enterprise, of our human condition, about them, somewhere.

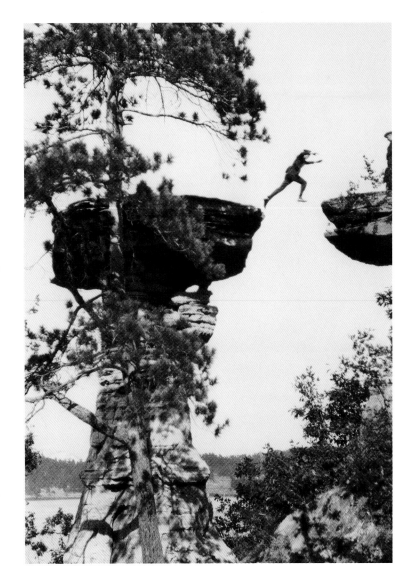

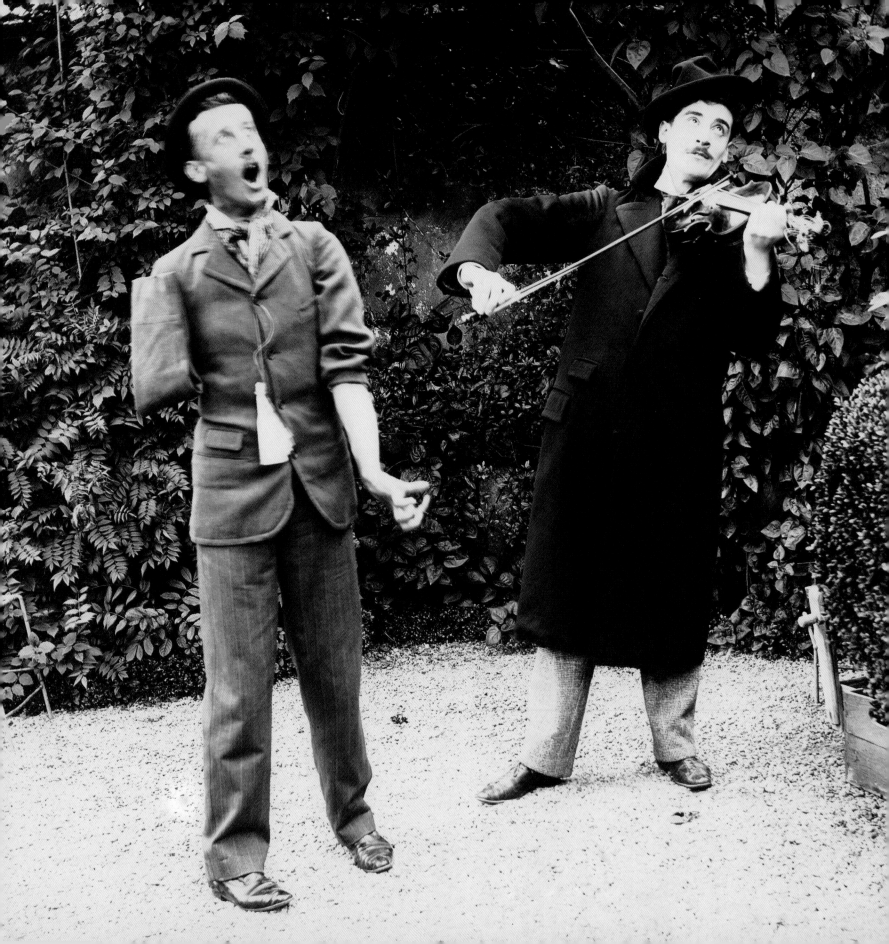

Robert Flynn Johnson accidental art

I see photographs everywhere, like everyone else, nowadays; they come
from the world to me without my asking; they are only 'images', their mode
of appearance is heterogeneous. . . . I realized that some provoked tiny
jubilations, as if they referred to a stilled center, an erotic or lacerating value
buried in myself.

Roland Barthes, *Camera Lucida*[1]

It is an often repeated story – in the panic of a catastrophic event, with little time for reflection, people locate their loved ones, family pets and photographs and flee for their lives. These are the things that appear irreplaceable in the clarity forced by adversity: their loved ones and pets are aspects of their present and future; their photographs are aspects of their past, their memories.

The protective feelings that people traditionally have towards their family photographs make the discovery of such photographs in a flea market disturbing. Often dumped haphazardly by the hundreds into cardboard boxes, their presence there is both heartbreaking and mesmerizing. Like slowing down to see a car wreck, there is a feeling that one should not be looking. However, for some, curiosity outweighs propriety or indifference. The fact that these anonymous photographs have found their way to such an unfortunate end signals that something tragic, sad or cruel has occurred. What act of death, estrangement or miscommunication has removed these photographic images from a world of familiarity and recognition into a purgatory of apathy?

Although family photographs and snapshots make up a large percentage of anonymous photography, they are not the only photographs that fall within this category. The majority of early photography – daguerreotypes, ambrotypes and tintypes, along with a lesser portion of paper prints, including carte-de-visite and cabinet-size photographs – have come down to us with no information about their makers.

From the end of the 19th century until the end of the 1930s, there was a sustained craze in America and Europe for the photopostcard. The majority of these are without attribution, varying in quality from professional to homemade. Almost every conceivable subject was recorded, from the mundane (portraits, homes) to the tragic (funerals, lynchings) and the bizarre (mock-weddings in drag, dogs smoking pipes). Other types of anonymous images include photographs taken for scientific, sociological, industrial, architectural, advertising, fashion, entertainment, erotic and legal purposes. They have found their way from a specific need into unintentional obscurity.

Finally, some photographs clearly seem to have been taken with an artistic goal in mind. Many of these photographs, displaying varying degrees of skill, were surely made with an aesthetic purpose and an implied desire for recognition by the maker. The intent was not that they be unacknowledged.

A photograph results when the operator of a camera uses the technical apparatus of lens and negative to capture and later to develop an image. The camera accurately records the humanity of an individual, the solidity of a place and the atmosphere of a moment. Photographs seem objective, but this perception of objectivity is an illusion. Photography is a malleable medium that wilfully or unwittingly can be manipulated. It may start as a factual, scientific process but ends as a fiction.

From the technical point of view, an anonymous photograph gives evidence of selection and viewpoint by its very existence. As John Szarkowski has stated, 'Photography is a system of visual editing. At bottom, it is a matter of surrounding with a frame a portion of one's cone of vision, while standing in the right place at the right time. Like chess, or writing, it is a matter of choosing from among given possibilities, but in the case of photography the number of possibilities is not finite, but infinite.'[2] What an anonymous photograph does not, cannot and never will reveal is why that subject, at that moment in time, was

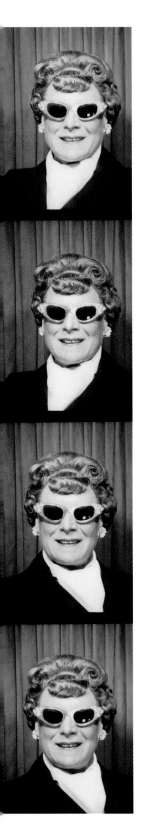

selected to be captured and visually frozen like some fly in amber. The unexplained motivation is the mystery that haunts these photographs.

Fine-art photography deals with images as critically validated expressions to be evaluated, judged, accepted or rejected. Premeditation and reference give these photographs gravitas that is recognized and acknowledged by the viewer. In the case of anonymous photography, the seemingly endless supply of visually discouraging banality defeats any casual attempt to give these objects conscious consideration.

John Szarkowski made the wry observation that there are more photographs in the world than there are bricks. Unverifiable, but believable, his statement pictures a world awash with photographs. The overwhelming majority of these images were not created with aesthetics in mind. They were the permanent recording of public works and private lives. The monotony of most of these photographs is the visual equivalent of T. S. Eliot's poetic observation of people measuring out their lives with coffee spoons.

There is a magical dimension, however, to this vast mundane accumulation of anonymous imagery. Like panning for gold among worthless pebbles by those skilful at detection, photographs of transcendent beauty and psychological insight await discovery and rescue from obscurity. This is where the individual who is willing to sift through the pictorial morass becomes crucial. Essentially dead and forgotten images can be resurrected by the process of selection. This searching out and collecting is an example of a highly personal connoisseurship. There are no art history books, auction catalogues or grand reputations to lead the way or reinforce one's decisions. It ultimately comes down to the photograph in one's hand and one's own thoughts concerning it.

The aesthetic that defines arresting photographic images is very much the same, whether they have been created by anonymous, known or even famous photographers. Compelling subject matter with interesting use of intended or accidental cropping, focus, toning and other technical features are some factors that make works stand out. It is hard to define

the alchemy of what makes many photographs memorable. Some have a universality that draws admiration from a broad spectrum. In other cases, the assertion of significance is one of singular subjectivity. Nobody sees the worth in the image except oneself.

A photograph is a record of a moment in time. Diane Arbus wrote of photographs, 'They are the proof that something was there and no longer is. Like a stain. And the stillness of them is boggling. You can turn away, but when you come back they'll still be there looking at you.'[3] The photographic commemoration of the present rapidly, over time, becomes a record of a quickly receding past. Roland Barthes poignantly commented on this fact when he wrote, 'In front of the photograph of my mother as a child, I tell myself: she is going to die: I shudder, like Winnicott's psychotic patient, *over a catastrophe which has already occurred*. Whether or not the subject is already dead, every photograph is this catastrophe.'[4] The realization of the inherent emotional power of photography, as it relates to time and remembrance, emphasizes a nostalgic sensibility that is always present, to some extent, in the consciousness or subconsciousness of the viewer. A photograph of the Eiffel Tower under construction in 1888 (p. 166) will always arrest our attention more than the required cliché snapshot of a hundred years later that proves to our relations that we have visited Paris.

An argument that is discussed in photographic criticism and collecting is whether anonymous photographs, lacking as they do the credentials of authorship and context, could ever be considered masterpieces. I find the opposition to this notion to be tiresome and irrelevant. Oscar Wilde once commented that there was no such thing as obscene literature; there were only books that were well written and books that were not. If a photograph is great, whatever its origin or authorship or lack thereof, it is great. In Western culture, we depend too much on the cult of personality in the creation of art. This is not the case in much of Africa, Asia and many other cultures. In those societies it is the work itself, beyond all else, that is the focal point. In recent decades in America and Europe, only folk art and photography by unidentified creators have been elevated to a high level of aesthetic appreciation. And even then, critical scepticism persists.

Within a living room, a boulder rests upon a rug casting shadows from the light streaming in from a nearby window (p. 18). What is this massive rock doing in a domestic scene, and why did this bizarre placement come to be photographically recorded *c.* 1890 somewhere in America? Our imagination is captured by this and other equally incongruous anonymous images in which the presentation of curious juxtapositions has no hope of further explanation. In the absence of

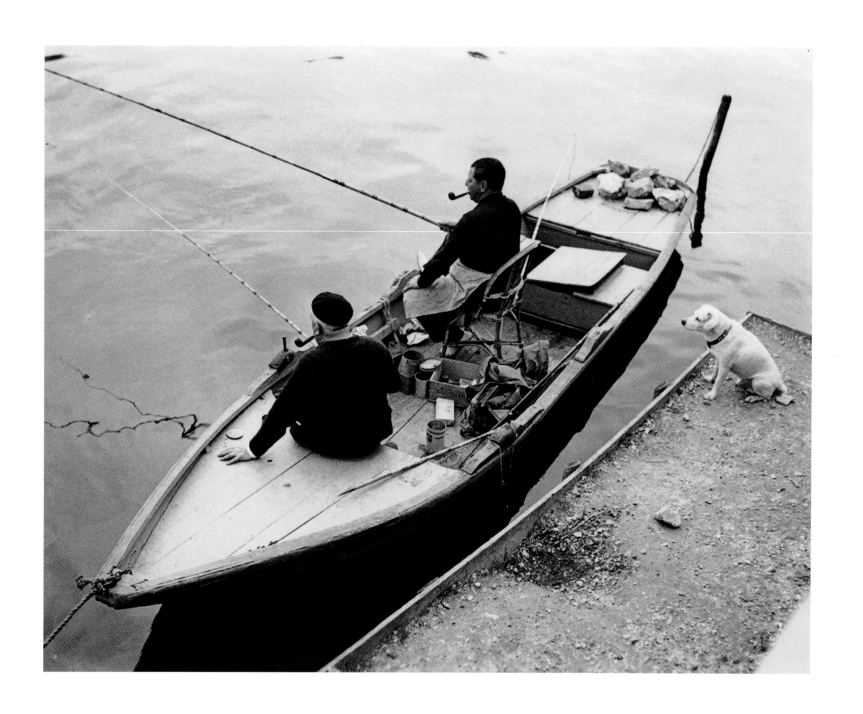

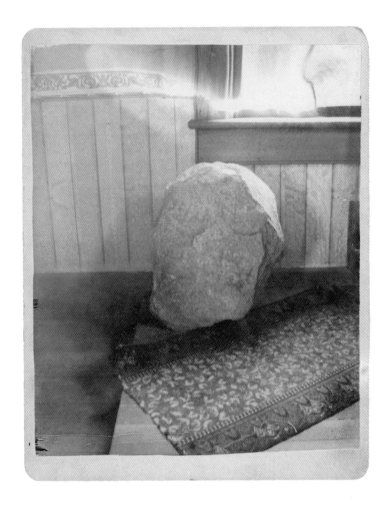

introspective vision of someone like Diane Arbus can have its equivalent in a photograph such as the image, *c.* 1960, of an elderly woman with a chihuahua inexplicably perched on her chest (p. 19).

Collecting is a journey, not a destination. When I began, my education and taste in photography were not where they are now, nor where I expect they will be in the future. I admire the great early pioneers of photography and the later masters and contemporary talents whose reputations have continued to grow throughout the 20th century and into the present one. I find, however, that I have visually, intellectually and emotionally used up many of the great photographic images of the past. The photographs themselves are not to blame. The ubiquitous overexposure of many photographic images in books, magazines, reproductions and exhibitions, however, drains admirable works of their original power to inspire. I observe that this is much more prevalent in photography than in other forms of art. Thus, if I never again see Ansel Adams' *Moonrise, Hernandez, New Mexico*, André Kertész's *Chez Mondrian* or Yousuf Karsh's *Winston Churchill*, it will be too soon. Despite the acclaim of such works, familiarity, alas, for me, has bred a form of contempt.

The search for a broader meaning of photography's potential led me to the parallel universe that exists in anonymous imagery. There is no danger of recognition overload since every photograph is virtually unique. Another refreshing aspect is that, for a change, money is not a limiting factor. These images can usually be purchased for anything from a few cents to a few dollars, although, due to the growing interest in anonymous photography, a few exceptional examples have sold for tens of thousands of dollars at auction. Once acquired, however, the photographic orphan enters the aesthetic family of the person who has bought it, to be praised, defended and appreciated.

Below the surface of established fine-art photography is a vast, unwieldy reservoir of untapped visual images that contains works of undeniable, if unintended, beauty, pathos and imagination. They are waiting to be discovered and transformed from trash into visual treasures by those willing and able to seek them out. They are not so much about art as they are about life. These seemingly inconsequential pictures have the potential to trigger a memory or emotional response as surely and profoundly as a remembered scent or melody. The photographs within this volume are the result of an individual's personal journey of discovery through these uncharted visual waters.

established fact, these photographs allow the viewers to construct freely their own scenarios. Many were undoubtedly created with an honest attempt at form and content, while others were surely the result of chance or fortunate accident. The reality is the photograph, the reverie is our interpretation.

Another undeniable quality of anonymous photography is the inadvertent association many of these pictures have with famous photographers and their established styles and subject matter. The 'it looks just like...' syndrome is one that can be startling, yet understandable. Like a set of notes on the piano that remind one of Bach or Mozart, a photograph can unintentionally recall and fit within the aesthetic of an established photographer's oeuvre. Thus, two men with their dog fishing in a French photograph *c.* 1930 (p. 17) vividly recalls the work of Jacques-Henri Lartigue or Henri Cartier-Bresson. Although taken in the 1940s, a photobooth image (p. 16) anticipates the deadpan hipness of Andy Warhol's use of the same commercial device in his pop-art imagery of the 1960s. Even the highly personal and

1 Barthes, Roland, *Camera Lucida* (New York: Hill and Wang, 1981), p. 16.

2 Sontag, Susan, *On Photography* (New York: Delta, 1977), p. 192.

3 Arbus, Diane, *Diane Arbus: Revelations* (New York: Random House, 2003), p. 226.

4 Barthes, Roland, *Camera Lucida*, p. 96.

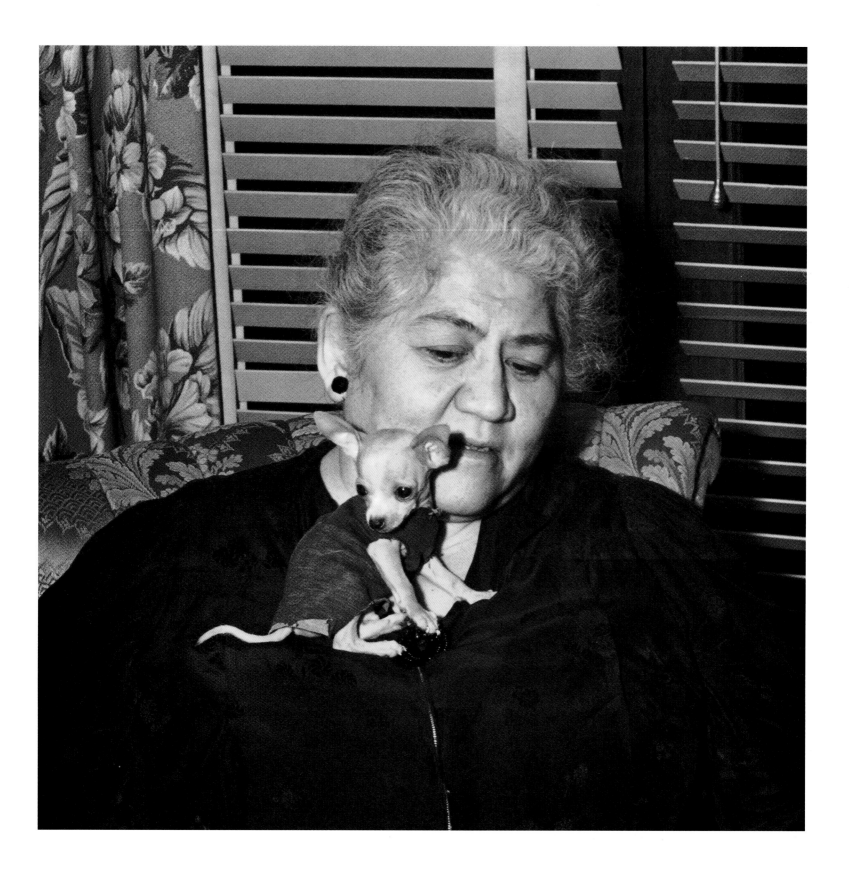

land, sea and sky

In 1850, August Salzmann photographed, near Jerusalem, the road to Beith-Lehem (as it was spelled at the time): nothing but stony ground, olive trees; but three tenses dizzy my consciousness: my present, the time of Jesus, and that of the photographer, all this under the instance of 'reality'. Roland Barthes

We become acutely aware of a world beyond our own through the surrogate experience provided by photographs. From the earliest days of photography, one of its main commercial purposes was to bring the natural and man-made wonders of distant places to an audience that might never

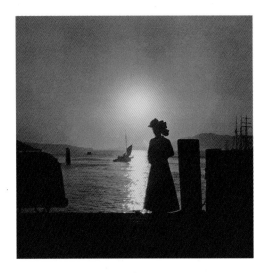

experience them first-hand. Photography dispelled lingering uncertainties about the veracity of earlier subjective painted, written and verbal depictions. The camera left no doubt as to the reality and scale of phenomena, such as Niagara Falls, the Pyramids of Egypt and the Colosseum in Rome. In many landscape photographs, humans are relegated to a subservient role in the composition, included only to give a sense of scale to the scene or to reinforce the notion of man's uneasy coexistence with nature.

Light is a crucial element in the technical process of photography, as well as one of its most potent subjects. The unpredictable quality of light at different times of day, throughout the seasons and changes in the weather has always been a preoccupation of photographers. This focus is taken further in the observation of atmospheric occurrences, ranging from the full moon and lightning to comet trails and lunar eclipses.

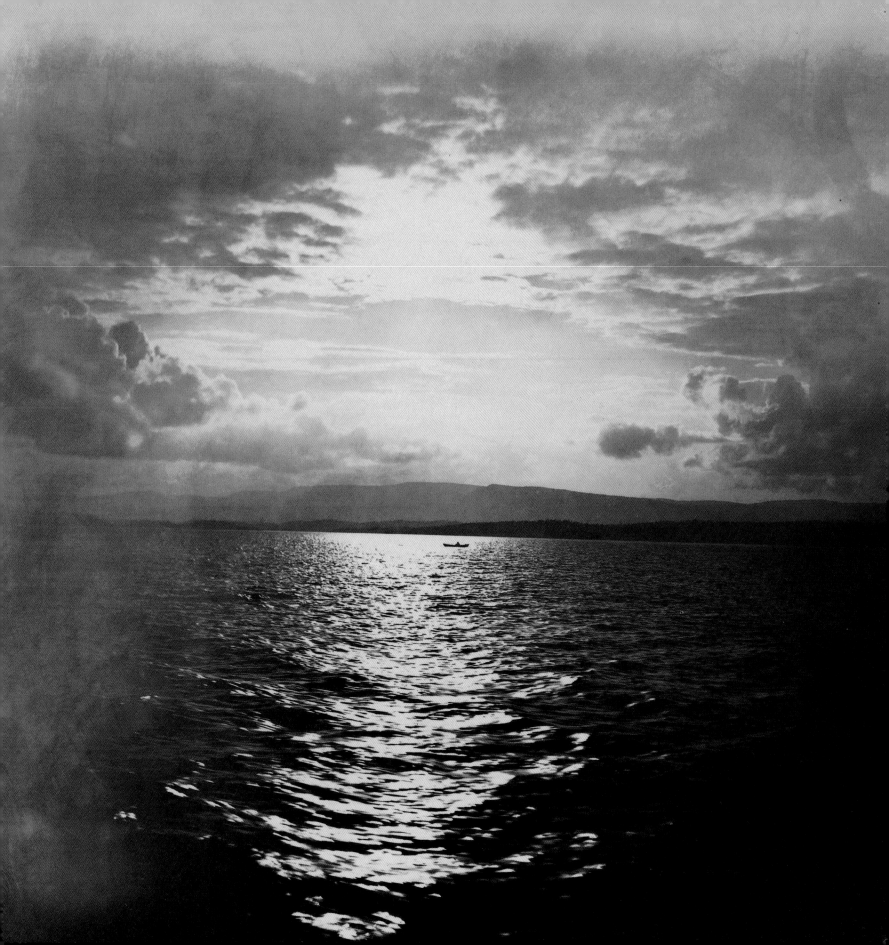

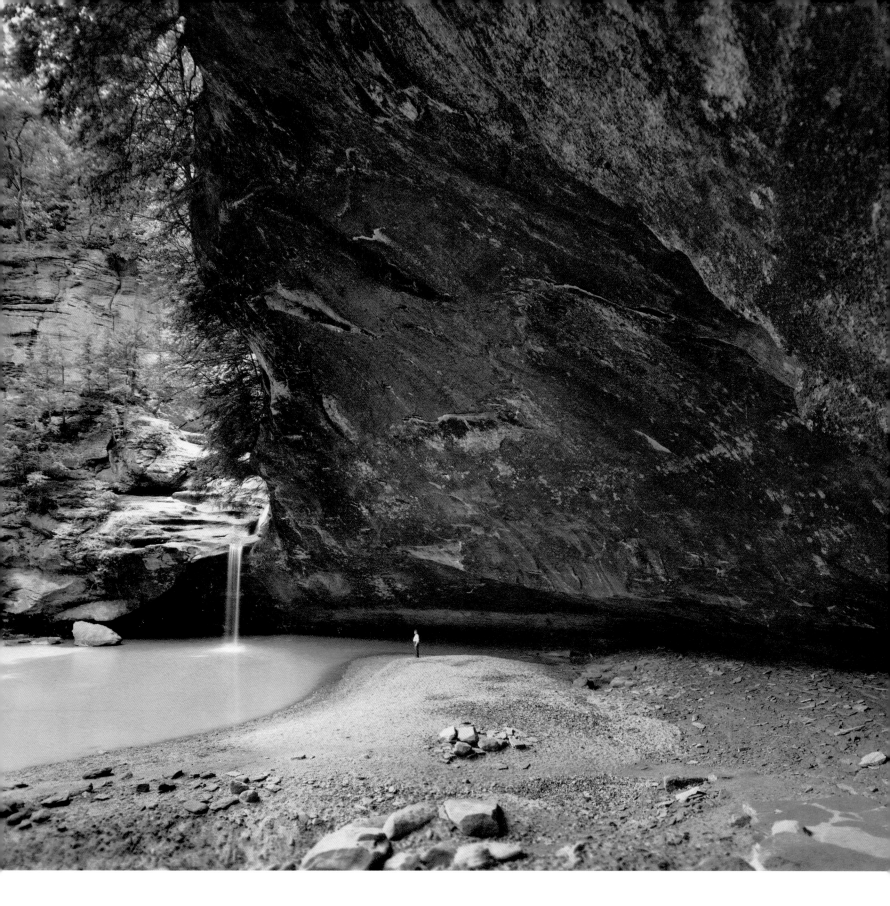

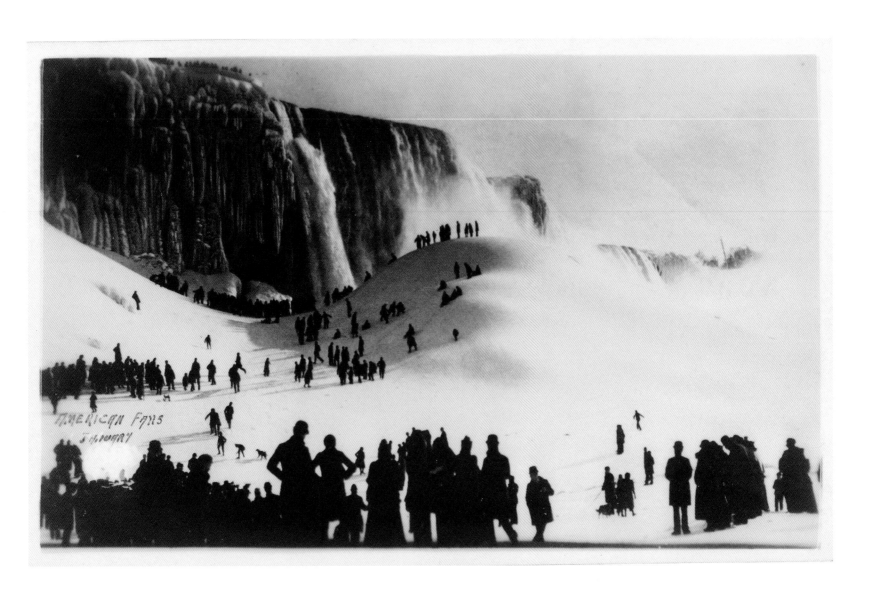

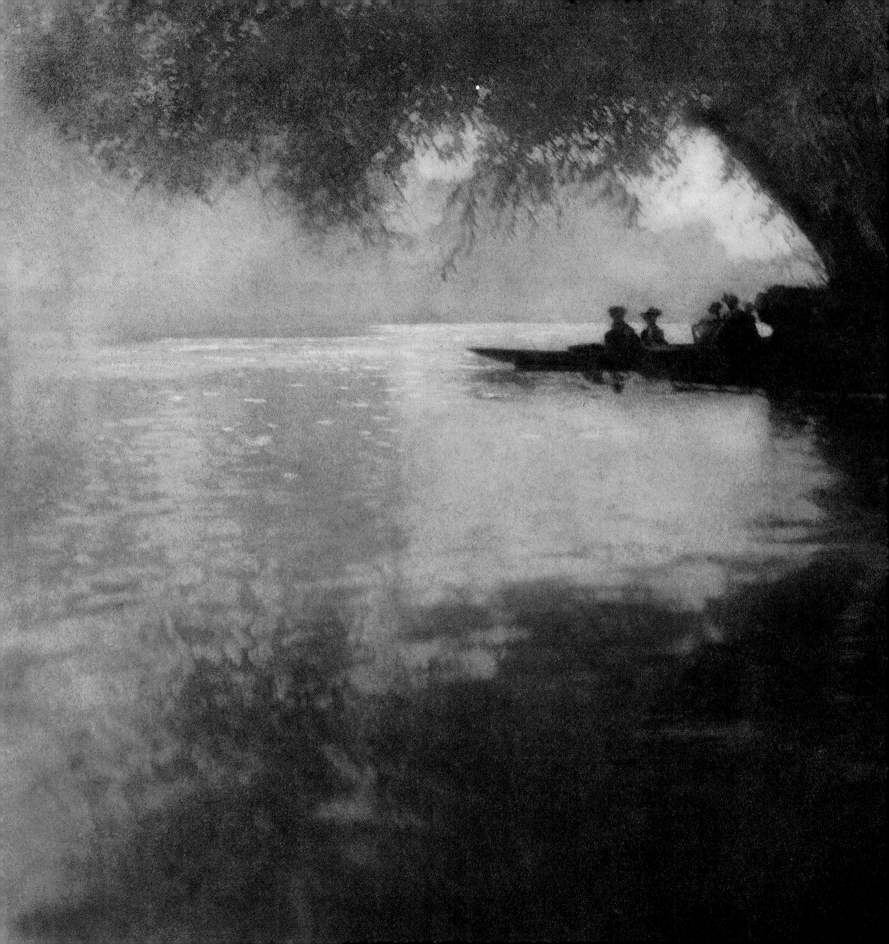

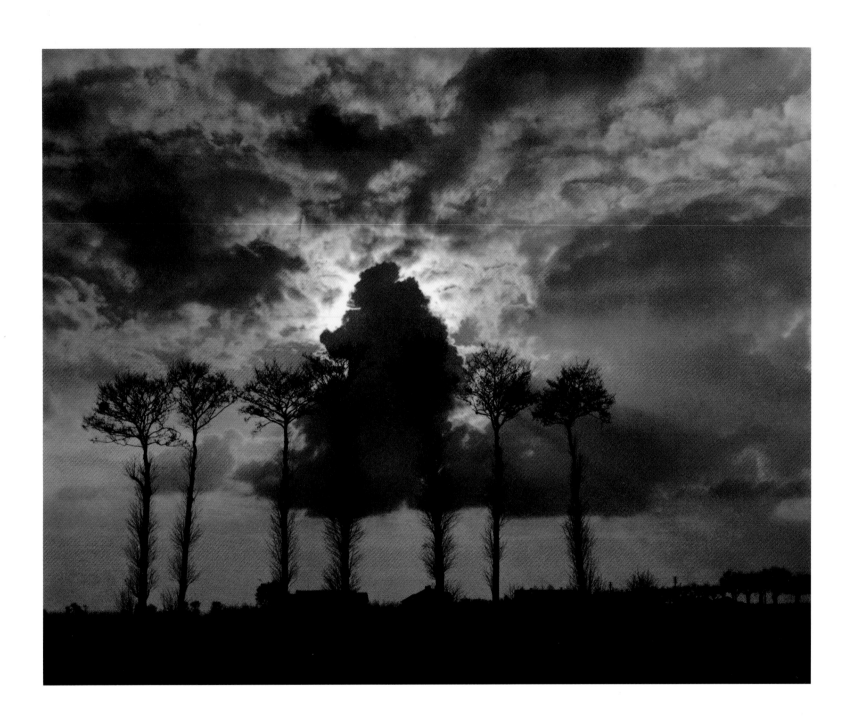

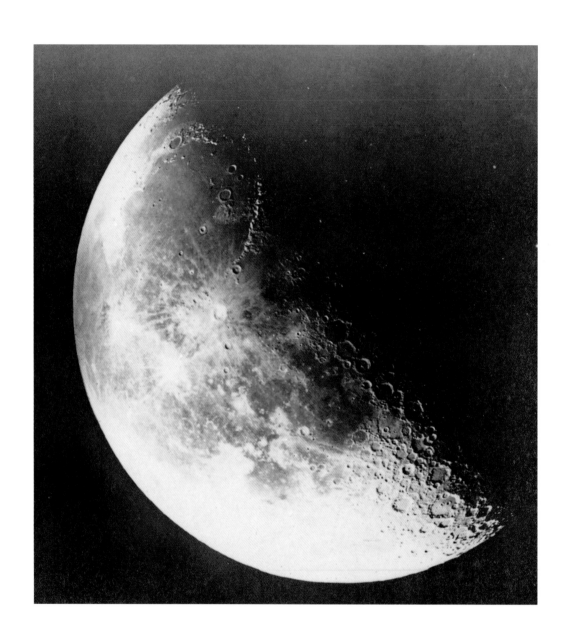

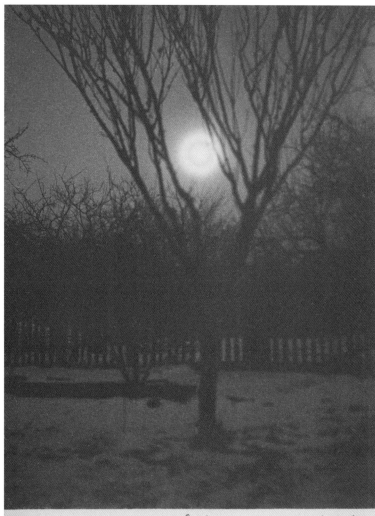

"a moonlight night":
(through the branches of a)
plum tree.

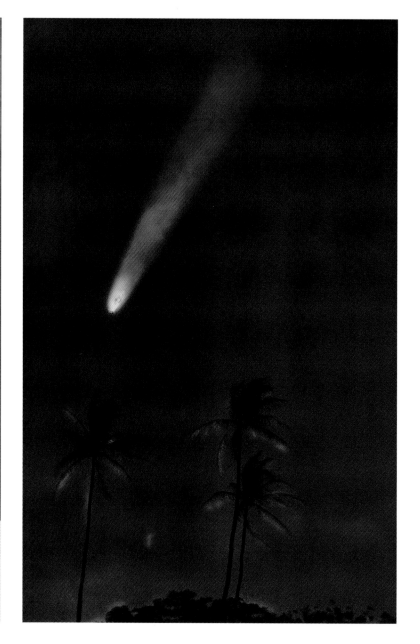

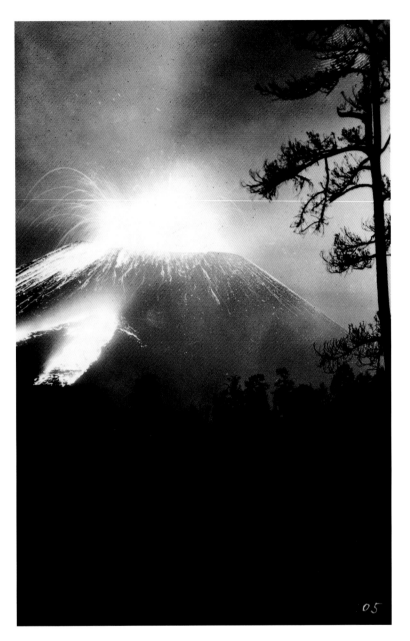

05

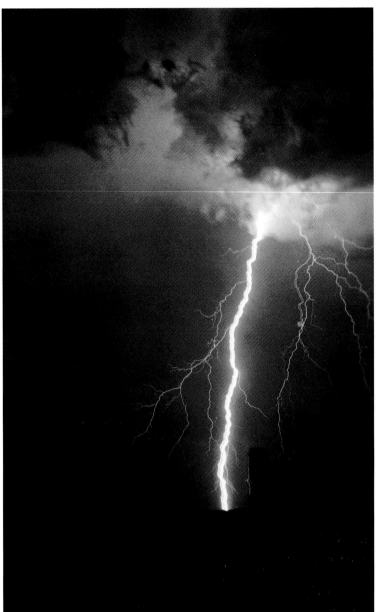

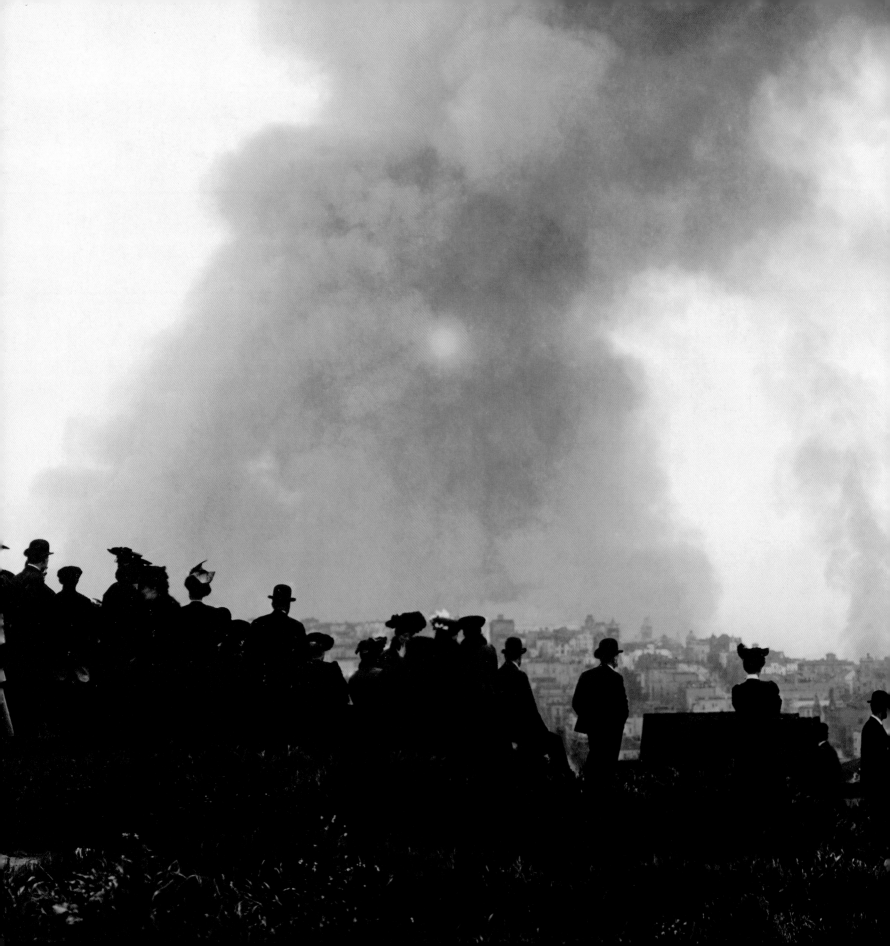

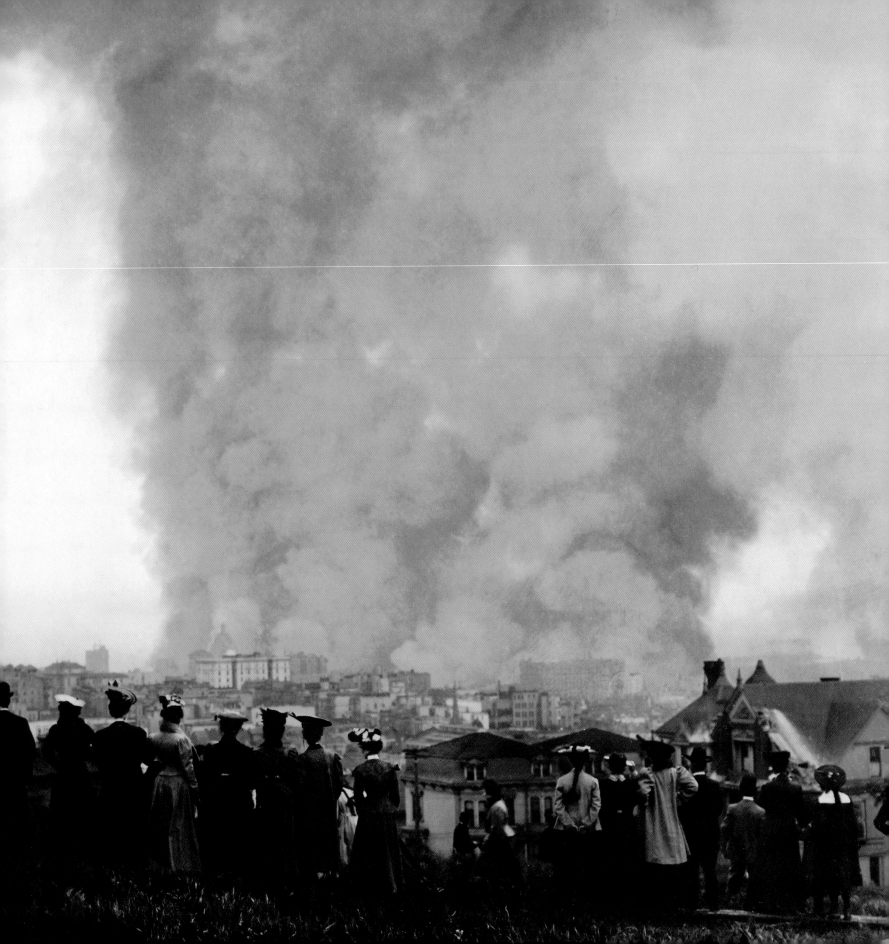

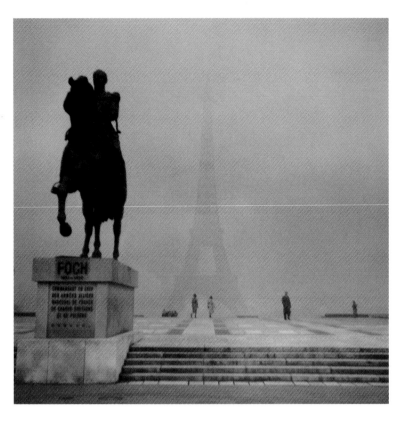

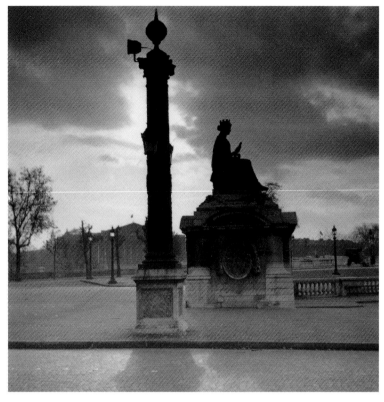

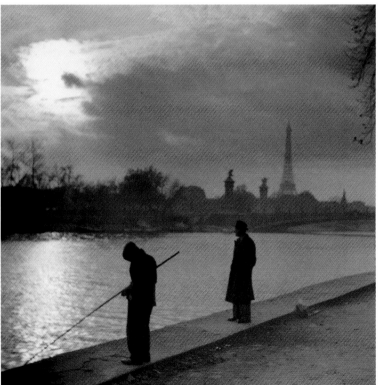

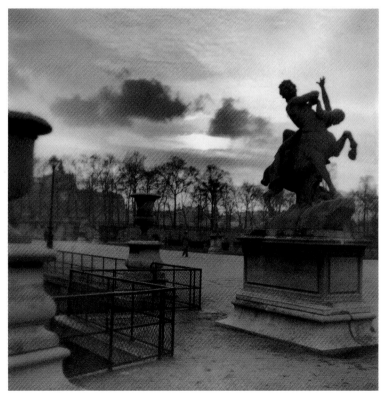

beginnings

Children enjoy the present because they have neither a past nor a future. Jean de La Bruyère

In the early 16th century, the great German Renaissance artist Albrecht Dürer made thirty-four prints of the Madonna and Child, more than any other subject. It is clear why this motif was so popular. The image of Mary and the Christ Child was not just a Christian symbol, but a visual link from the Divinity to the life experience of Dürer's contemporaries, who witnessed the miracle of

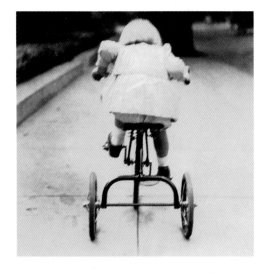

birth, infancy and growth of children in their own lives. For similar reasons, there is no area of photography where the camera lavishes more obvious affection upon its subject matter than in images of children. There is a refreshing innocence in the way children appear in photographs. Even the very young radiate a certain individuality, but without the awareness of the camera that preconditions adults to assume poses that shield their private selves.

There is an element of quiet urgency in the way children are photographed. The awareness of change and transformation from infancy to adulthood requires the immediate documentation of these stages of growth. Overlooking this process results in the irrevocable loss of visual memory. The camera preserves images of youth and innocence that all too soon will be gone. Photography defeats time, yet it also makes us painfully aware of what we have to lose and have already lost.

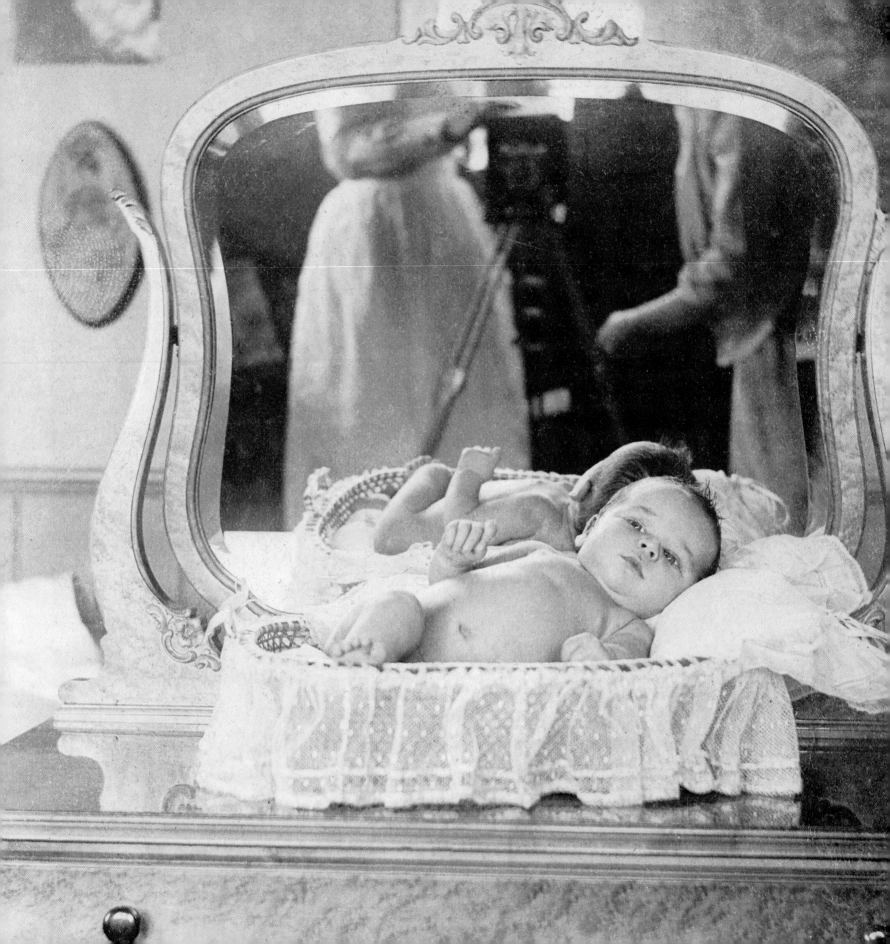

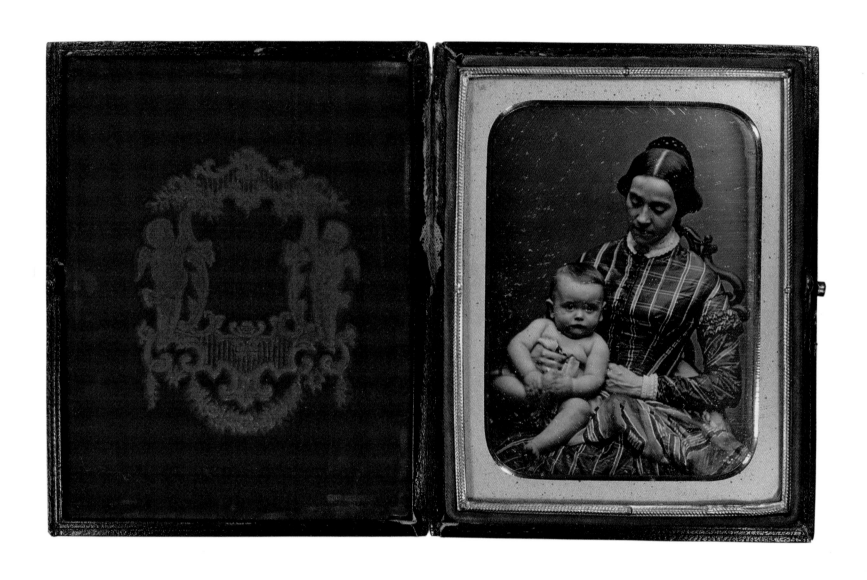

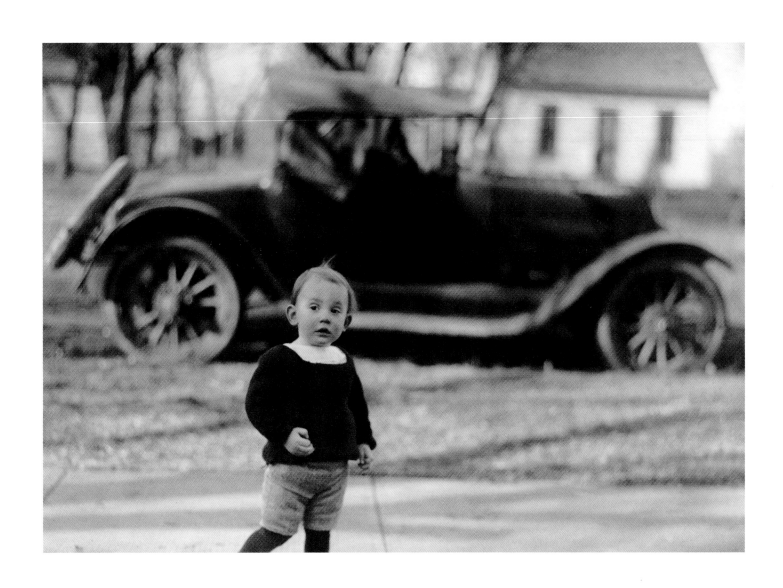

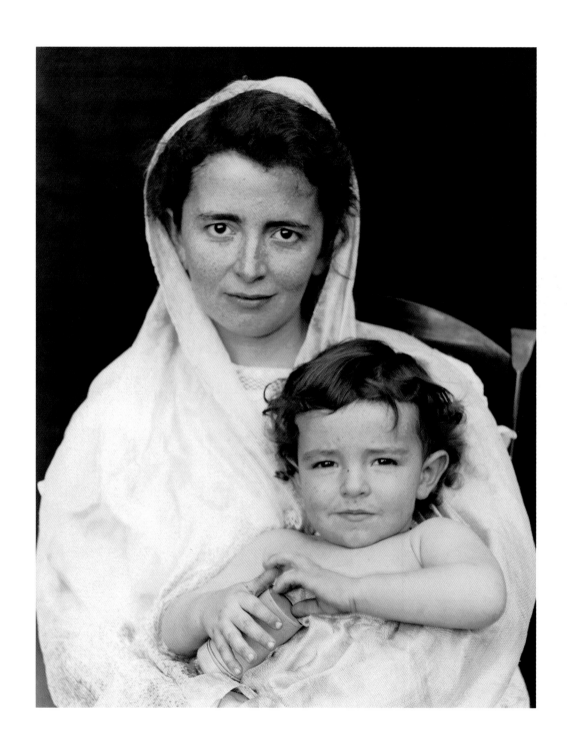

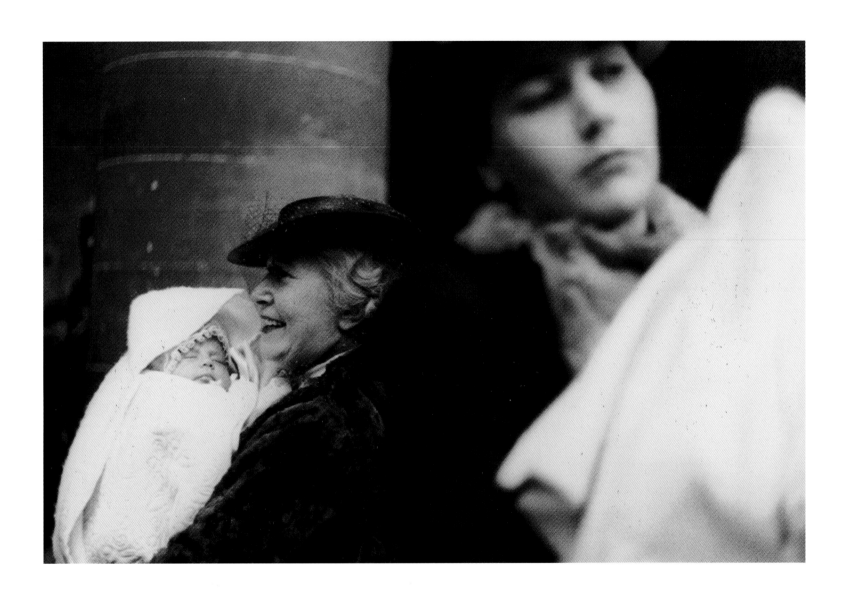

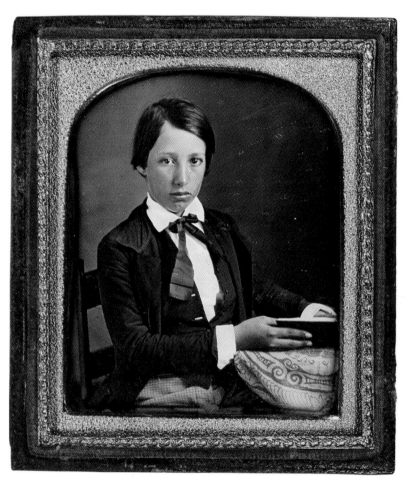 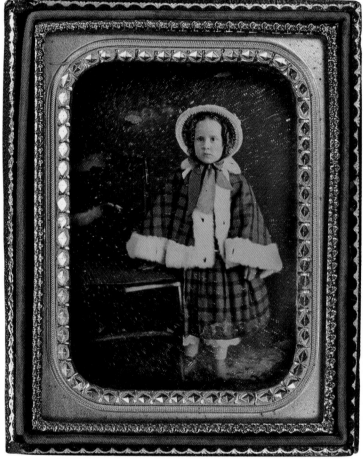

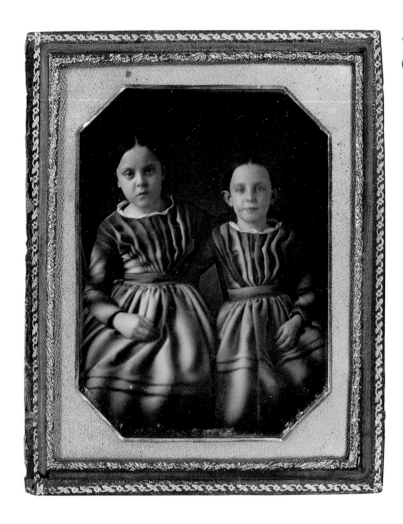
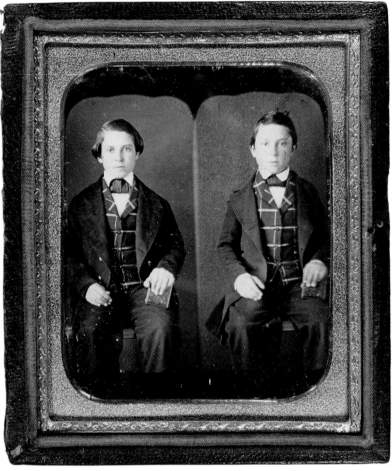

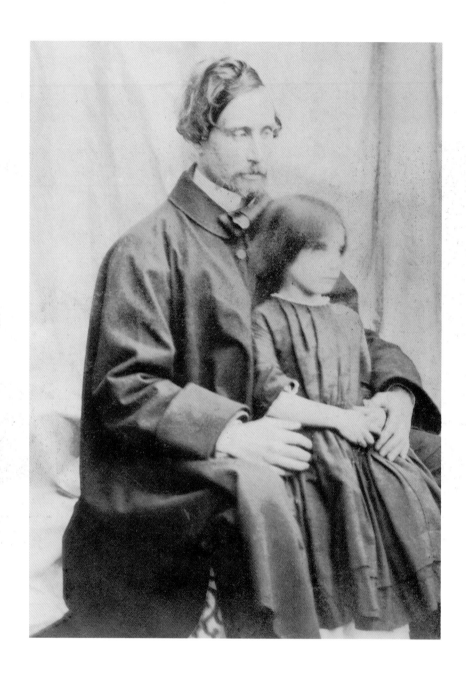

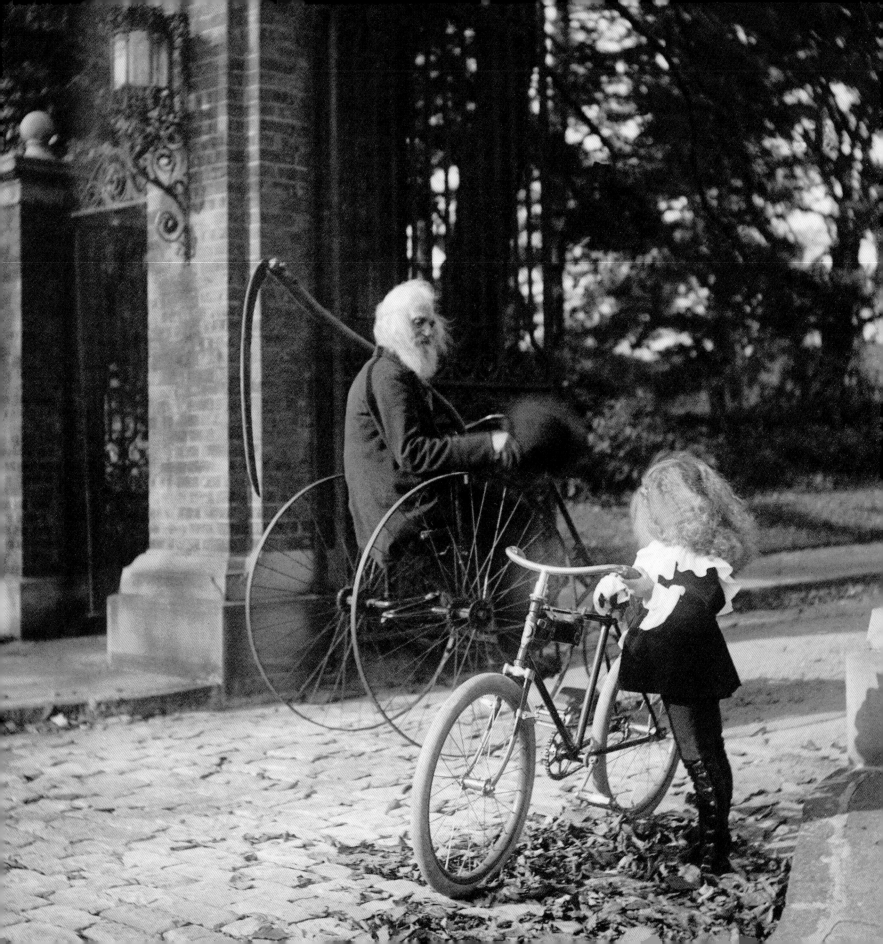

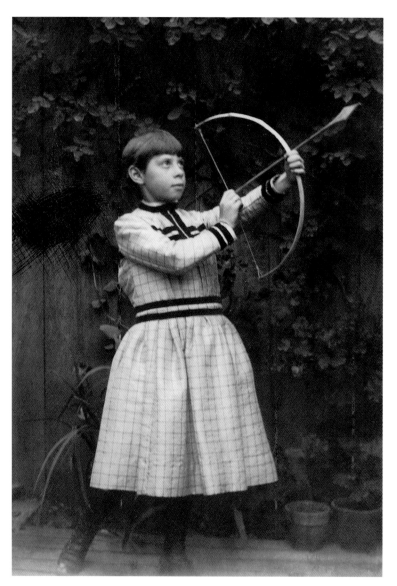

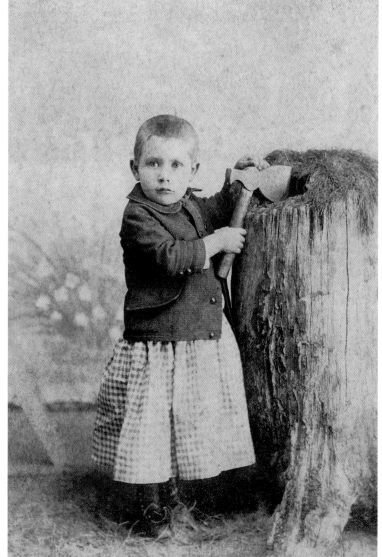

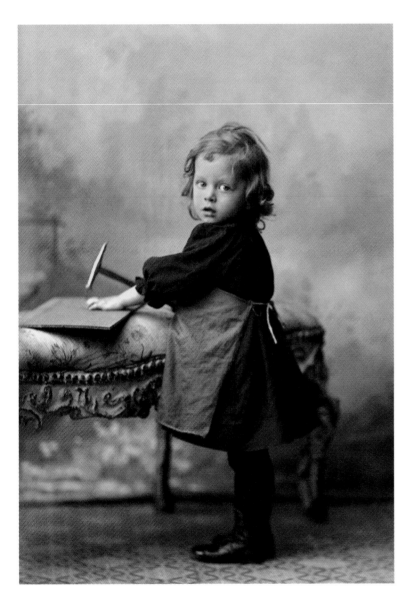

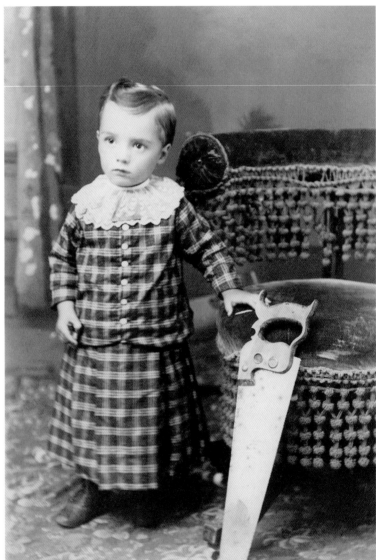

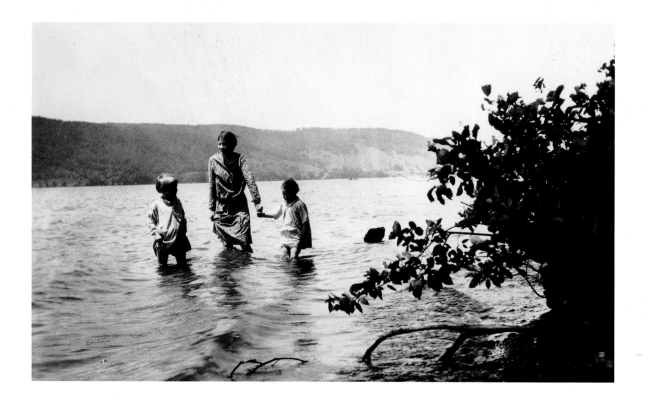

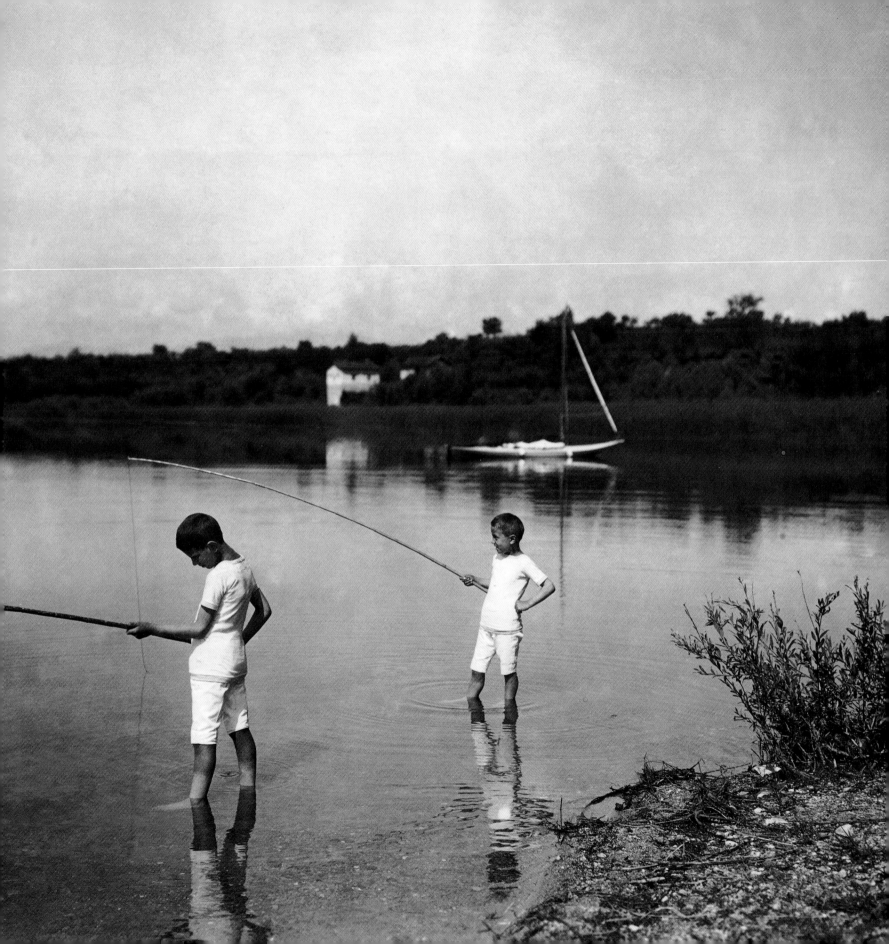

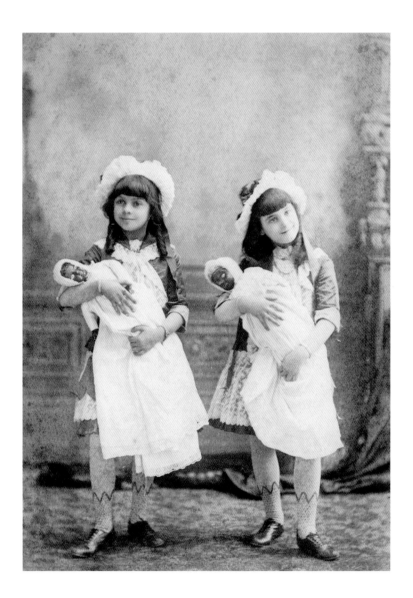

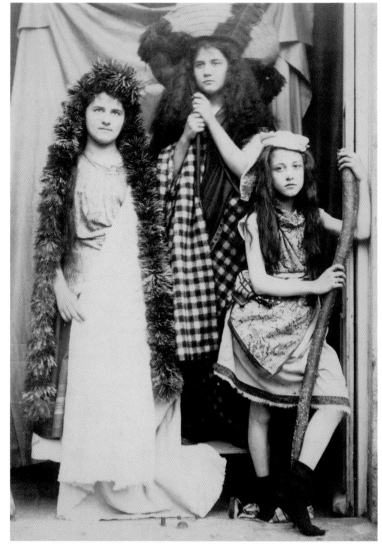

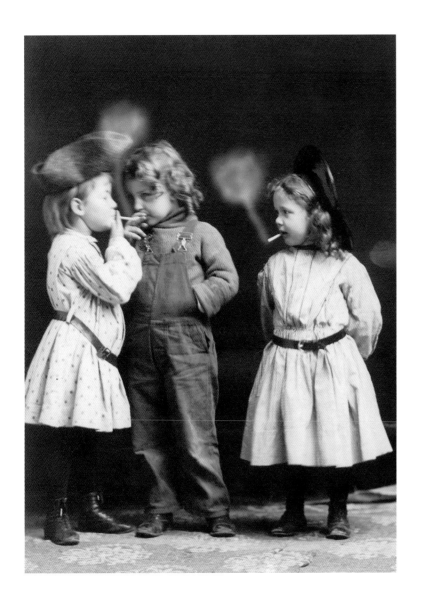

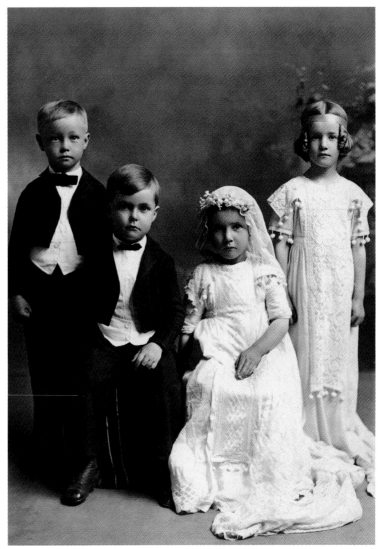

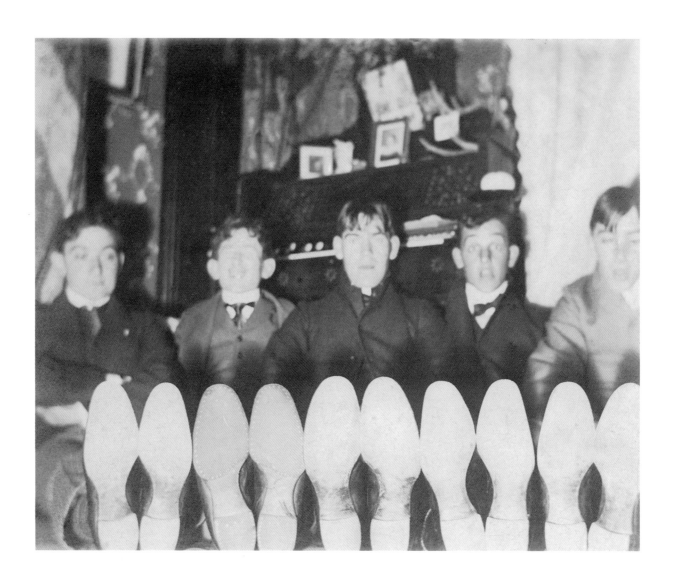

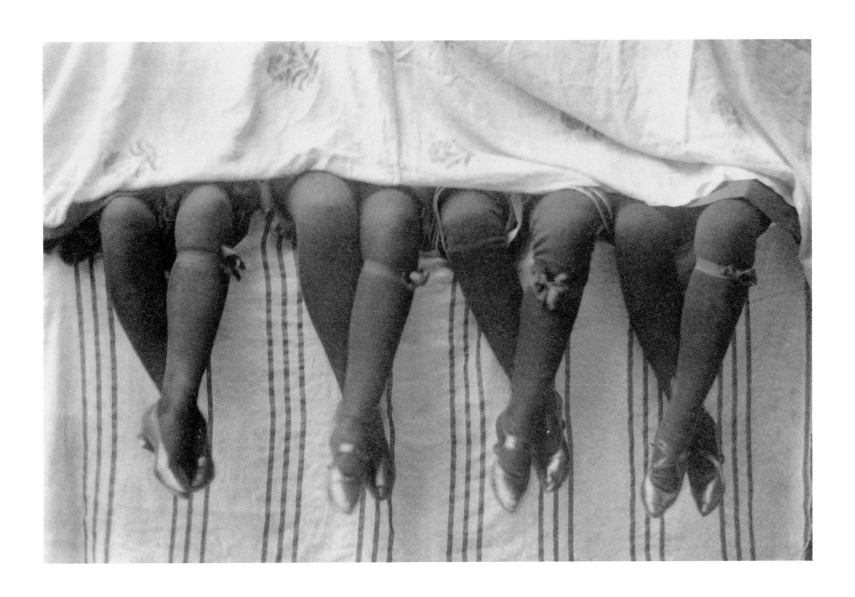

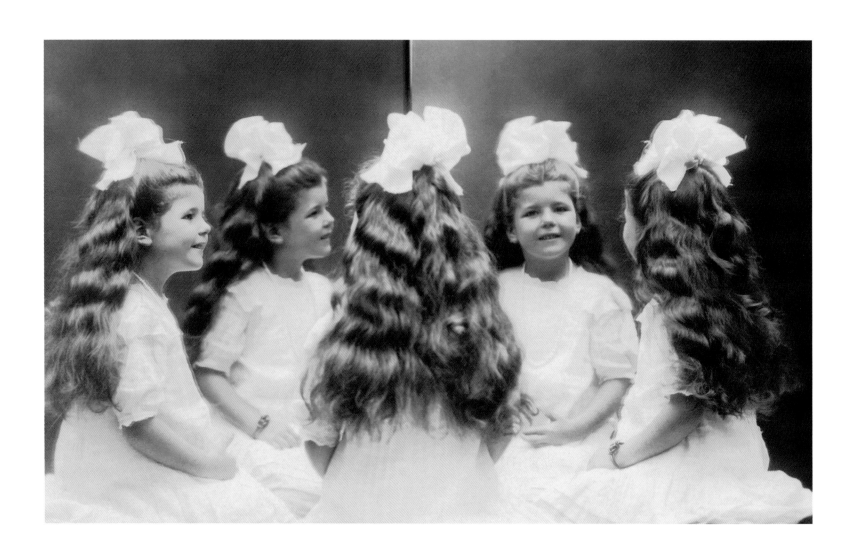

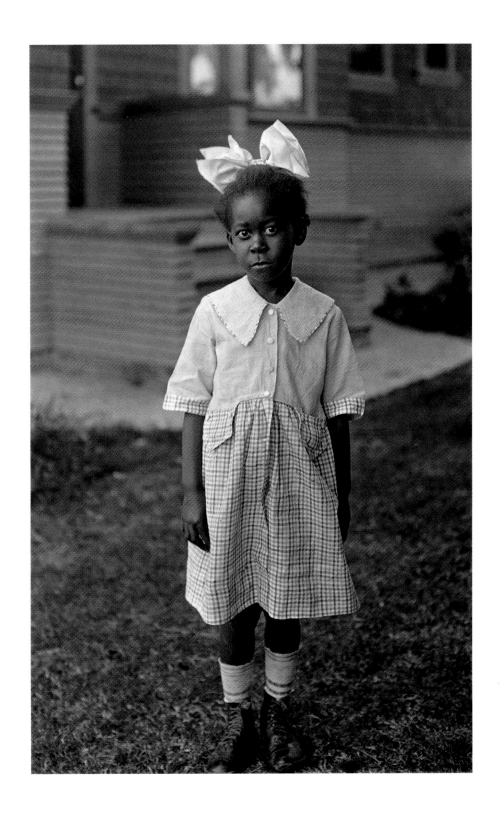

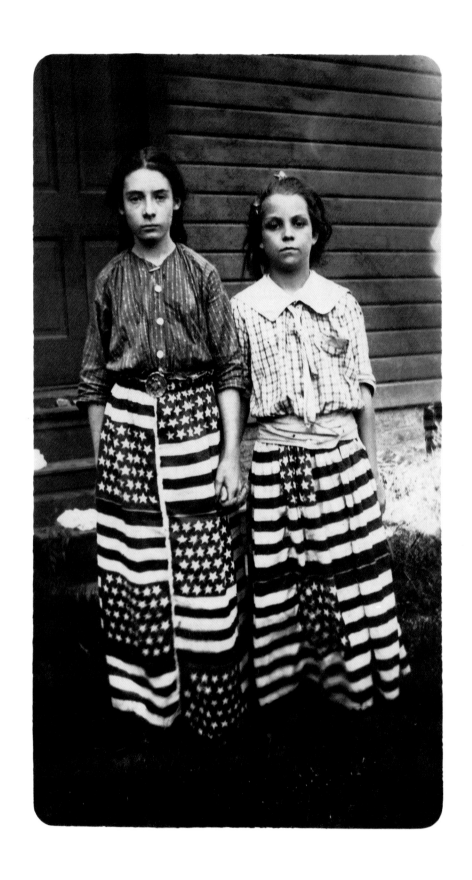

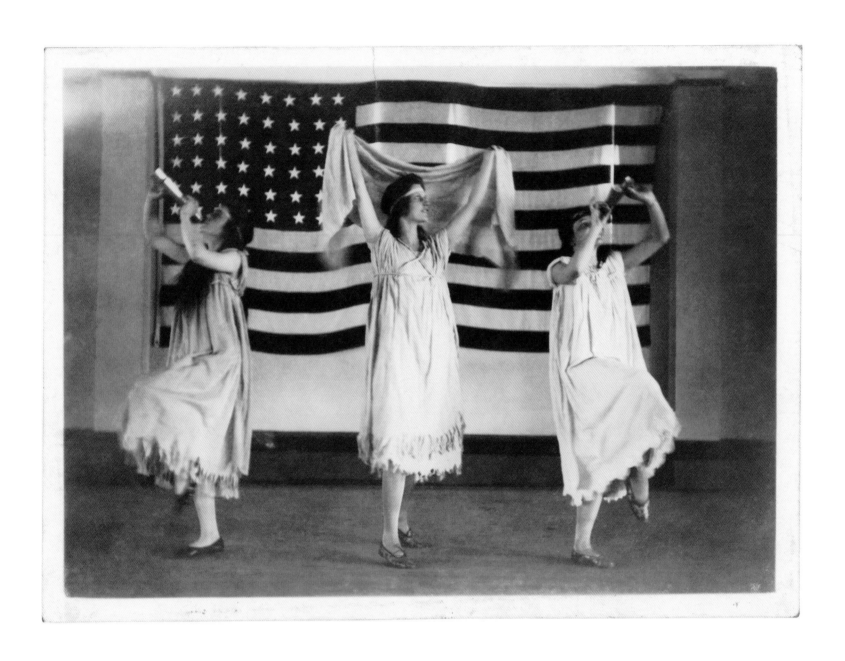

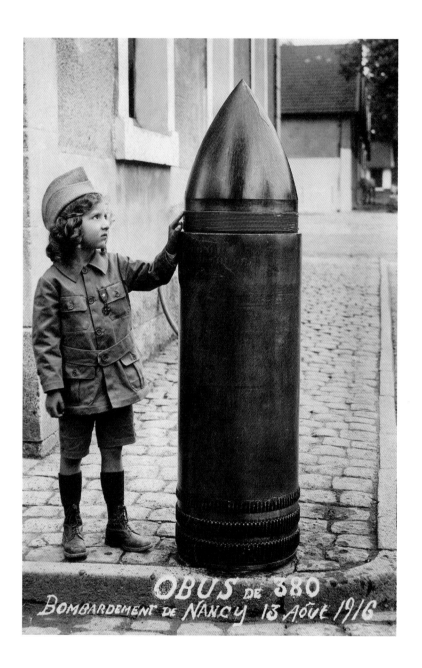

OBUS DE 380
BOMBARDEMENT DE NANCY 13 Aôut 1916

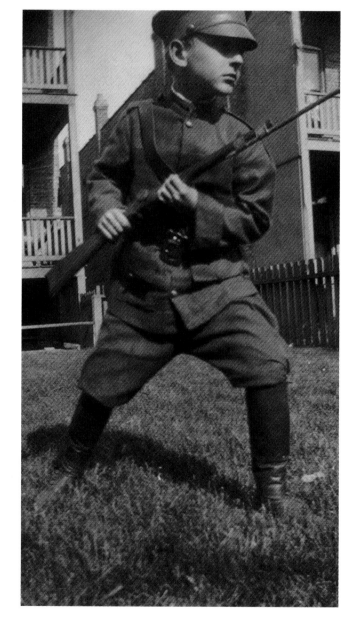

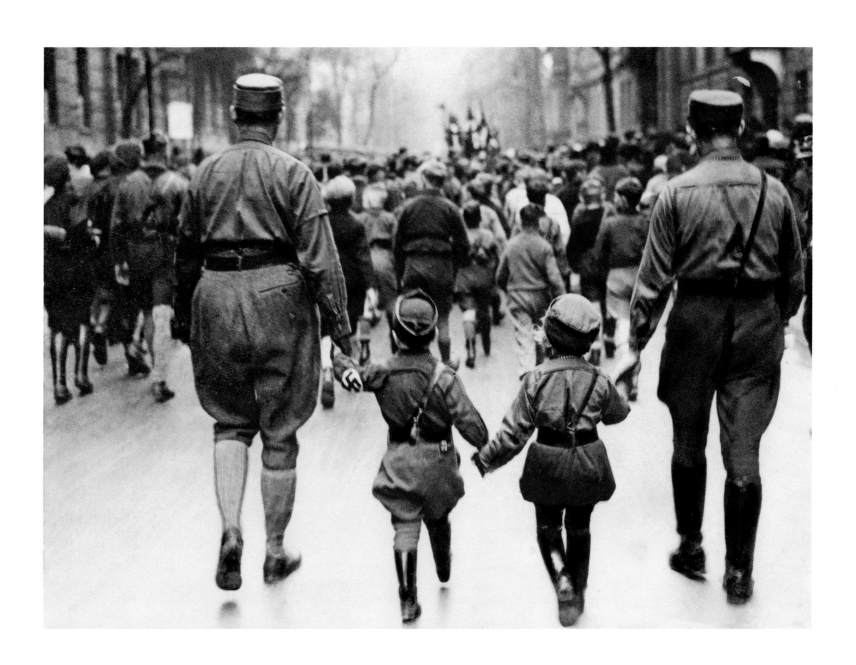

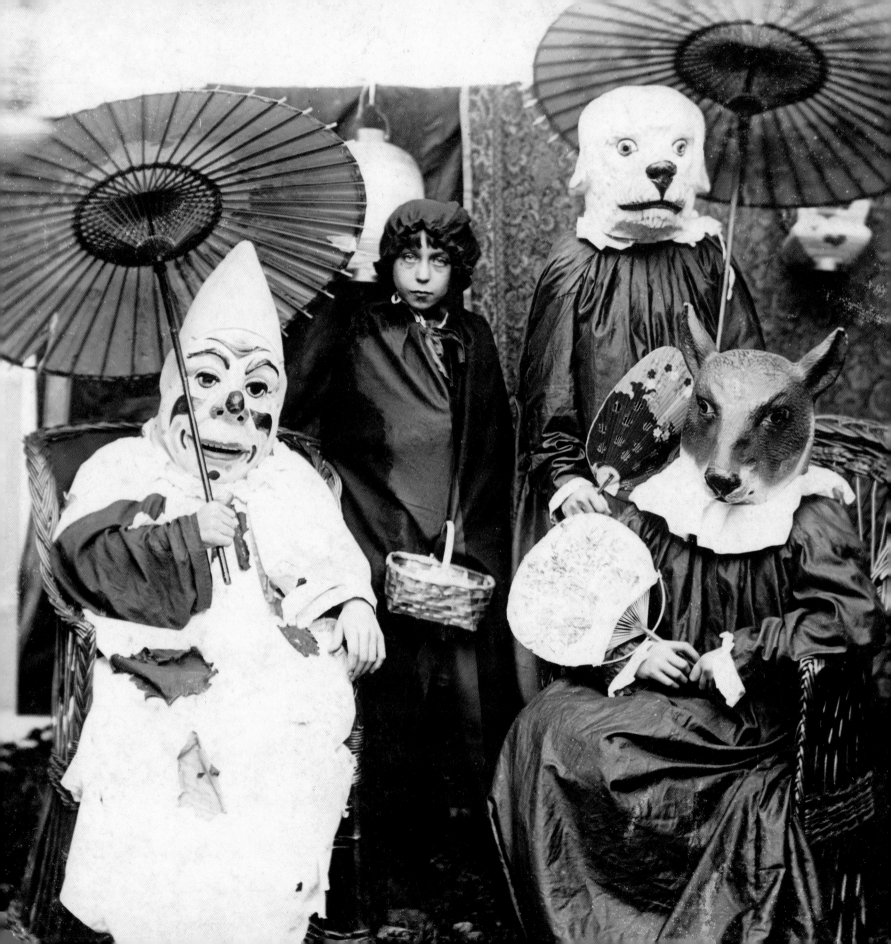

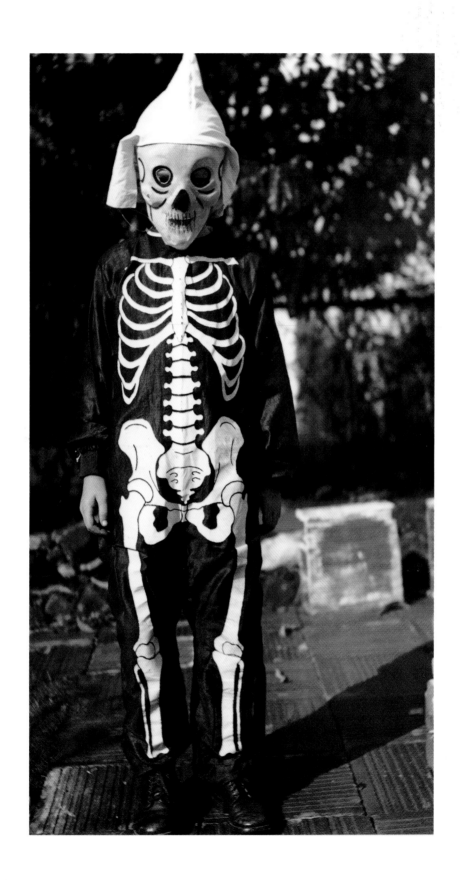

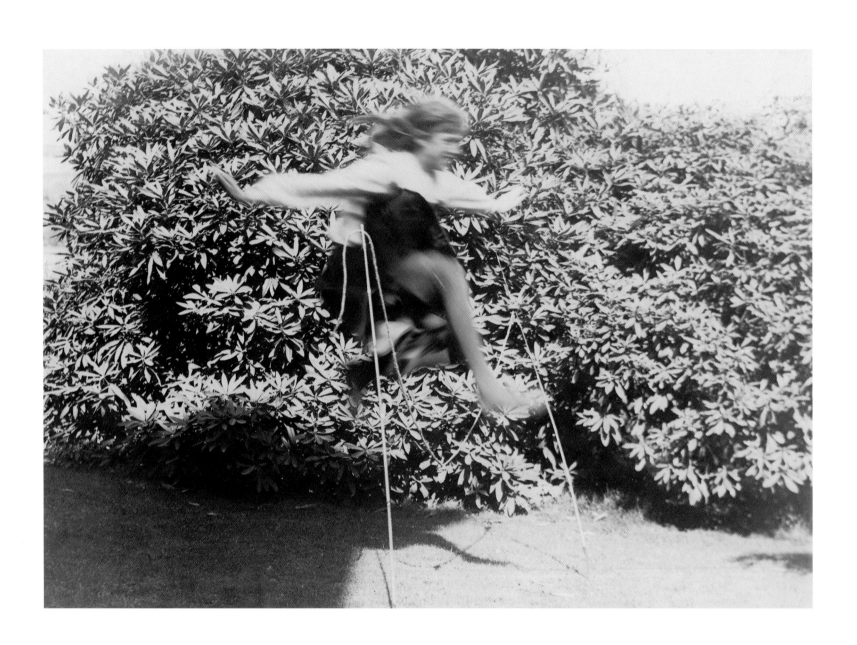

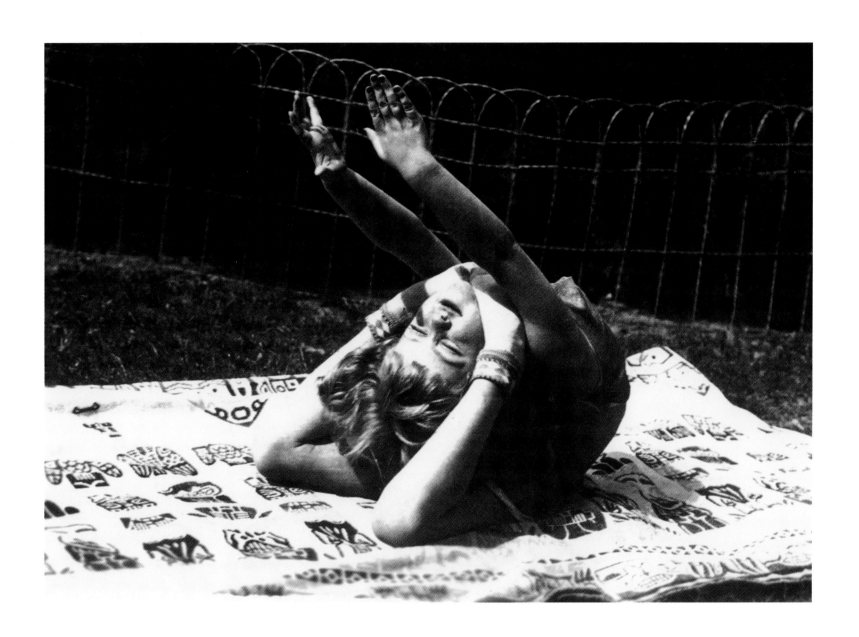

creatures

There is a mixture of domination and envy in the way humans interact with animals. We bend them to our will for our food, transportation, livelihood, amusement and companionship. At the same

time, however, we are jealous that animals have no sense of shame. Their actions in matters of bodily function and sexual activity are in stark contrast to the rigidity of man's religious, moral and social structures. Animals exude a freedom that man disparages.

When people are photographed with animals, the creatures often display a natural nobility of presence. It should always be remembered that humans quickly recognize the objective of the camera. They assume poses and expressions in an attempt to flatter themselves before the lens. No matter how posed or controlled, animals have no consciousness of the purpose they are subjected to in photography.

There is a 19th-century saying that if you wanted to sell a picture, you painted a little girl. If it didn't sell, you painted in a dog next to the girl. Finally, if it still didn't sell, to ensure success, you painted a bandage on the dog's paw. Controlled intimacy and forced pathos are the subtle undercurrents in many photographs of animals with man. It is only when animals are photographed by themselves in their natural environments that their character, based on instinct and reflex, becomes truly apparent.

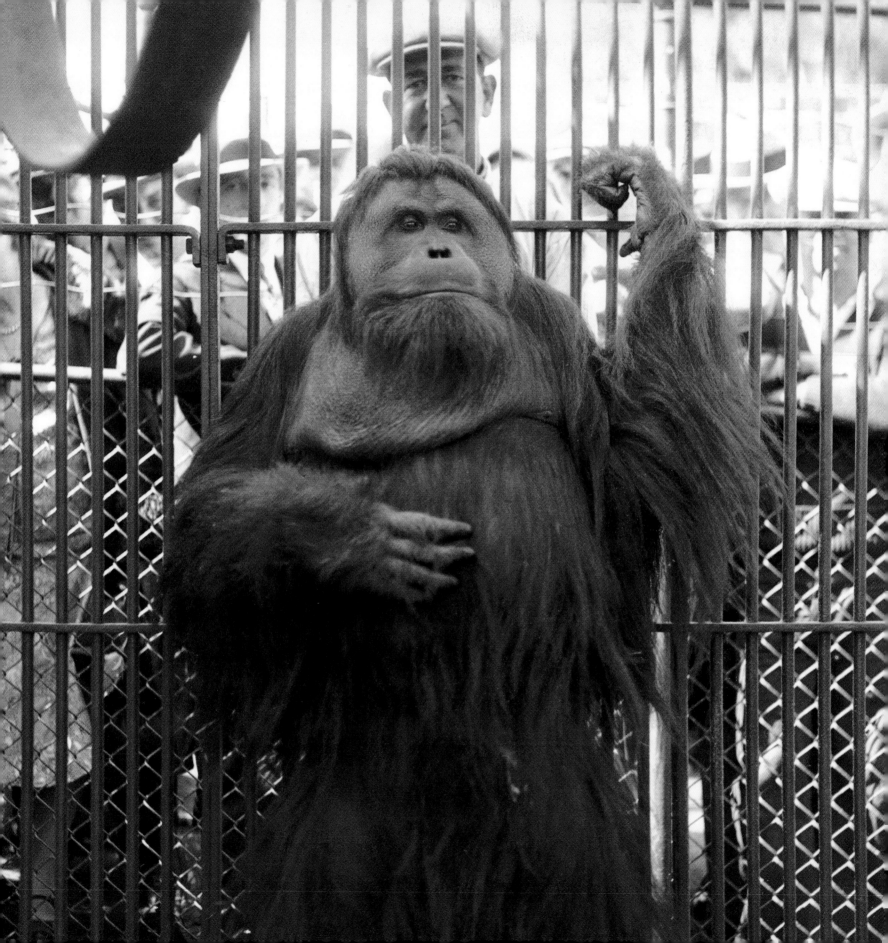

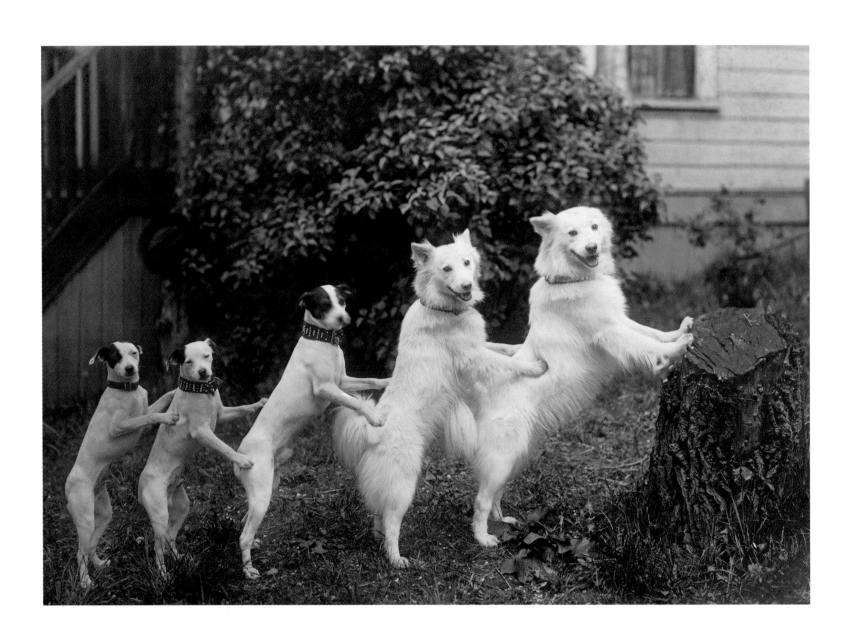

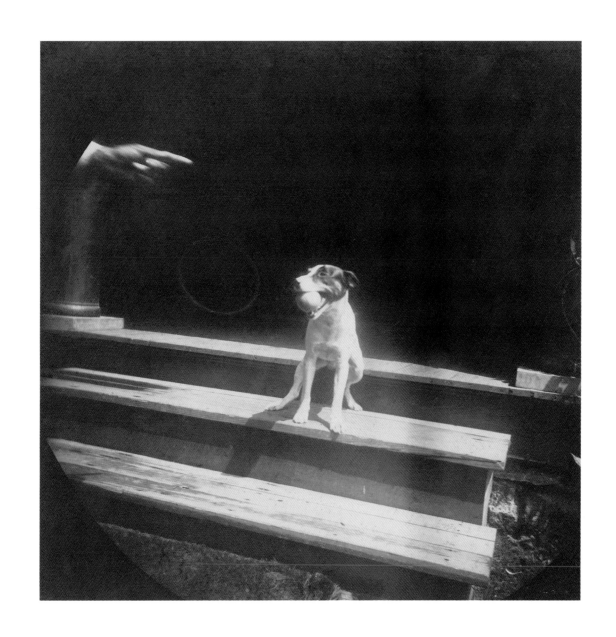

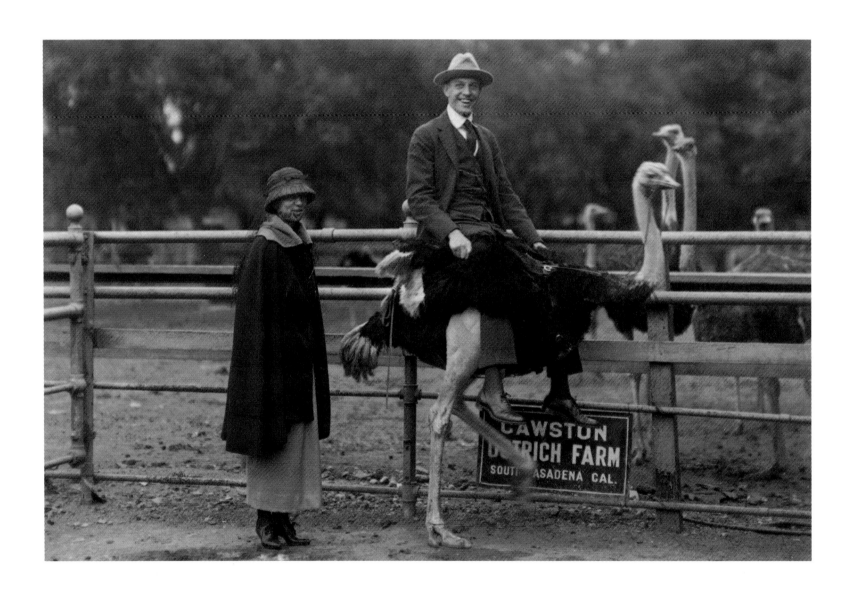

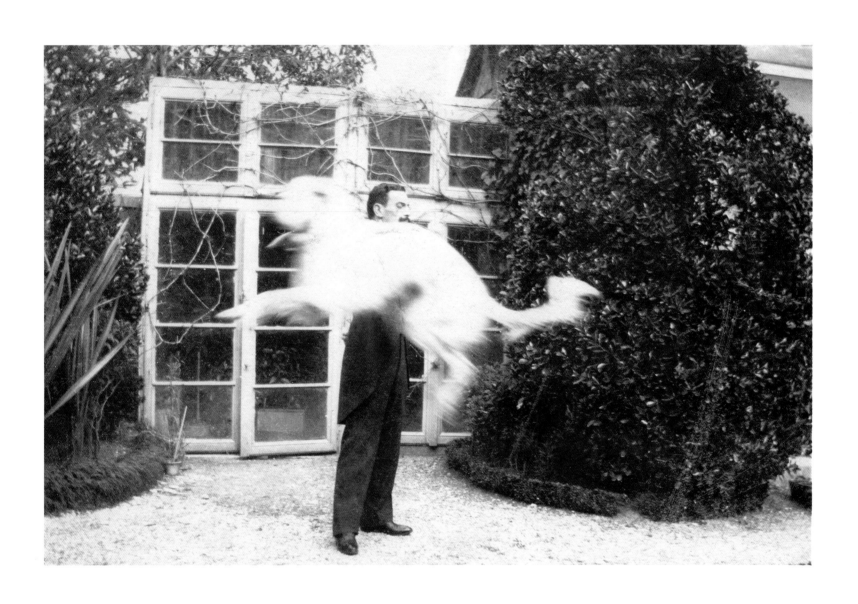

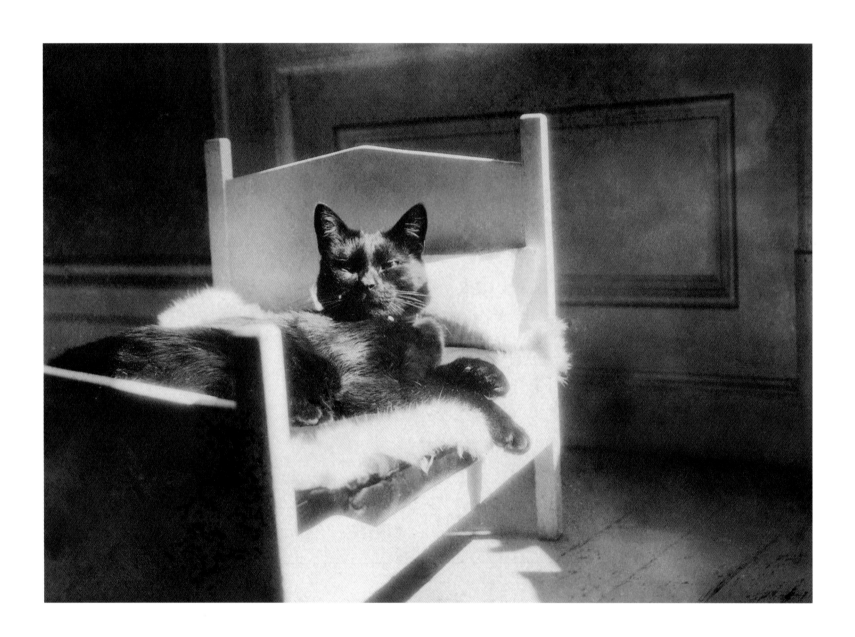

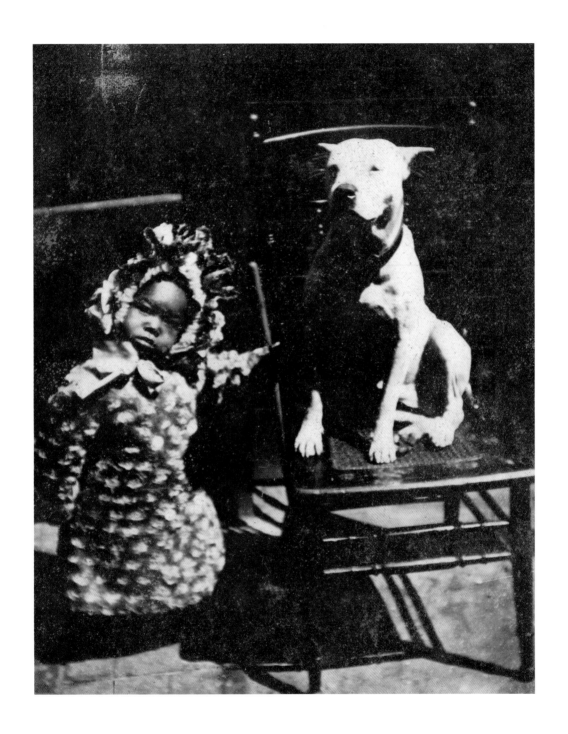

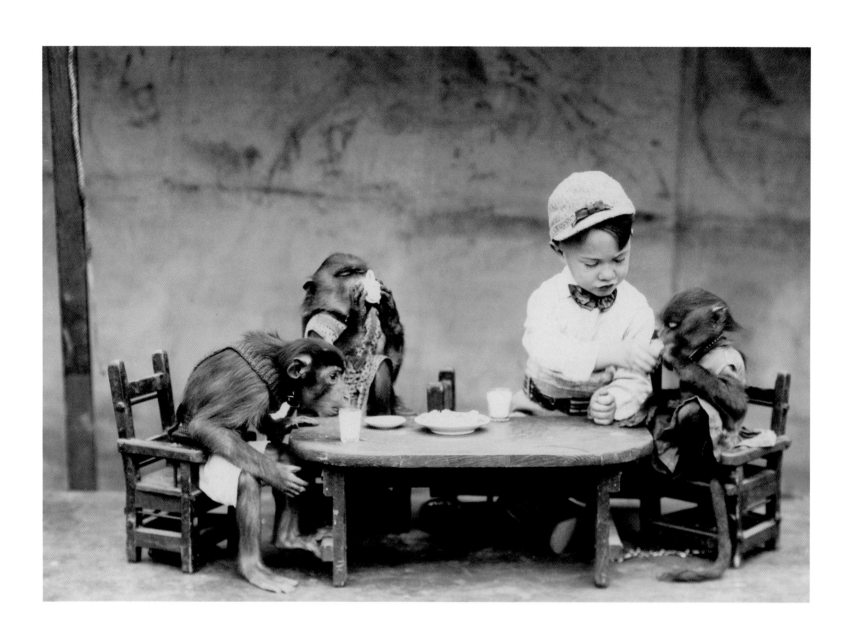

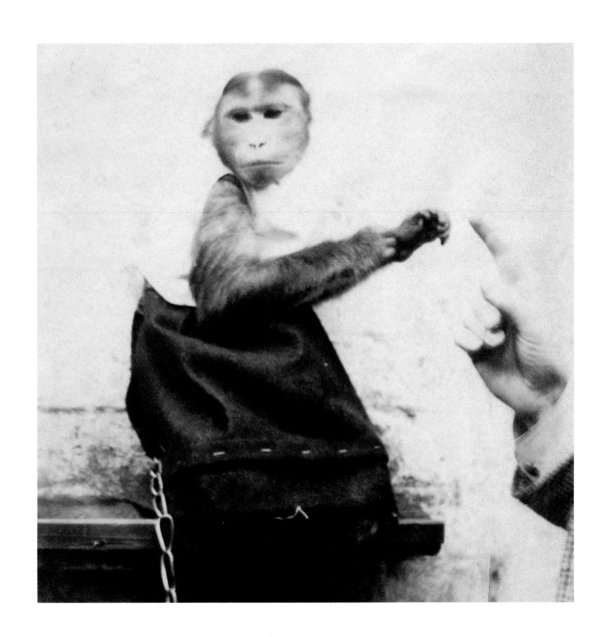

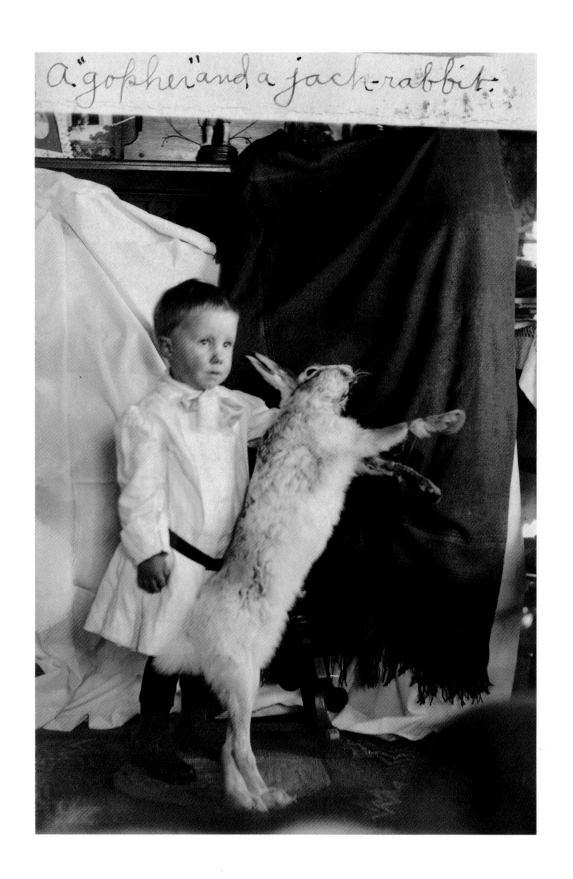

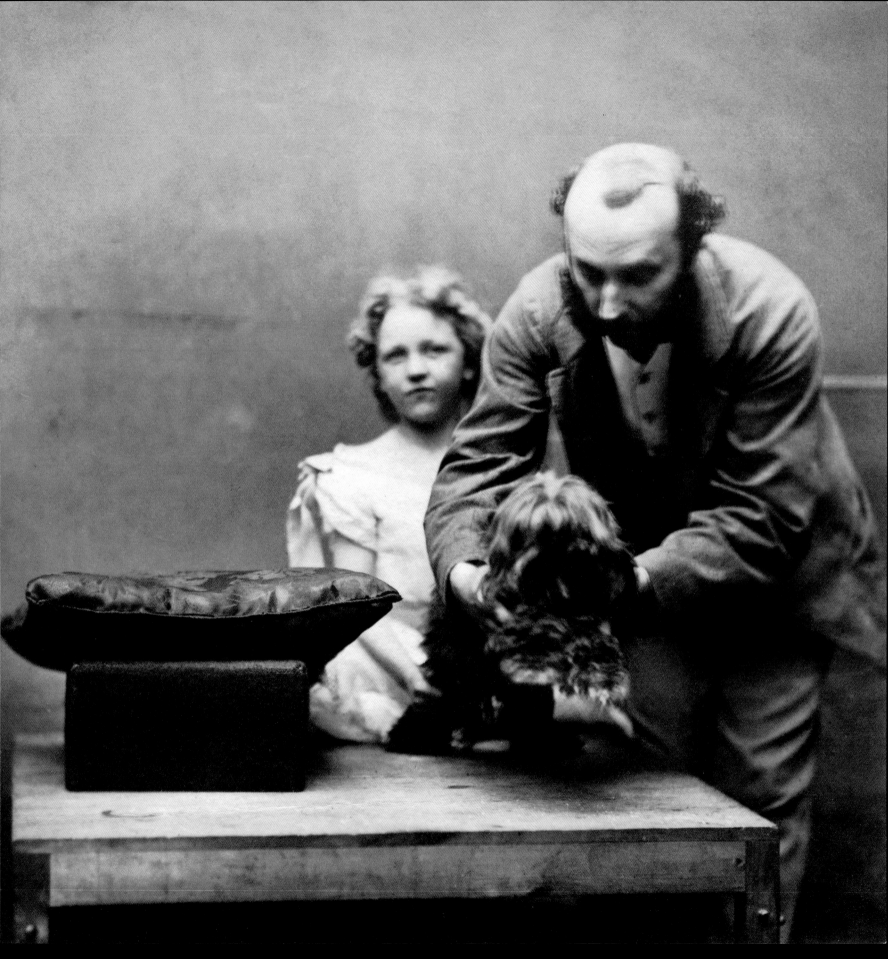

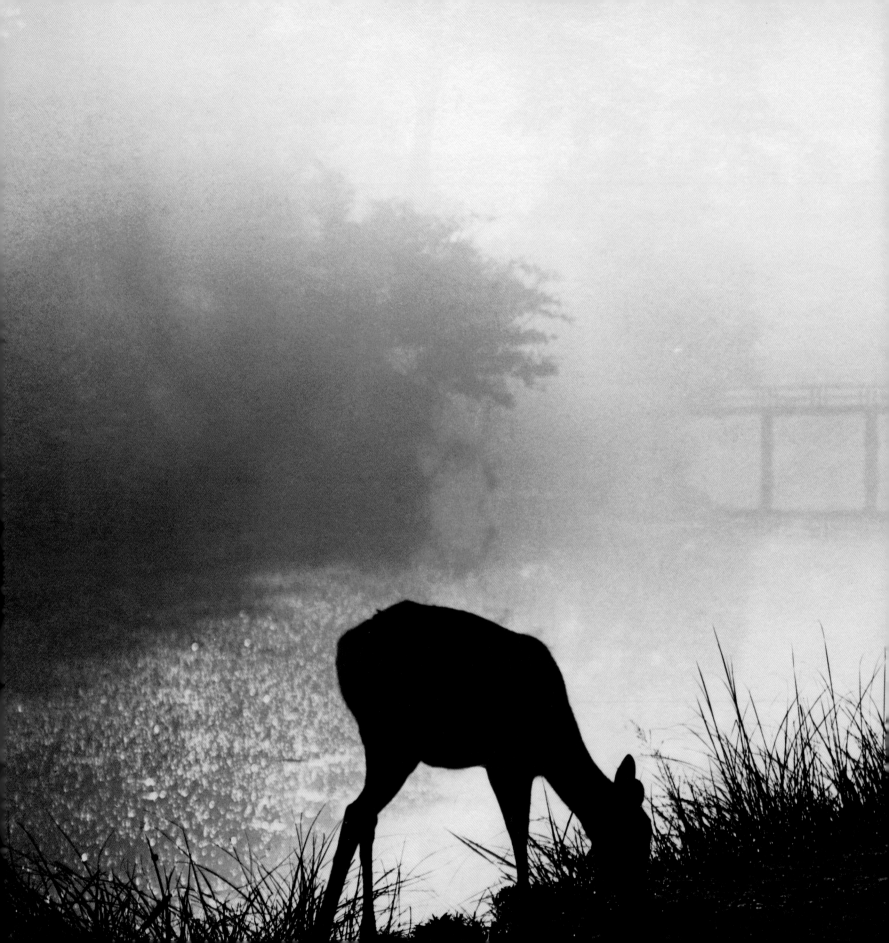

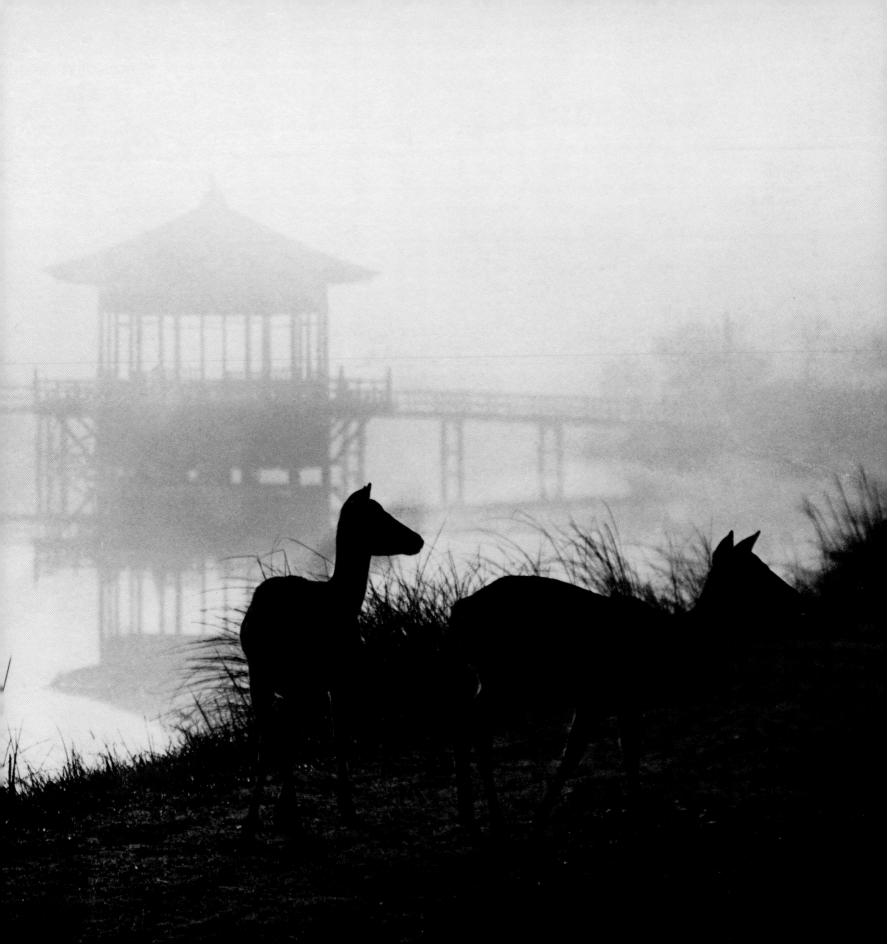

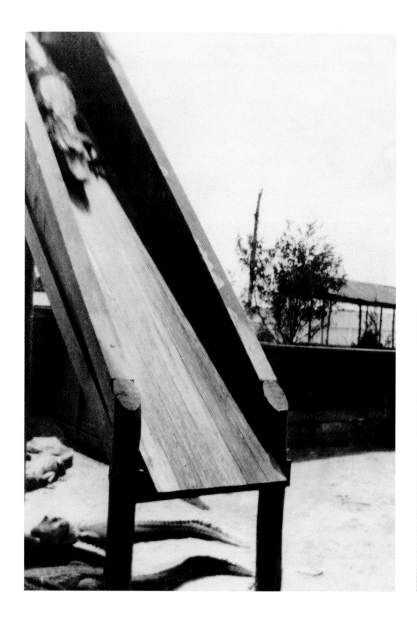

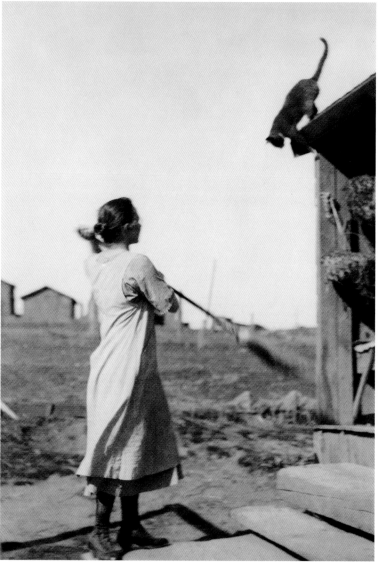

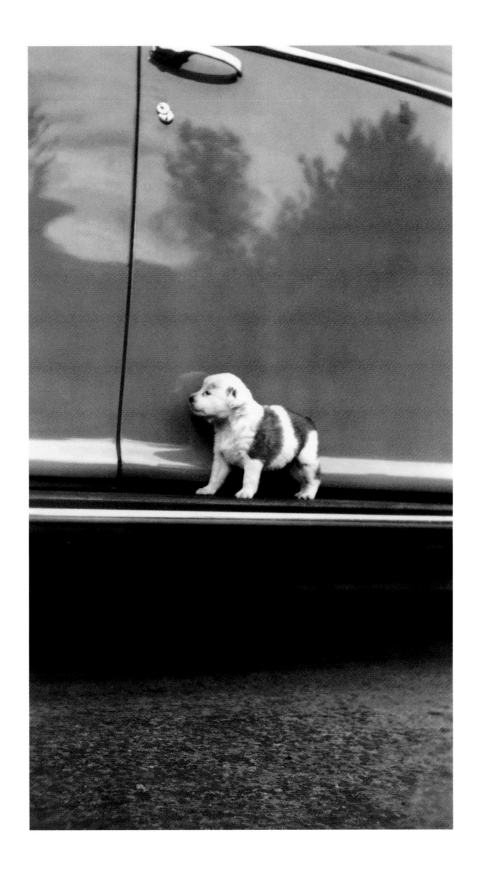

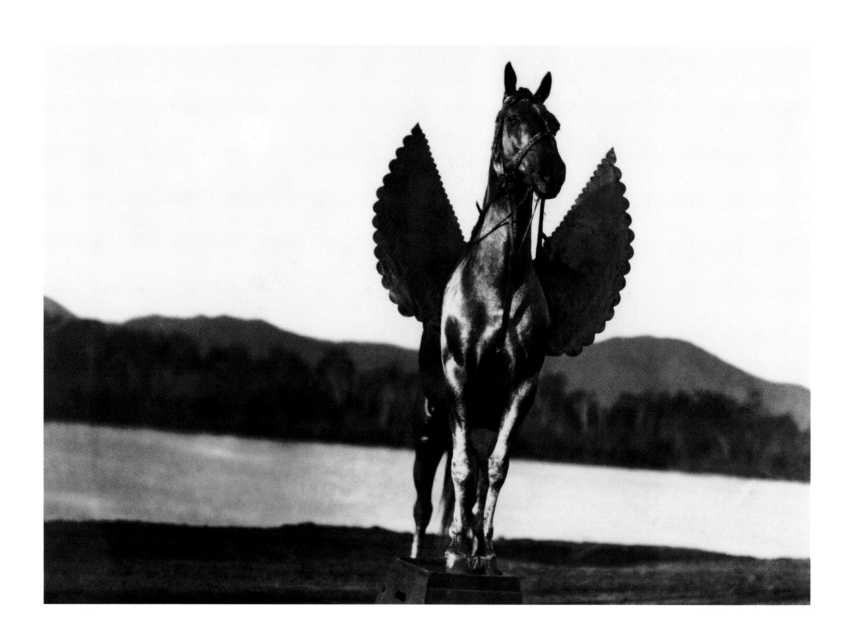

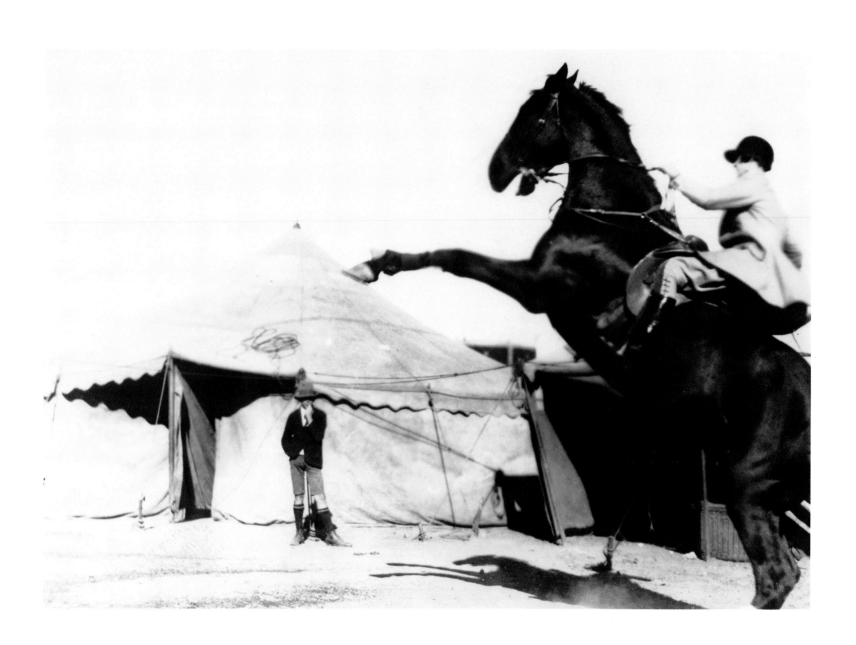

maturity

I sometimes think that God in creating man somewhat overestimated His ability. Oscar Wilde

There are, not surprisingly, more anonymous photographs of adult men and women than any other type of picture. Many are so numbingly banal as to be of interest only to the subjects and their immediate families. People almost never throw away family photographs at the time they are developed. However inferior some might turn out to be, there is some sense of possible future usefulness

that demands their preservation. This need is rarely fulfilled. This is the reason for the vast unedited photographic flood of episodes from strangers' lives that pass before one's eyes in the search for compelling images.

Cut off from context, these photographs of men and women must appeal visually. There has to be some personal element of recognition, sympathy or curiosity that makes us care and holds our attention. Humour, both forced and natural, is not uncommon in these pictures. True emotion, however, is rarely evident.

Rather than being a medium of revelation, photography often involves a degree of manipulation by both the operator of the camera and the sitter. It is amazing how adept people have become in presenting themselves to the camera with their photographic masks in place.

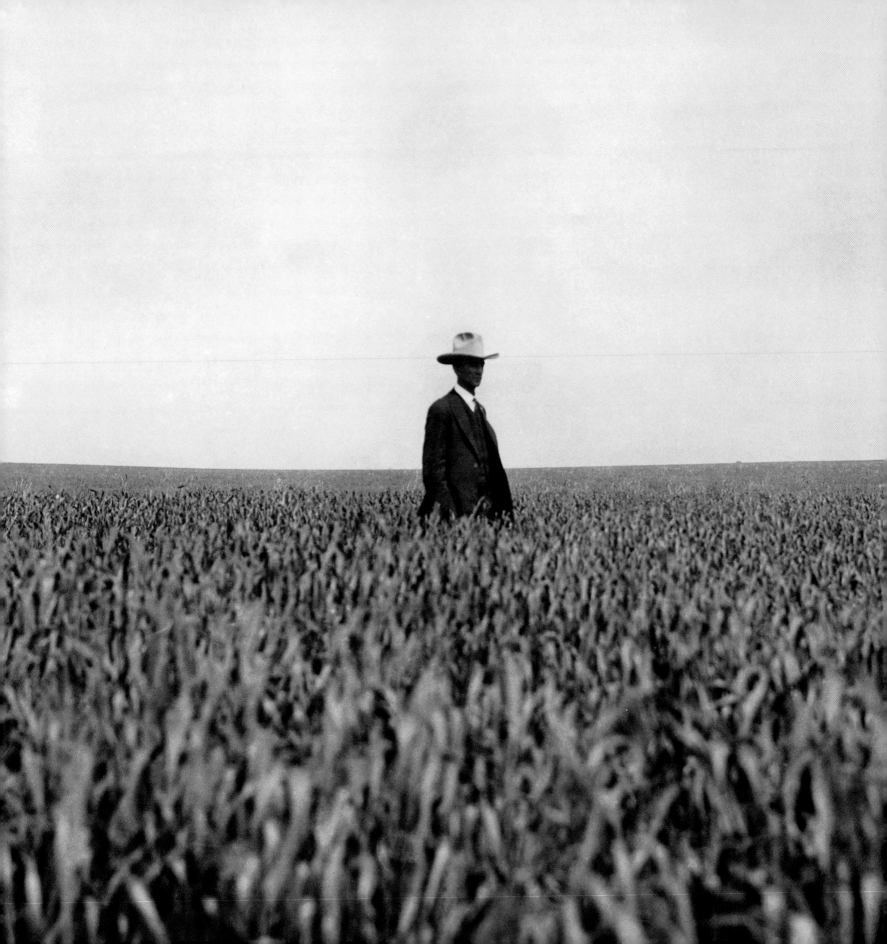

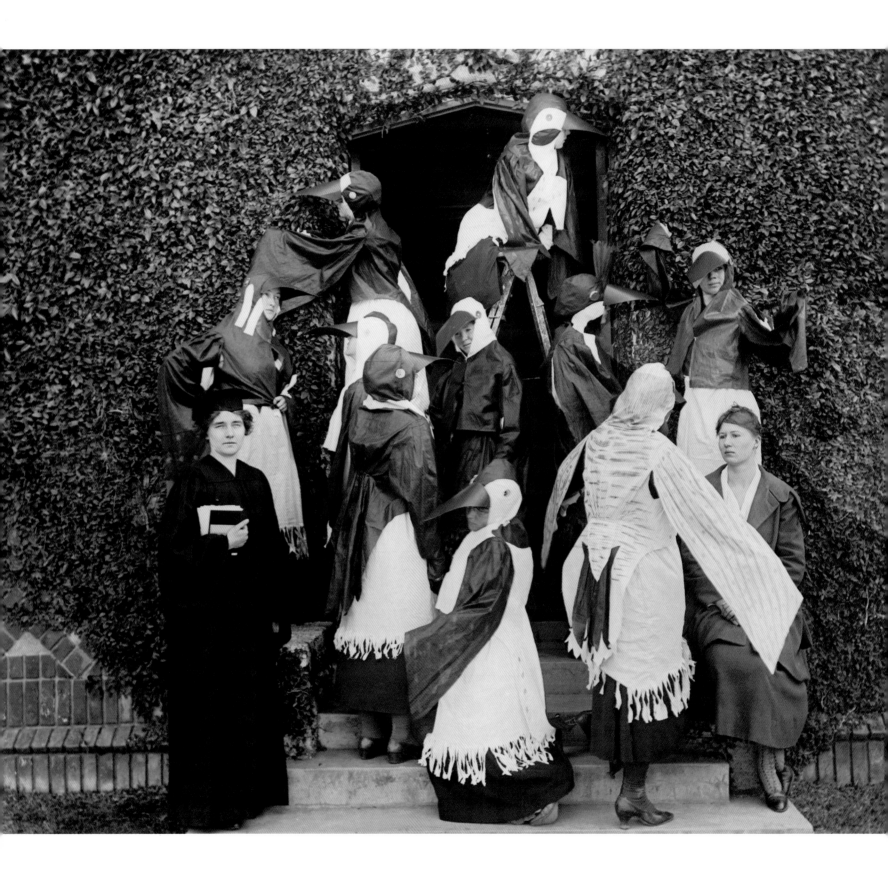

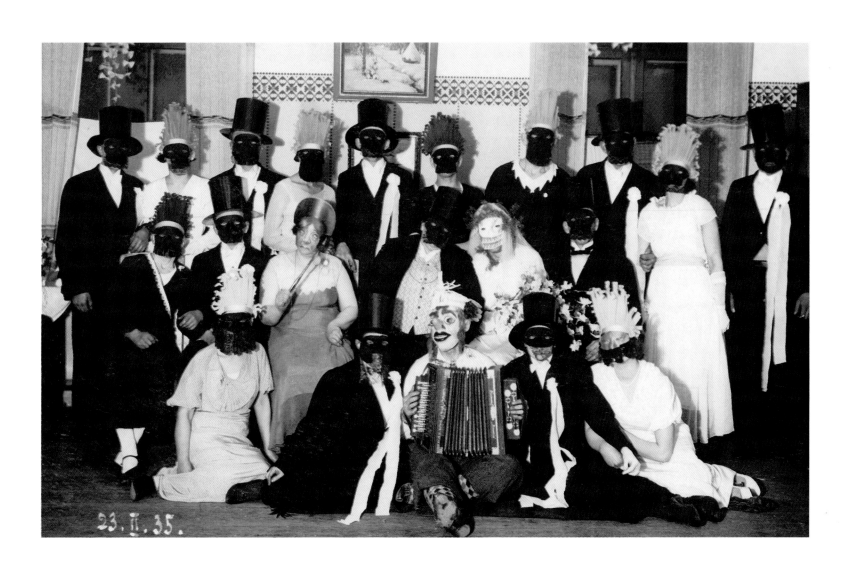

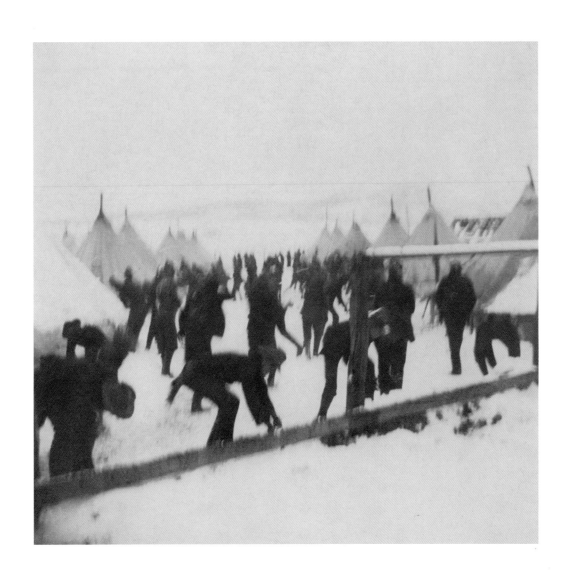

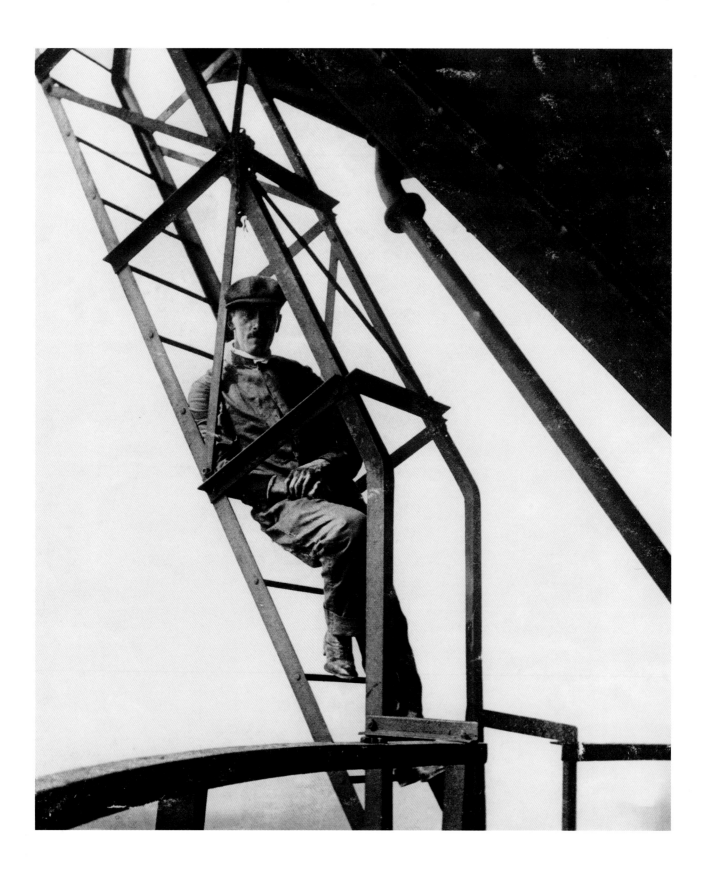

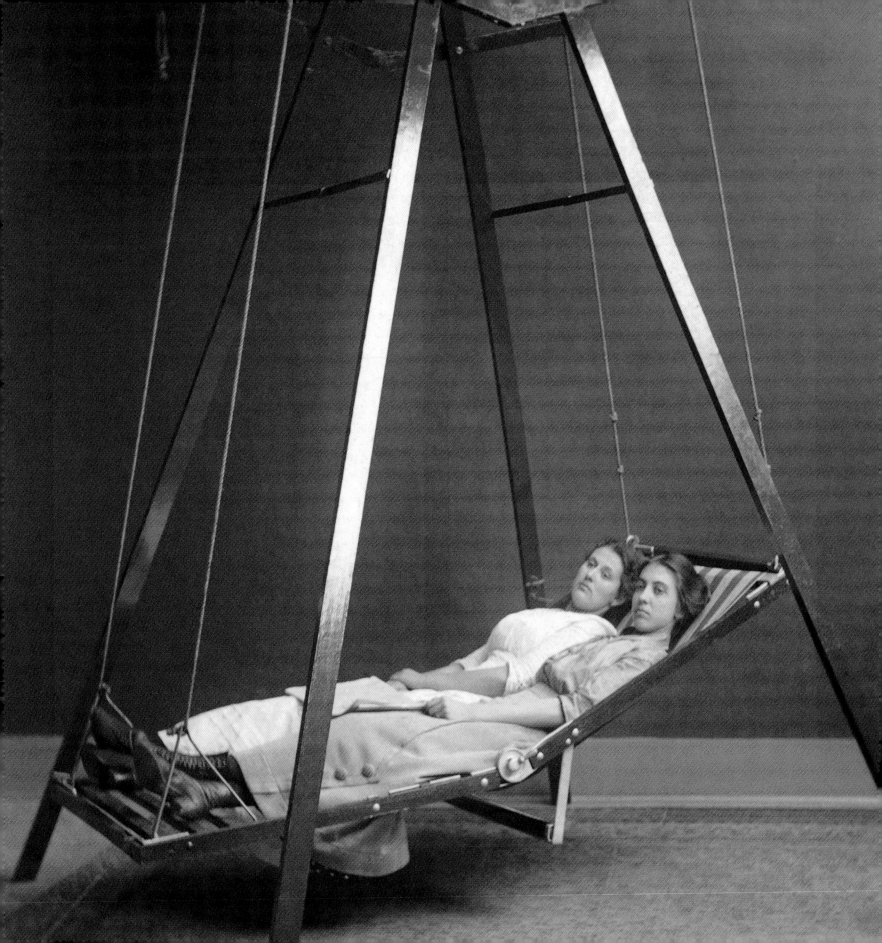

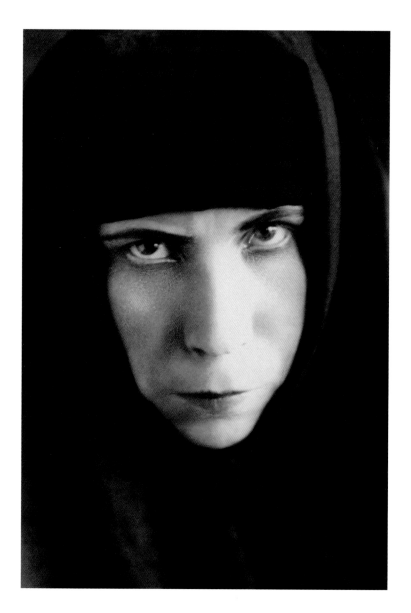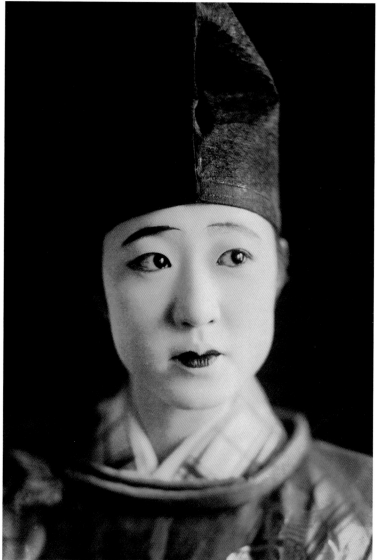

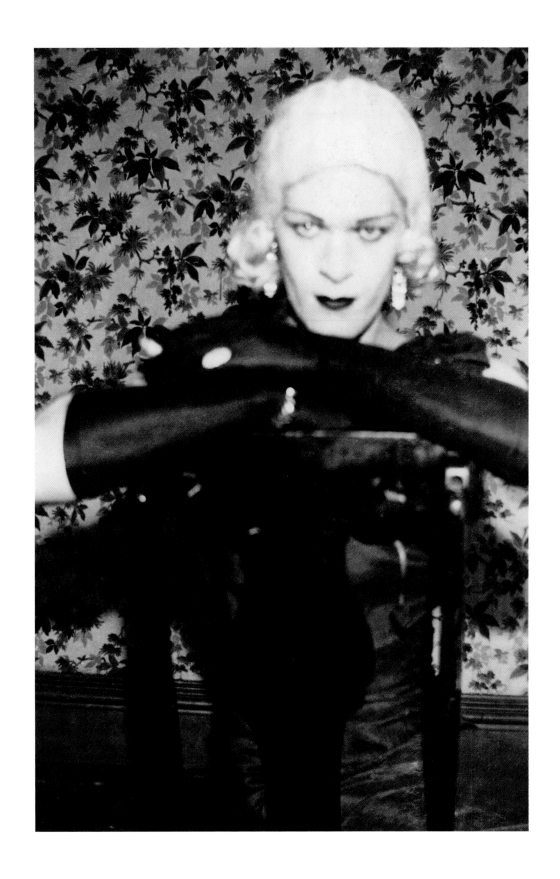

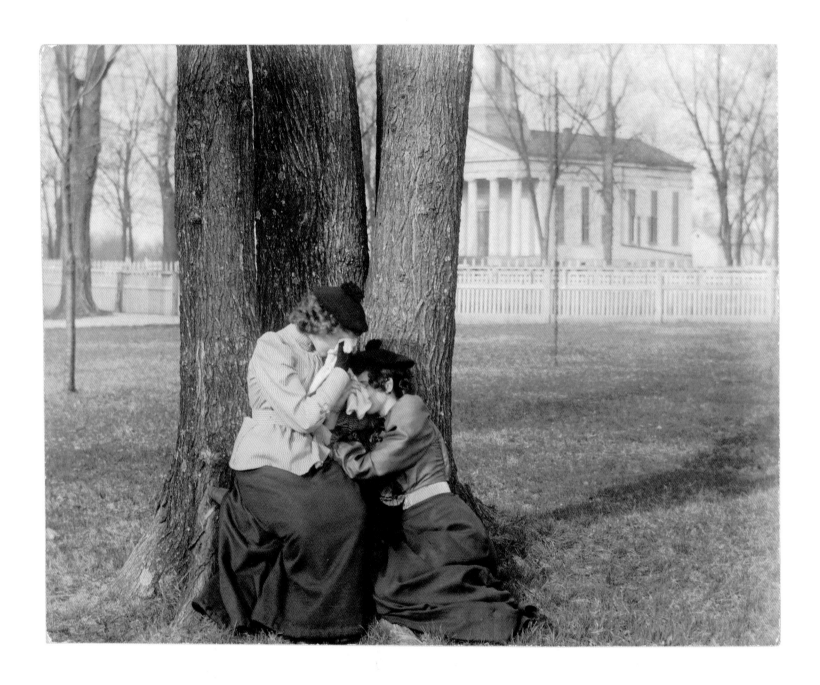

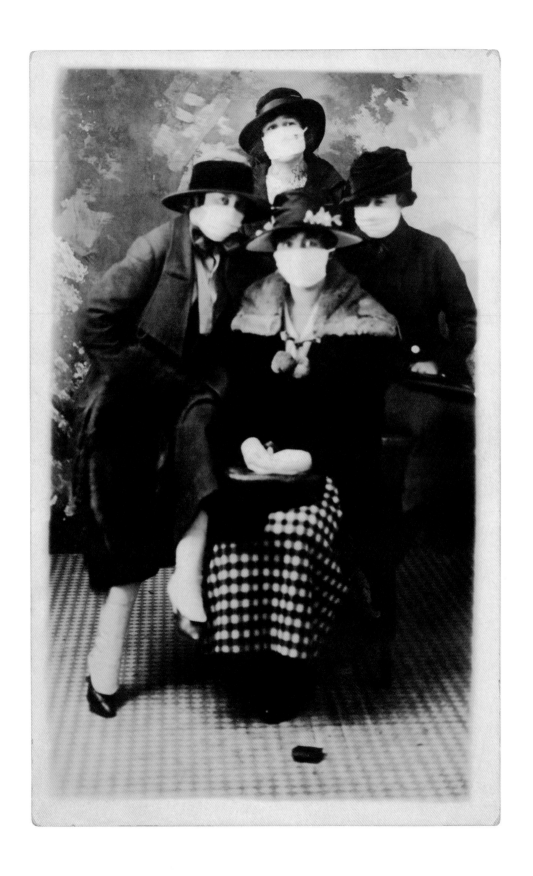

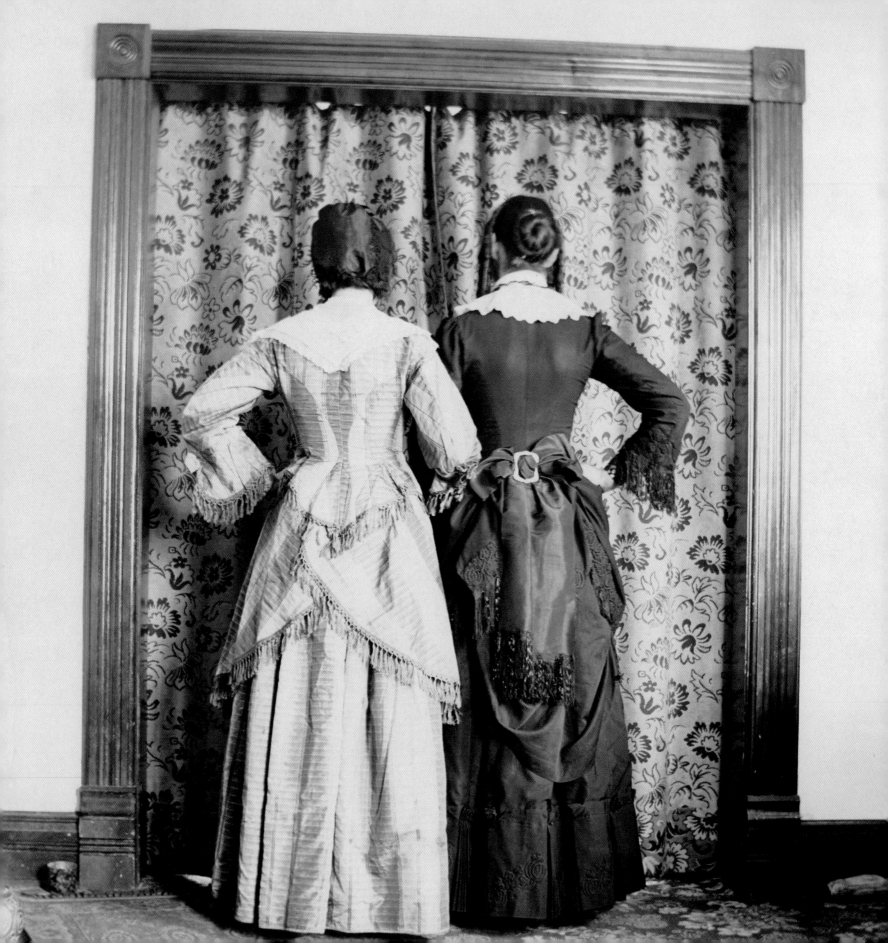

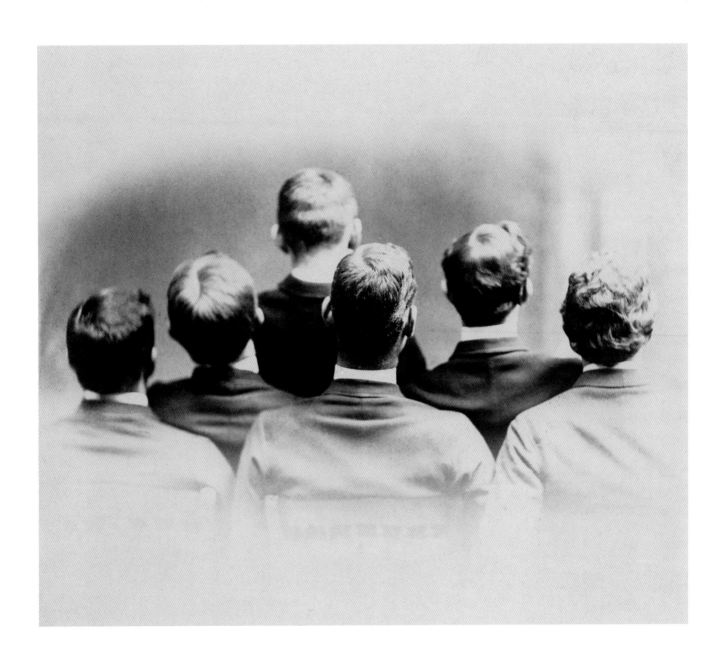

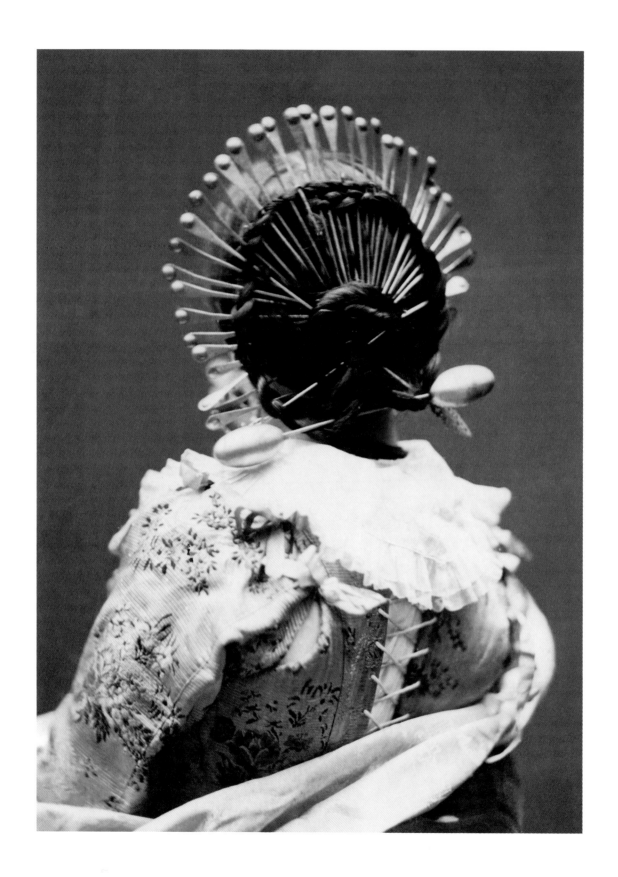

94 maturity

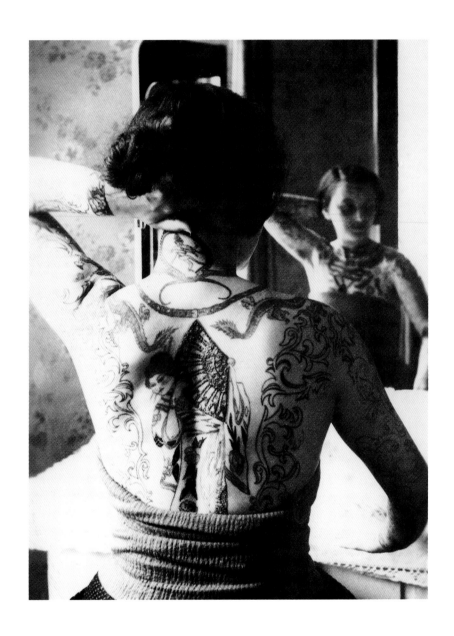

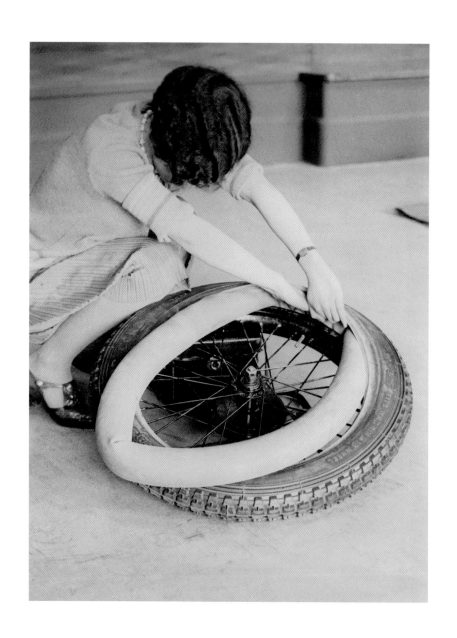

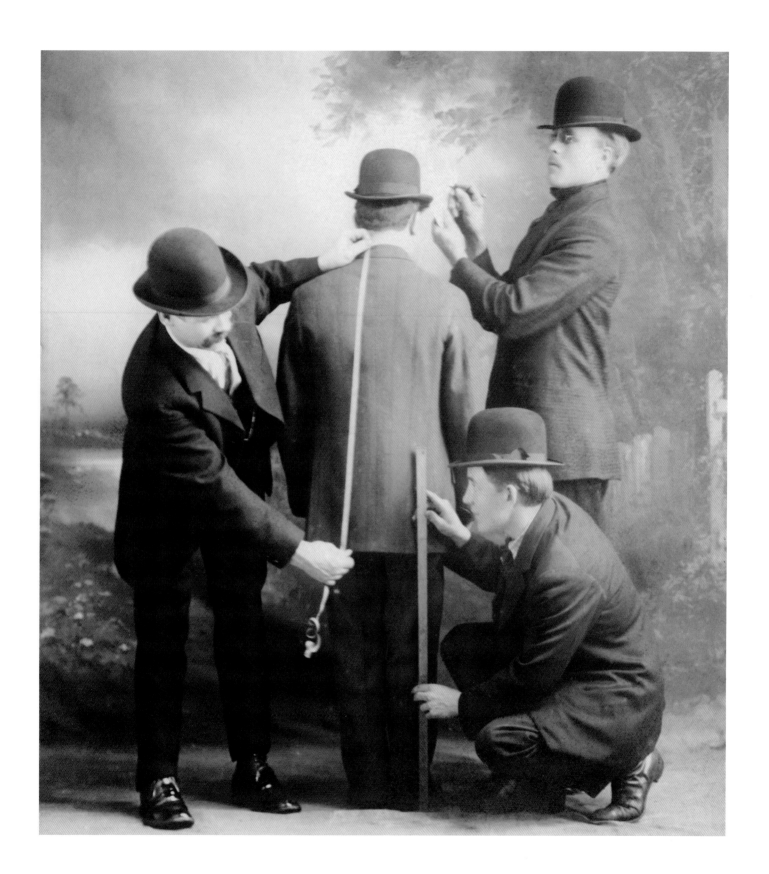

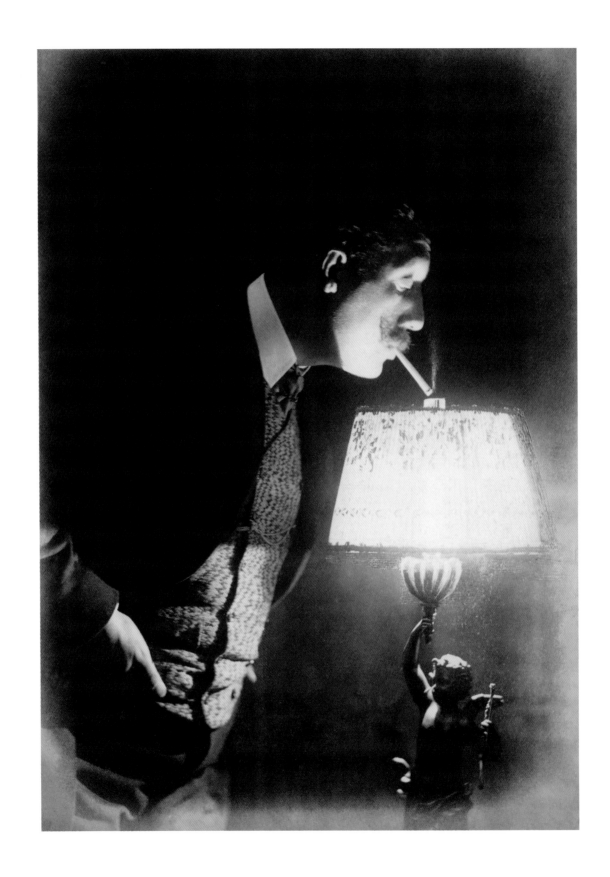

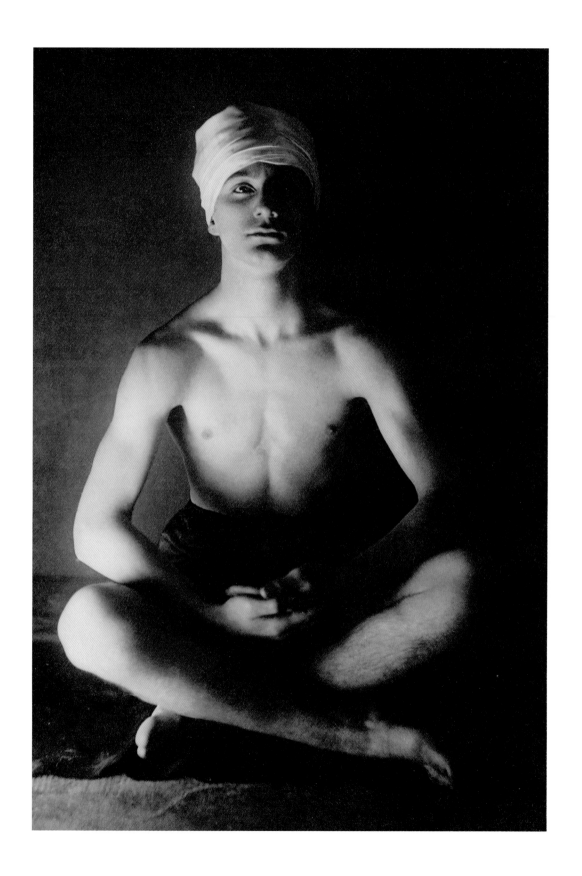

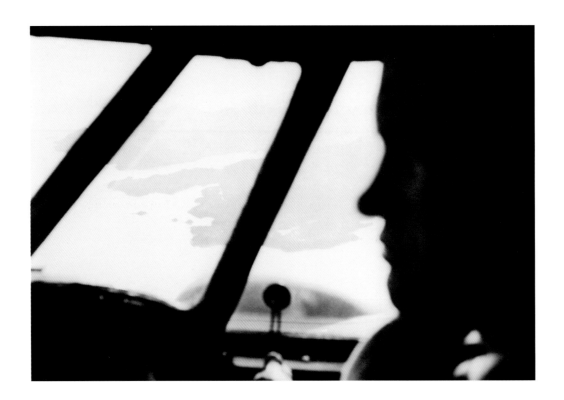

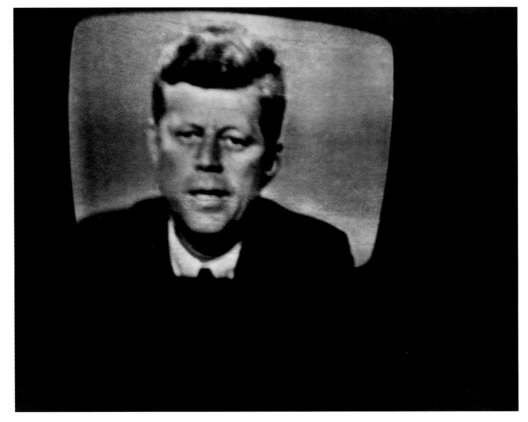

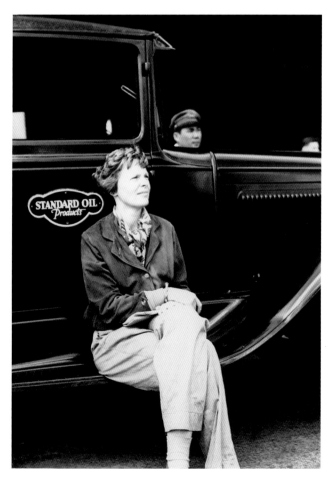 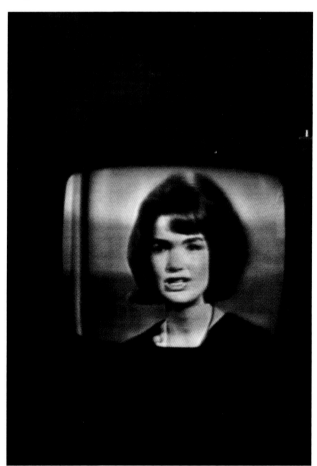

eros

There are three things that cannot be seen, even though they may be right in front of our eyes:

the sun, genitals, and death. Georges Bataille

It is often said that in matters of Eros man is stimulated by the visual and woman by the verbal. If there is truth in this concept, then it explains the vast number of representations of women

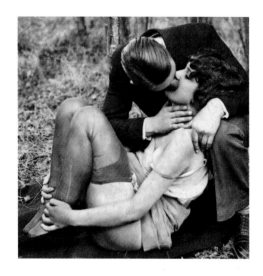

intended for heterosexual males, ranging from the mildly titillating to the outright pornographic. What remains a mystery is the question of women's visual desires.

The nature of what is seen as erotic in photography is highly personal to the individual. It is also subject to the evolving tastes of society over the past century and a half. During the 19th century, photographs of female nudes were usually marketed as visual aids for artists. Despite their absolute nakedness, the almost clinical presentation of flesh deflated their ability to arouse. Far more provocative were images that emphasized the sensual and dramatic unveiling of a specific body part, such as a breast, a thigh or an ankle. Many photographs are sexual in content, yet fail in their attempt to be erotic. What is missing in these pictures is an element that allows the viewer to fantasize. The more stark, harsh or pornographic the photograph, the less room there is to introduce oneself into the visual scenario.

The camera is an intrusive instrument in matters of sensuality, as it records scenes and acts that in reality should only be seen and experienced by the participants themselves. The most tender and truthful are amateur photographs or snapshots, usually, one assumes, of the photographer's object of affection. They have a guileless quality that is absent from more exploitative examples of the genre.

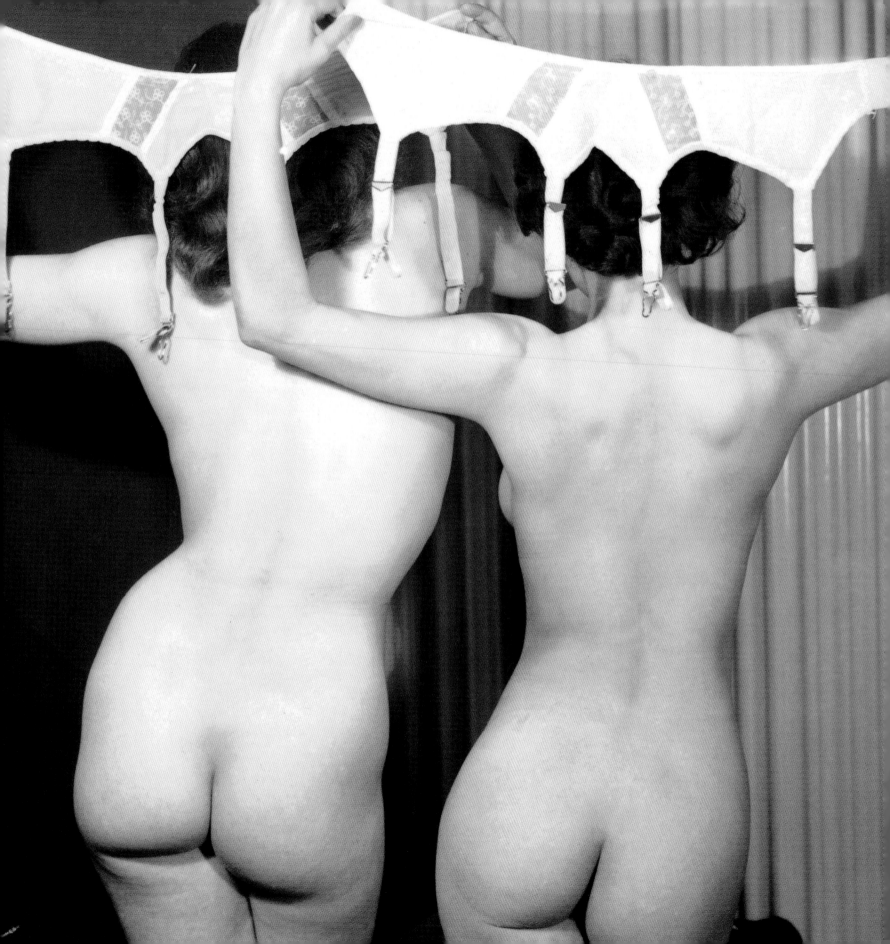

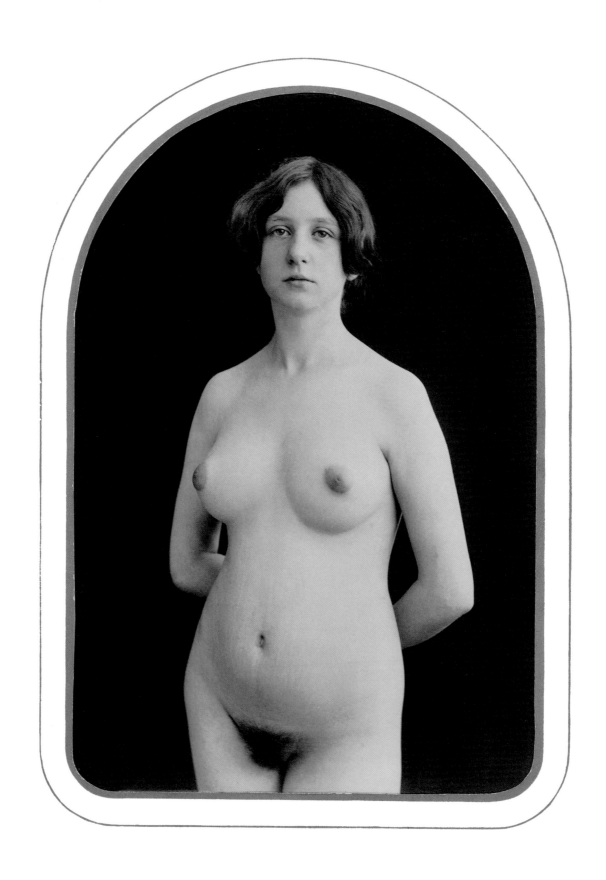

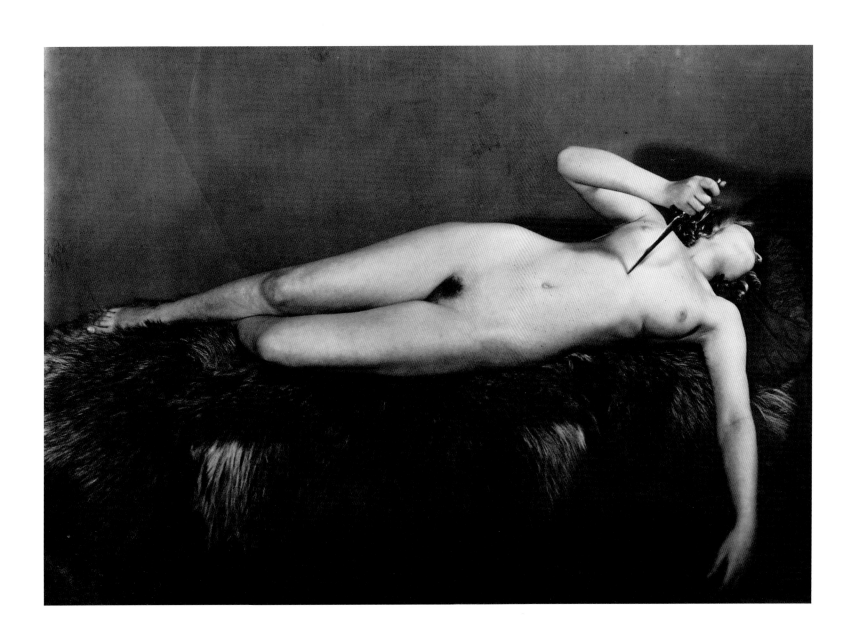

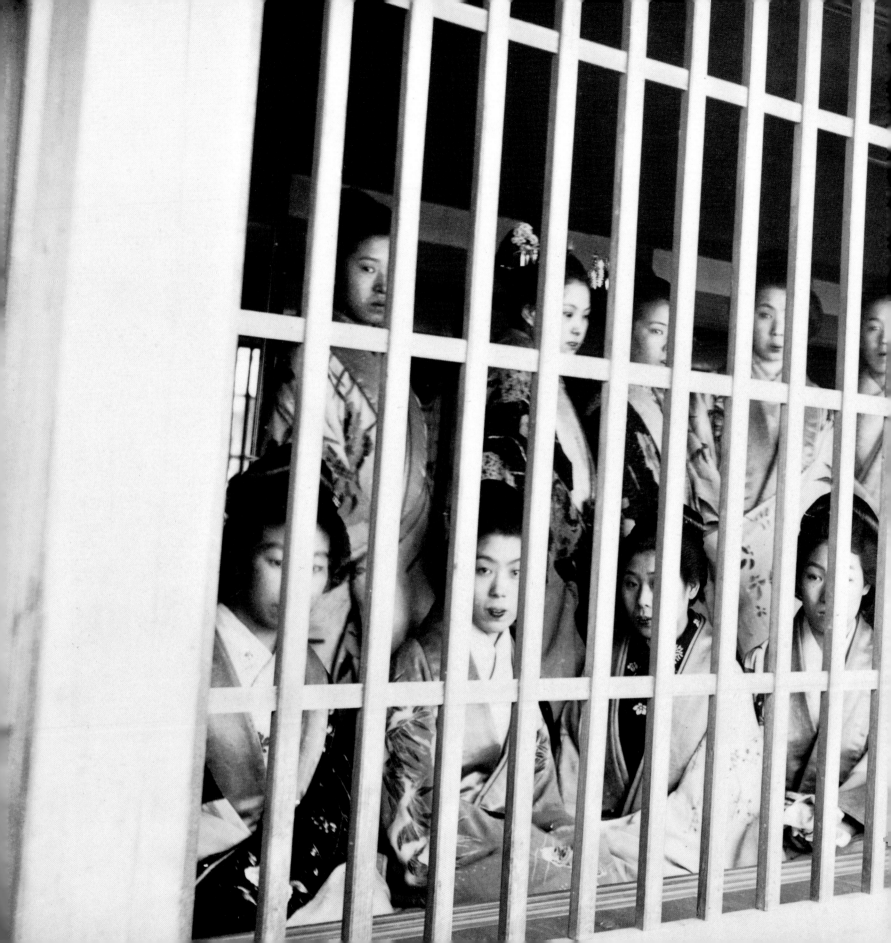

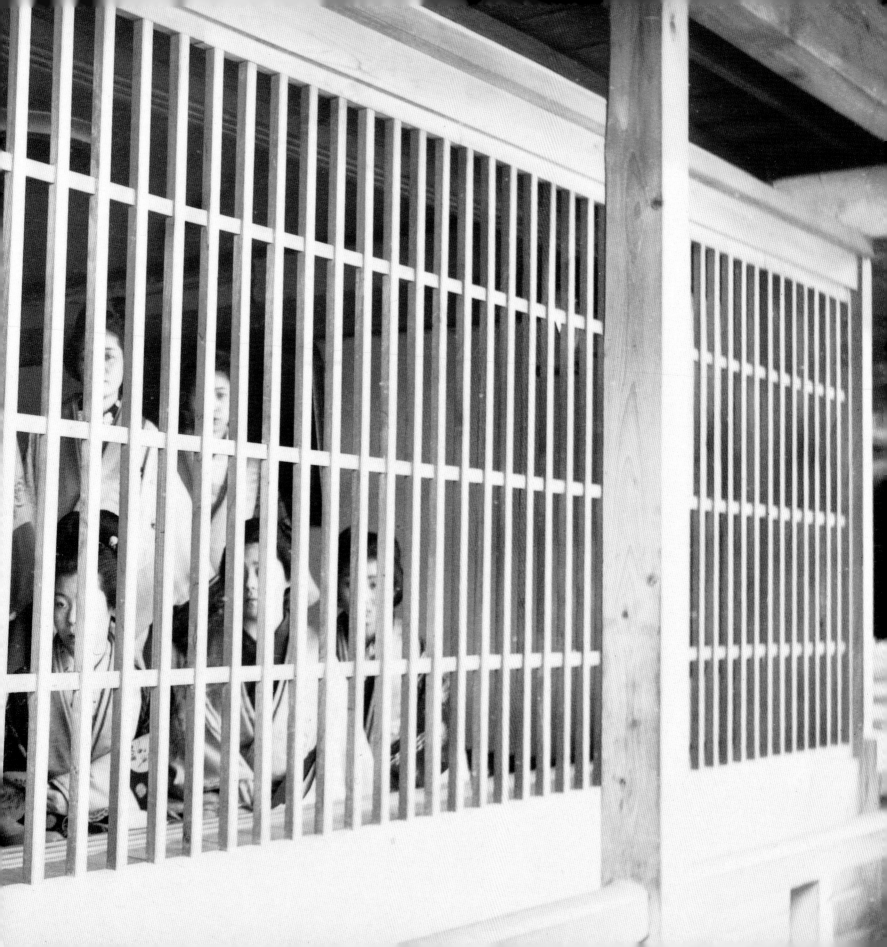

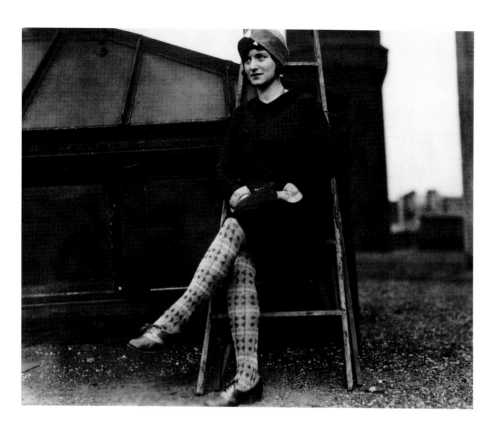

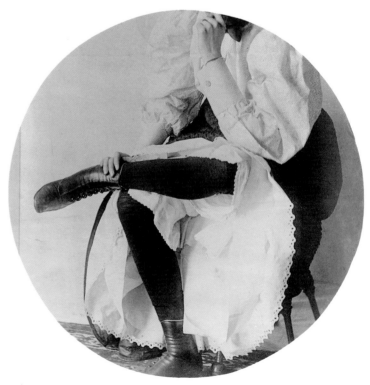

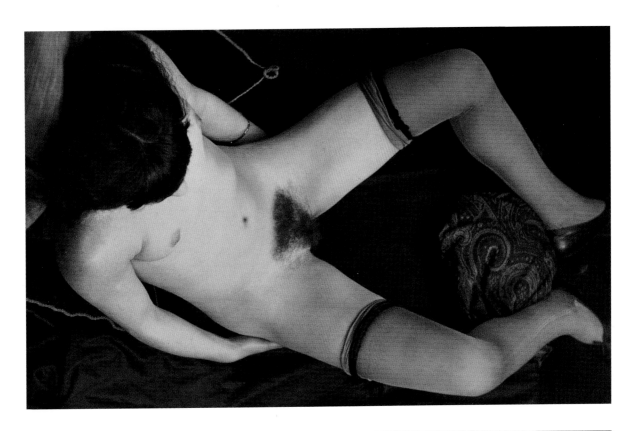

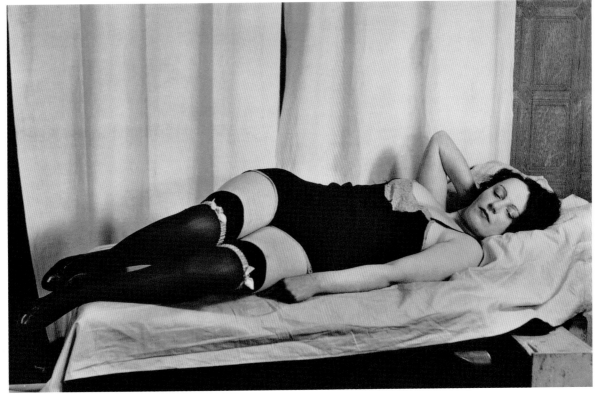

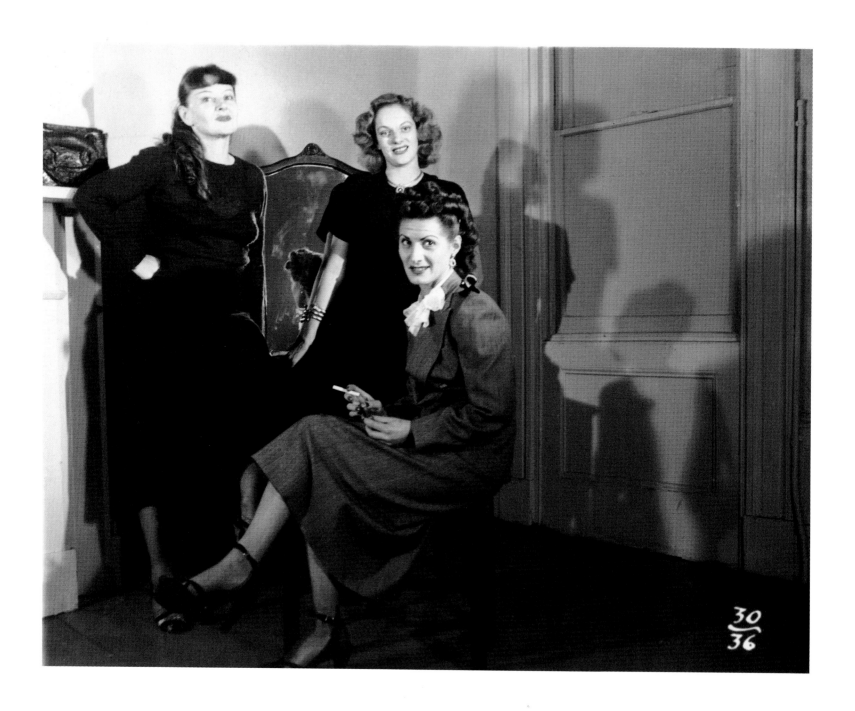

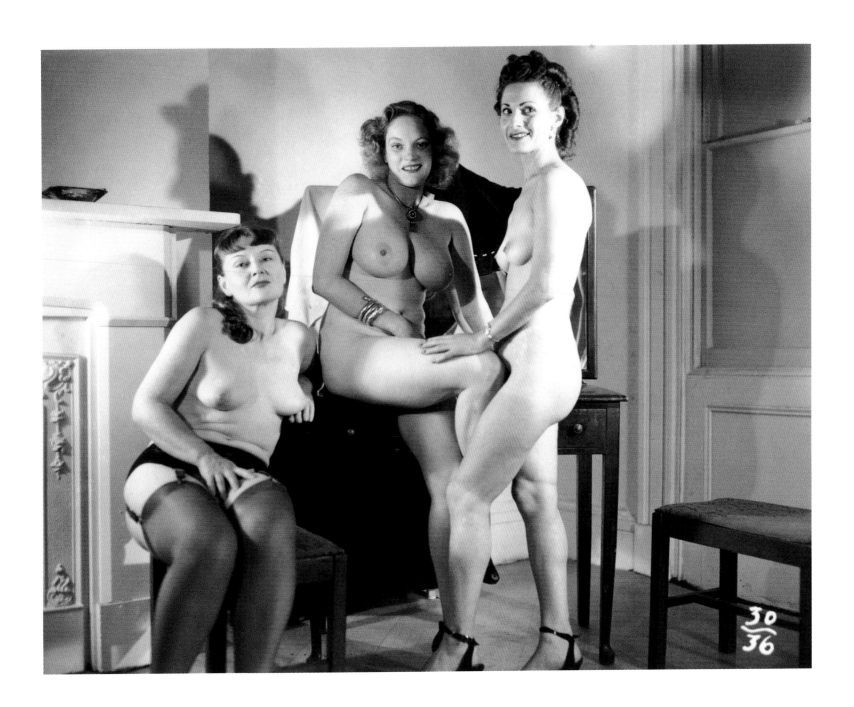

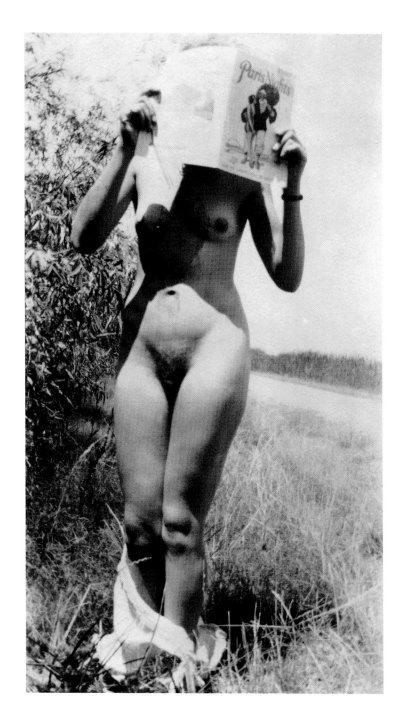

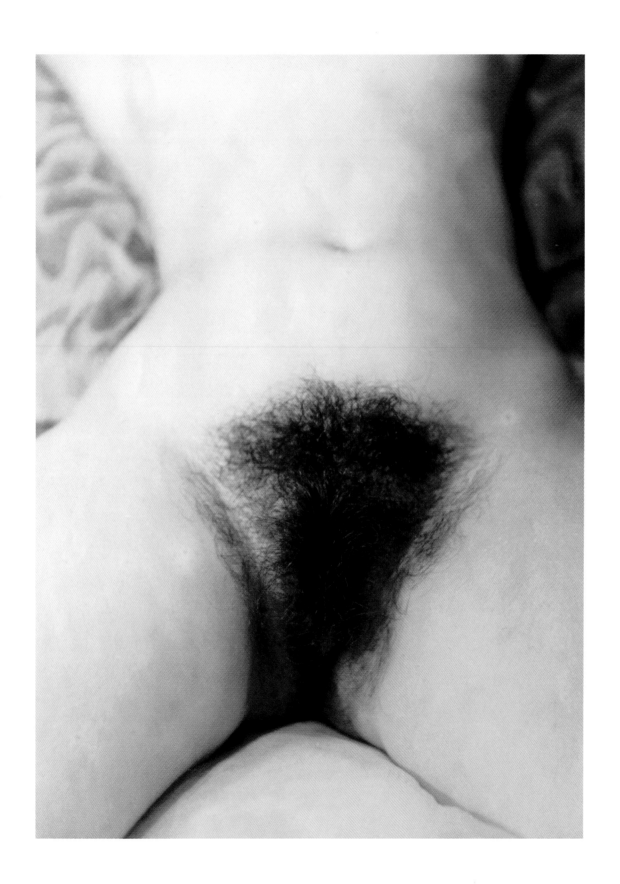

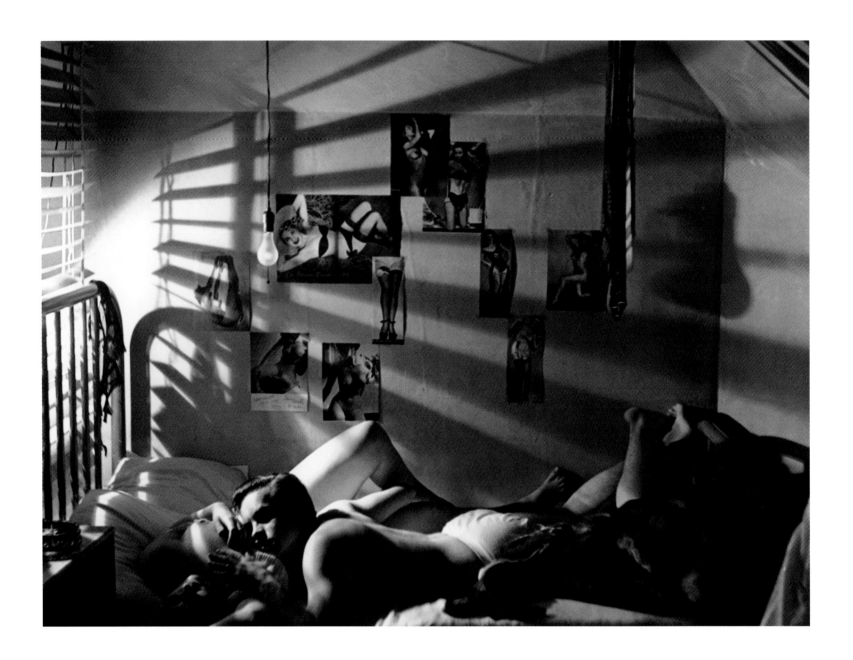

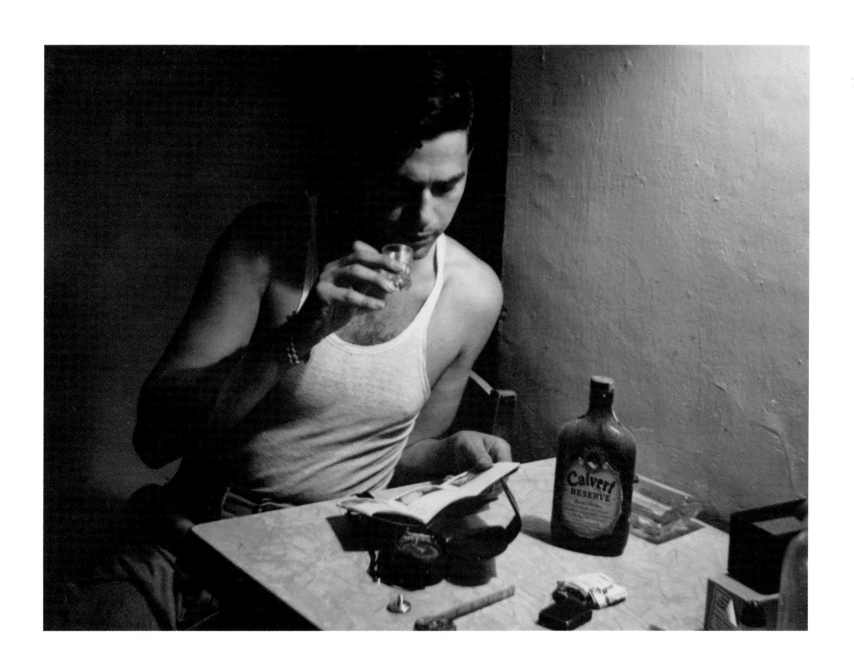

going places

What is this romanticism of modern life?. . . It is the nostalgia of railroad stations, of arrivals and departures, the anxiety of seaports where ships, their hawsers loosened, sail into the black waters of the night, their lights aglitter as in cities on a holiday. Giorgio de Chirico

Before the invention of the camera, only the very rich could afford to hire an artist to document their travels to distant landscapes and monuments. Photography eventually gave every traveller the means to prove that he or she had actually set foot in those destinations. It is no wonder that the camera was also used to record the method of transport to those locations near and far.

There is an inescapable feeling of nostalgia in viewing modes of transportation. With the flow of time and technology, what was once the standard means of transport is inevitably superseded by newer and more efficient means. The sight of spoked wheels, running boards and jump seats are invitations to connect to a time and place one might never have actually experienced.

A special quality in some of these photographs is that movement is a major element within the picture. At times, the sky or landscape flies past, captured by a camera from a car window, the rear of a train or a cockpit of an aeroplane. In other images the fixed camera freezes for all time the moving object that has passed momentarily before one's field of vision.

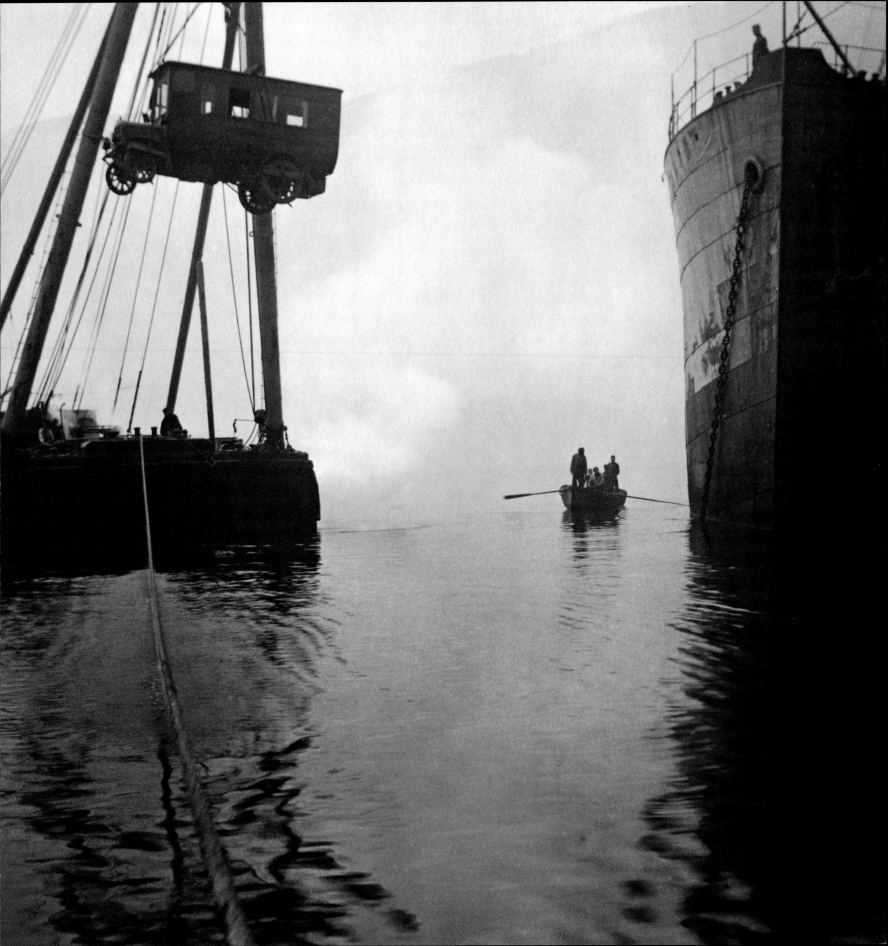

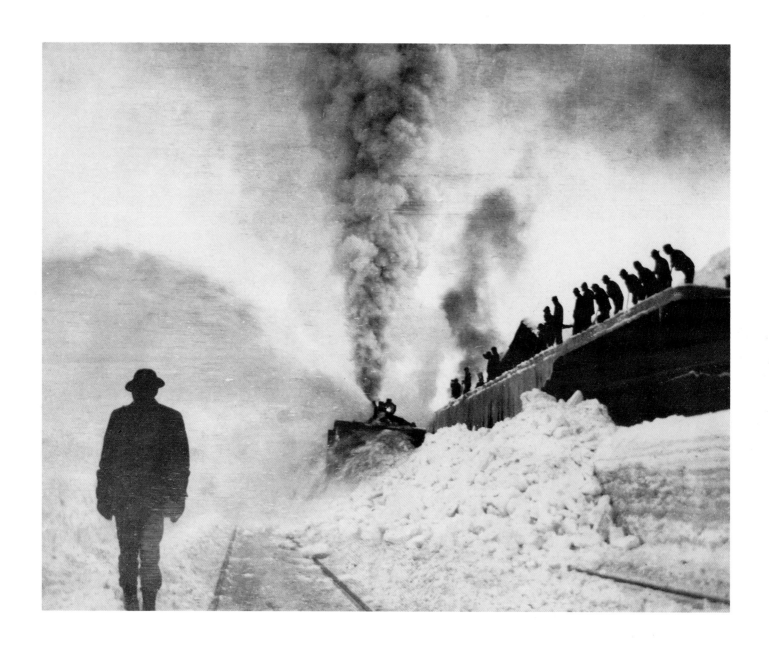

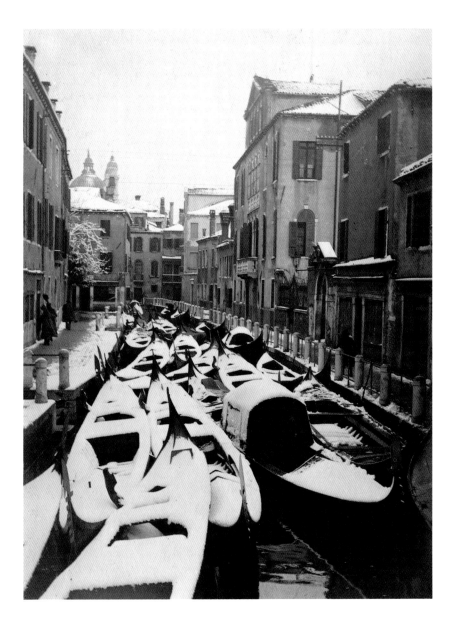

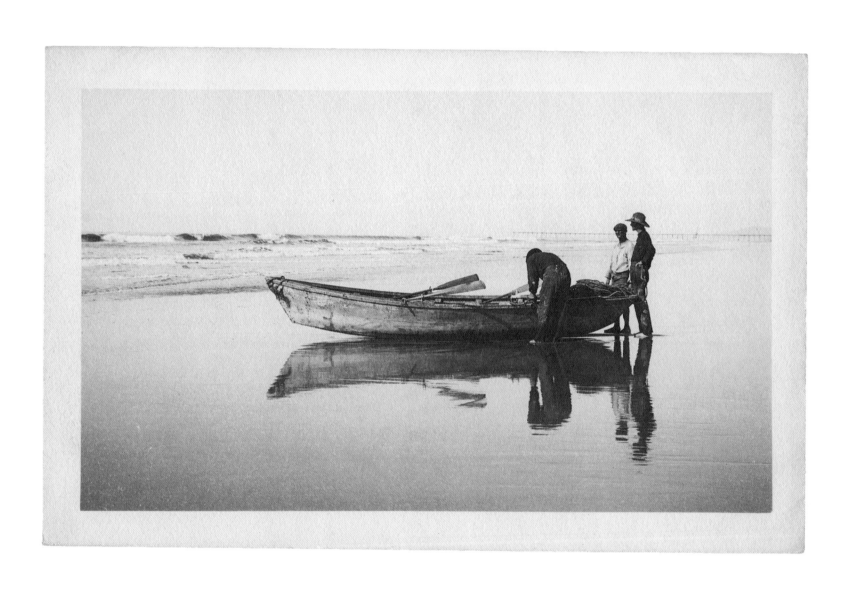

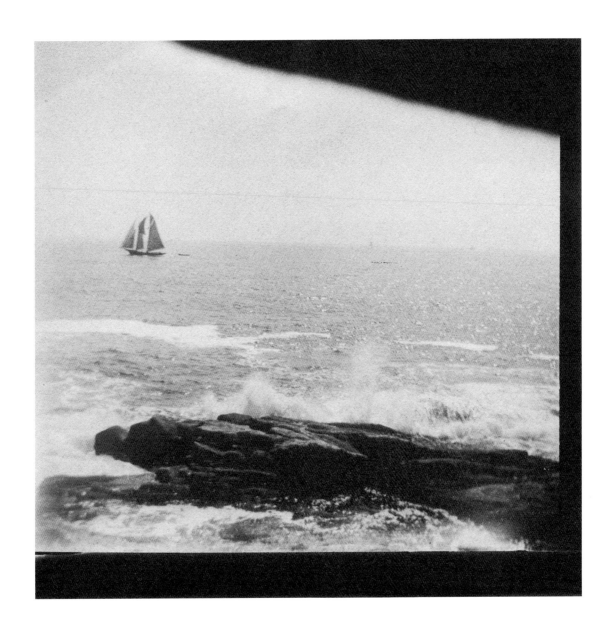

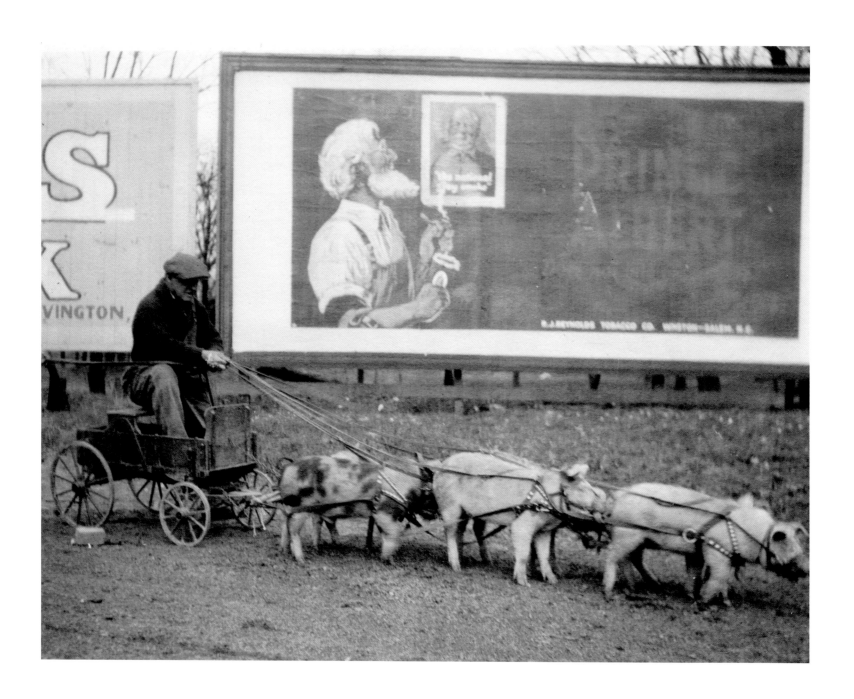

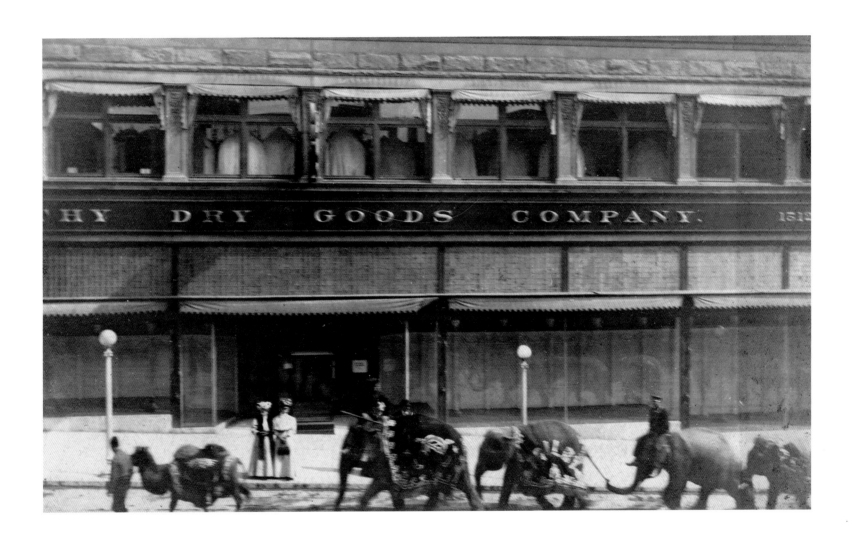

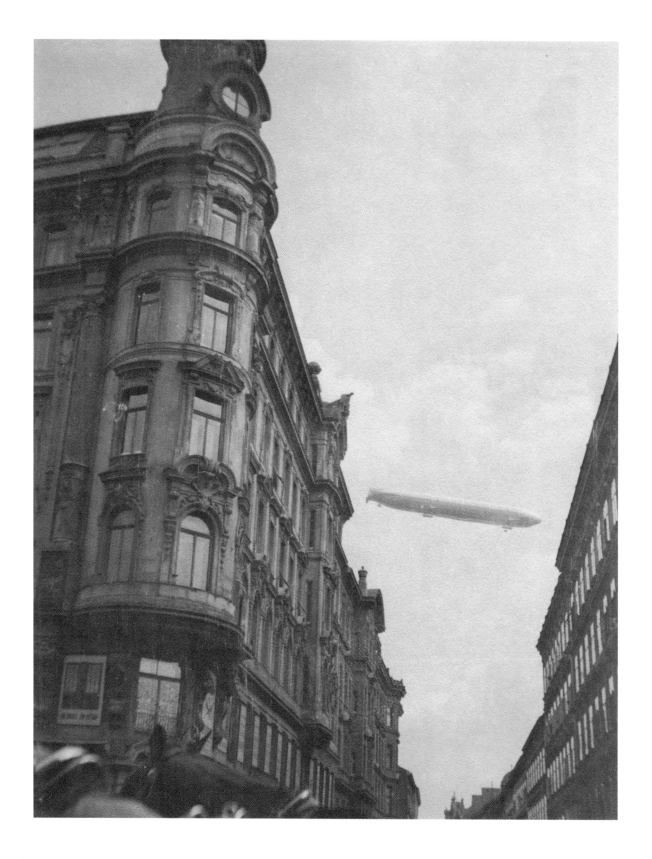

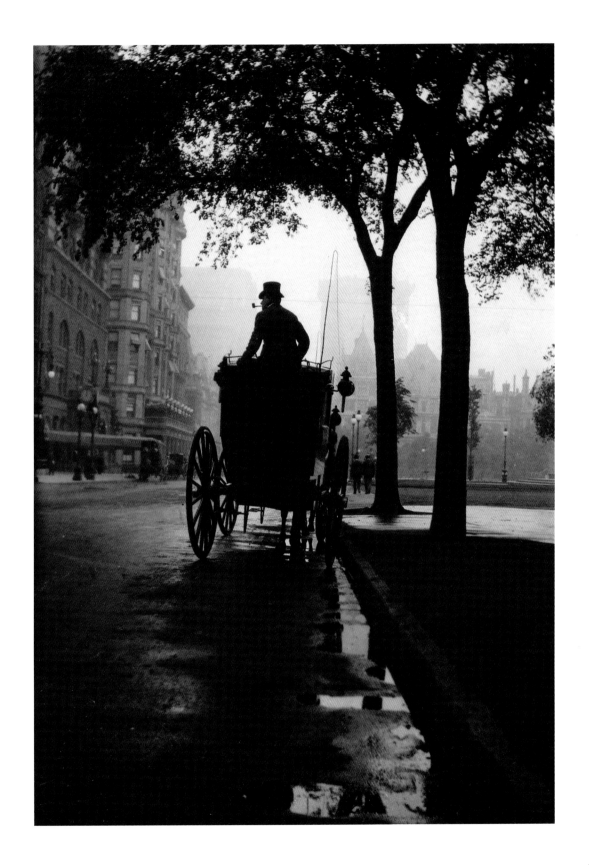

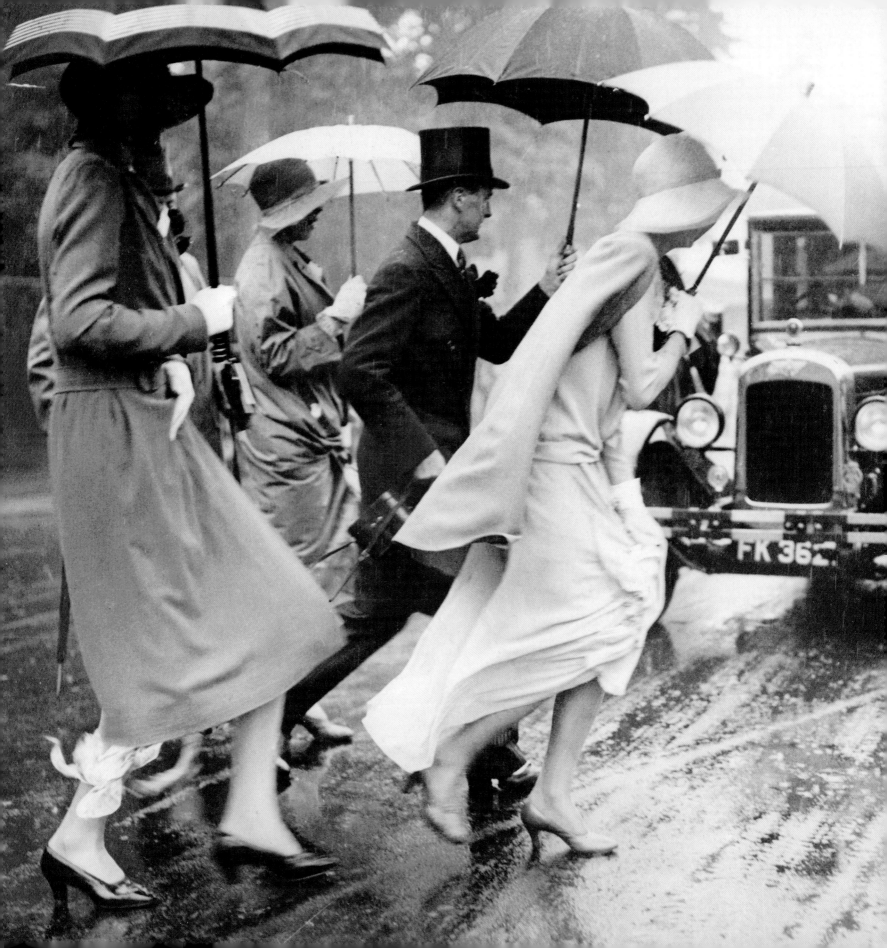

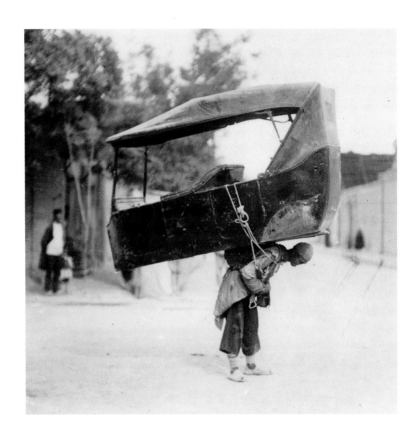

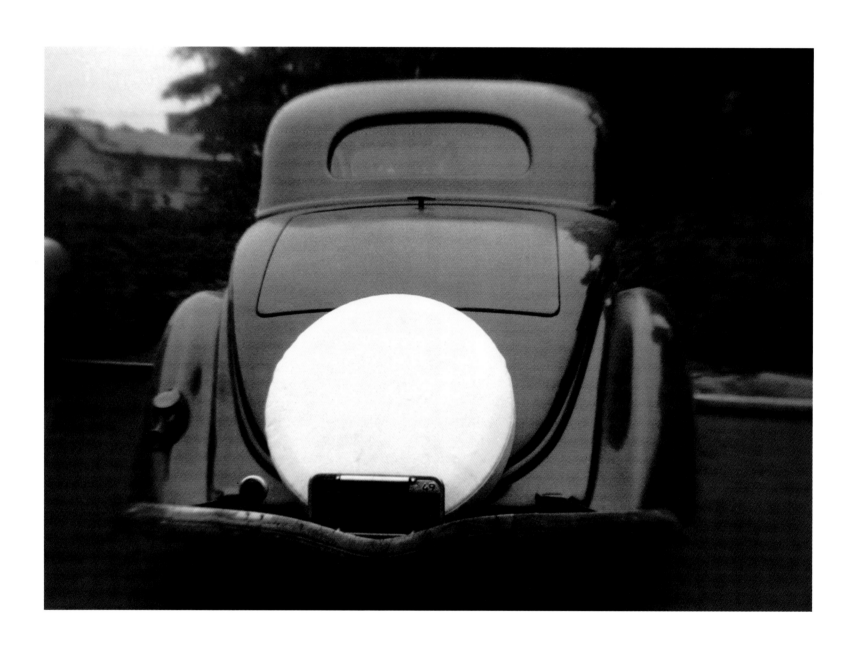

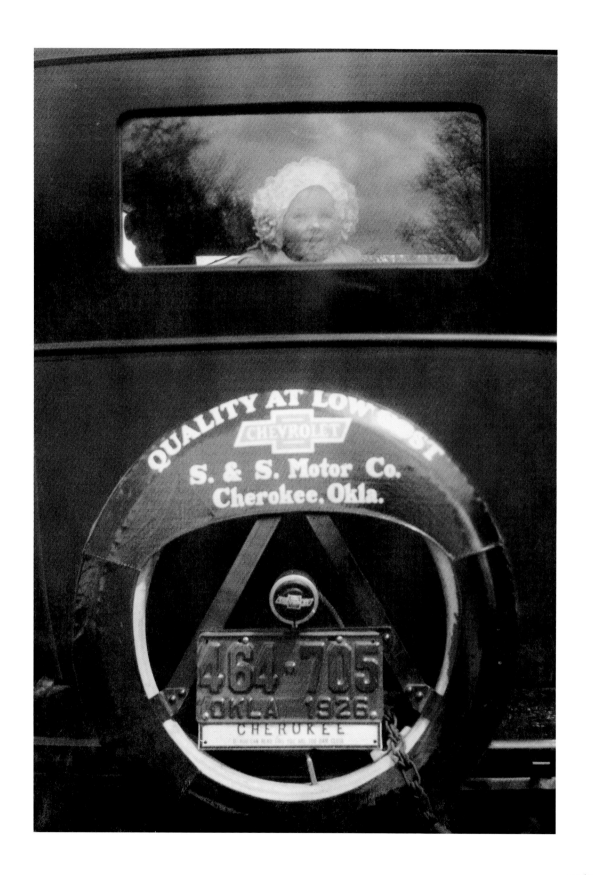

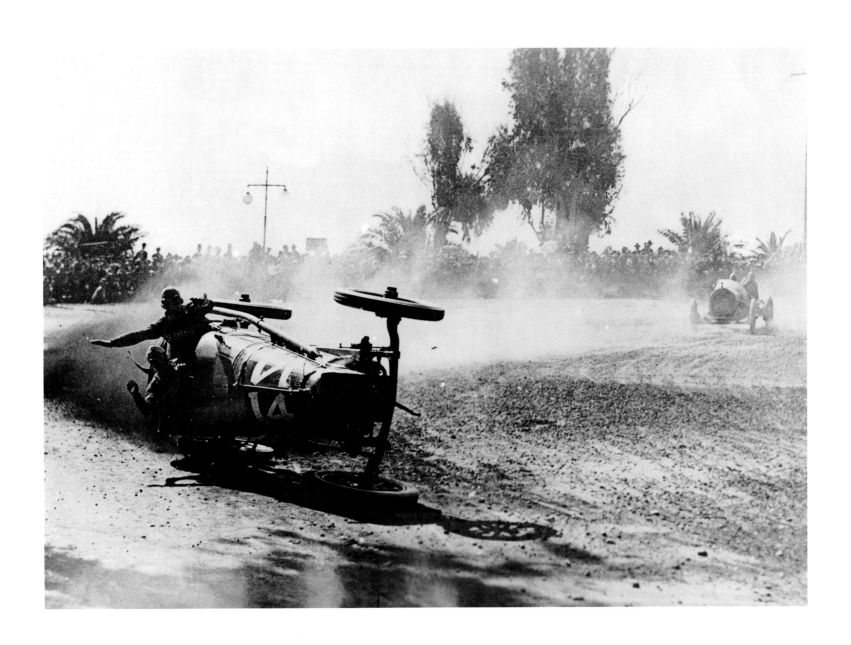

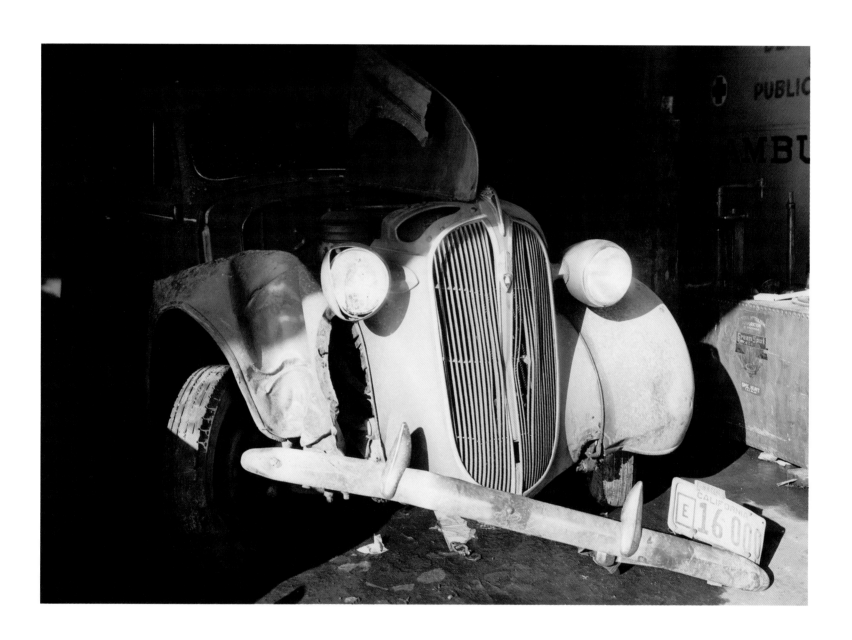

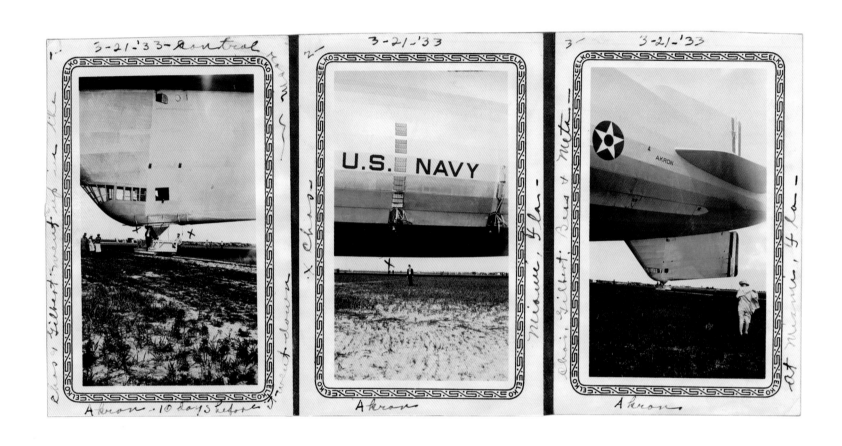

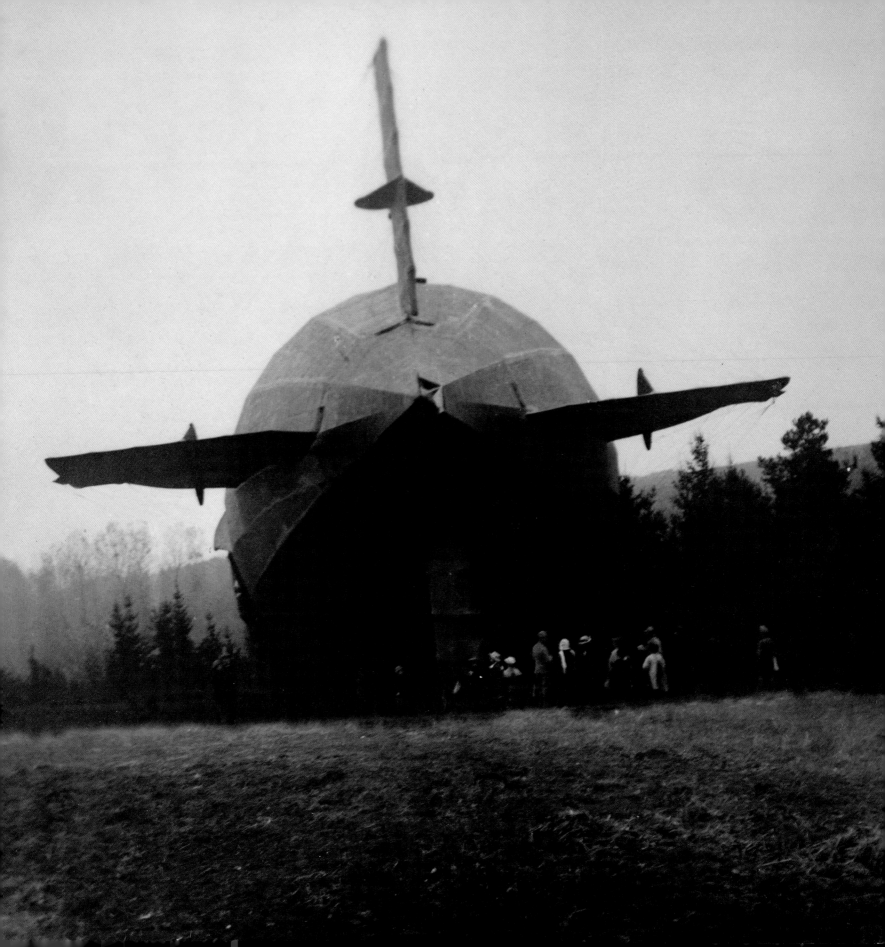

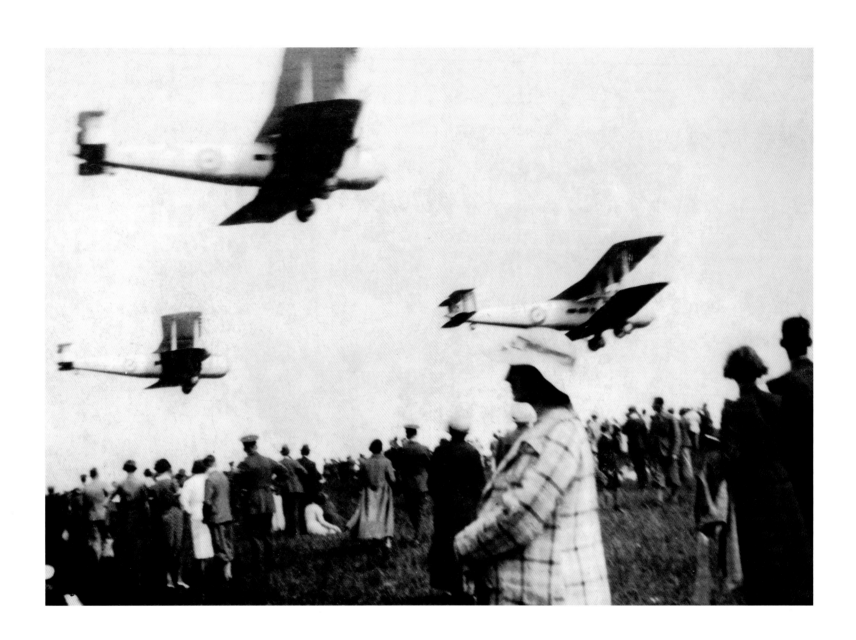

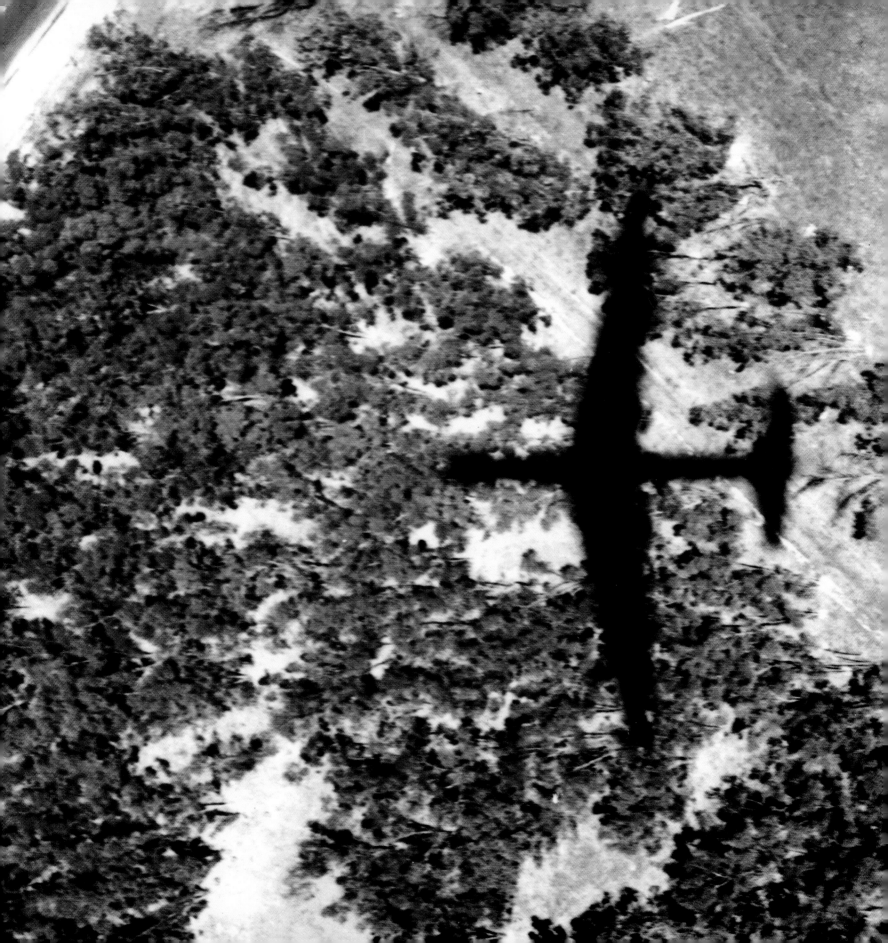

signs and messages

A clumsy 'For Sale' sign clamped on a delicate pillar, a junk pile before a splendid gate, are living citations of the Hegelian theory of opposites. Photographic surprises and accidental conjunctions are not merely superficially grotesque. They are serious symbols allied in disparate chaos. Lincoln Kirstein

Photographers have always been attracted to the graphic clarity of words and symbols. There is a directness of purpose in many of these images that is absent in other anonymous photographs. The words are the message, which can be one of a high moral or judicial authority, or simply an attempt to sell an insurance policy or a sack of flour.

These photographs chronicle the gradual encroachment of words, messages and slogans onto our visual landscape. In a sense, they document the increasing literacy rate – society had progressed to the point that enough people could read and potentially act upon what they read to warrant the words and messages. There is a curious directness and honesty in many of these earlier images that no longer exists in our saturated media society. Many of the best messages are conveyed through handmade signs that verge on folk art.

A prevalent and curious characteristic of photopostcards and other pictures at the turn of the 19th century was the habit of inscribing correspondence or messages directly on the image. This convergence of text and picture personalized these works and has given us a greater insight into the characters of both writer and recipient.

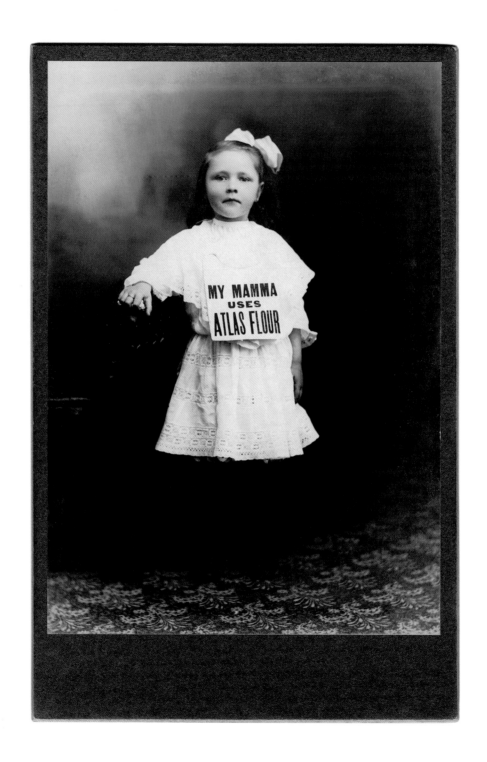

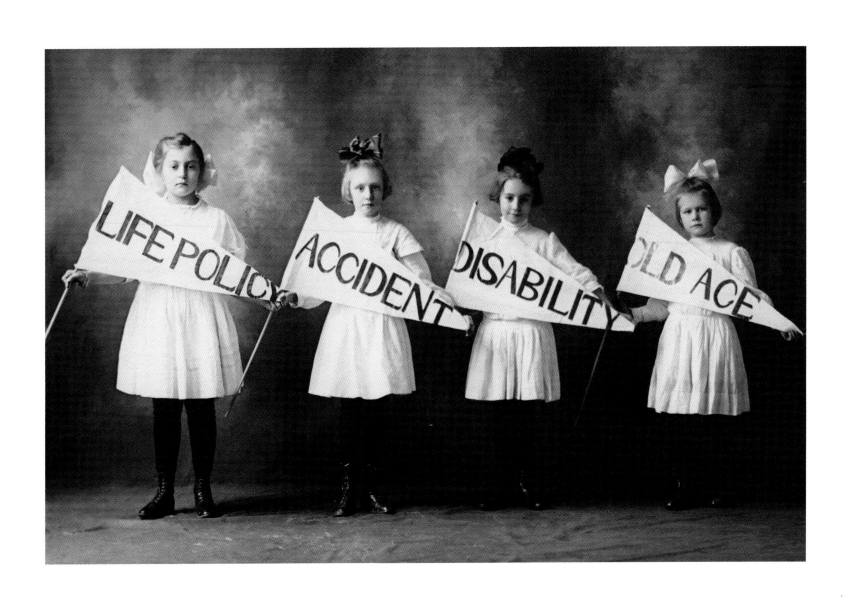

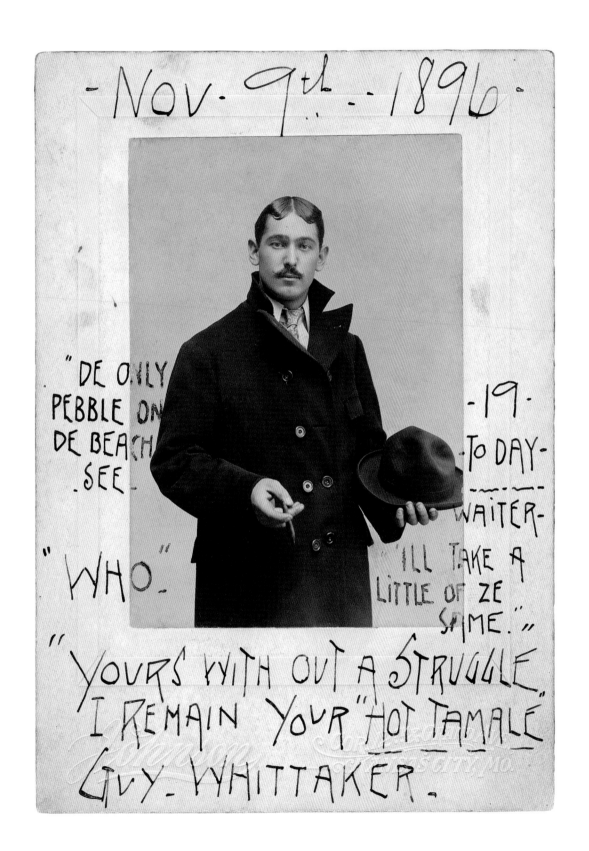

- Nov. 9th. - 1896 -

"DE ONLY
PEBBLE ON
DE BEACH
. SEE .

- 19 -
- TO DAY -
- WAITER -
"ILL TAKE A
LITTLE OF ZE
SAME."

" WHO."

"YOURS WITH OUT A STRUGGLE
I REMAIN YOUR "HOT TAMALE"
GUY. WHITTAKER .

Orders of Recitations

Virgil	Lockwood,	to 9.15
Caesar	Shaks.	9.55
2d alg.	2d Alg.	10.3
	Recess	10.40
1st Alg.	Eng. Hist.	11.20
Homer	1st French	12.
	Recess	12.30
Cicero	Chittenden	1.
Geom.	2d French	1.3

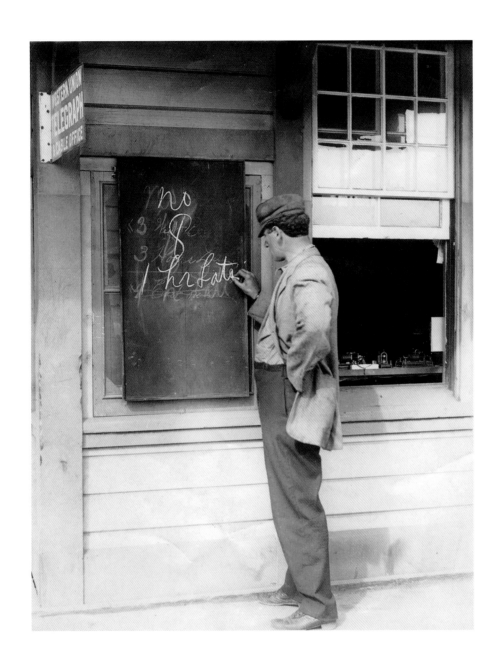

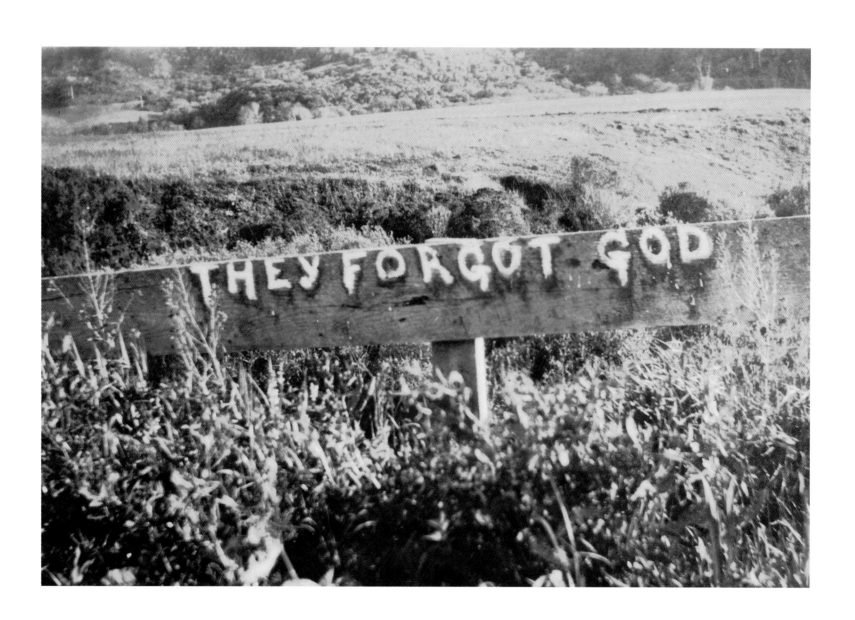

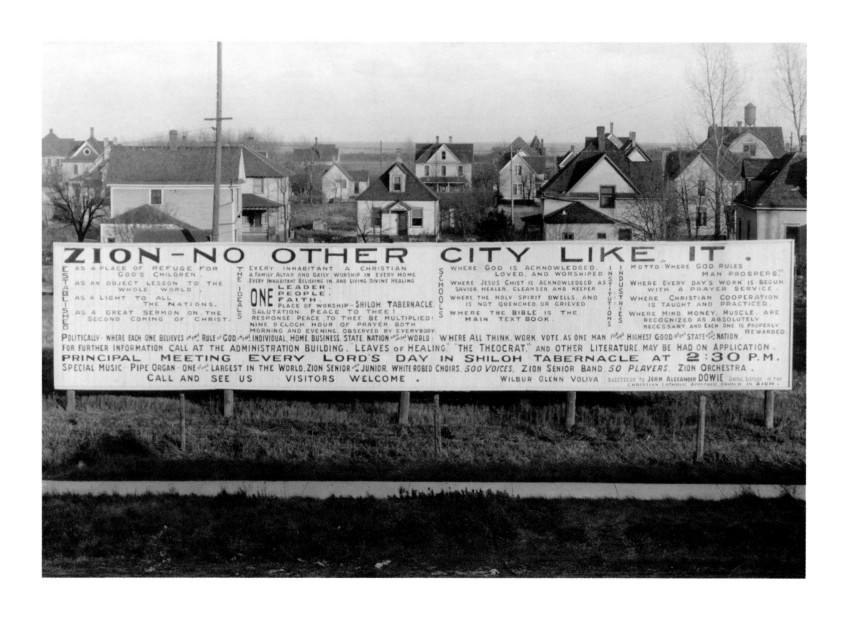

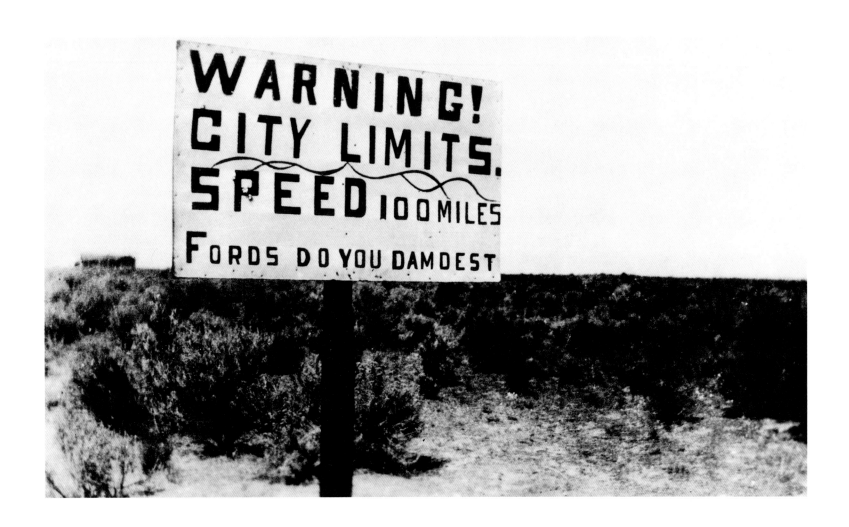

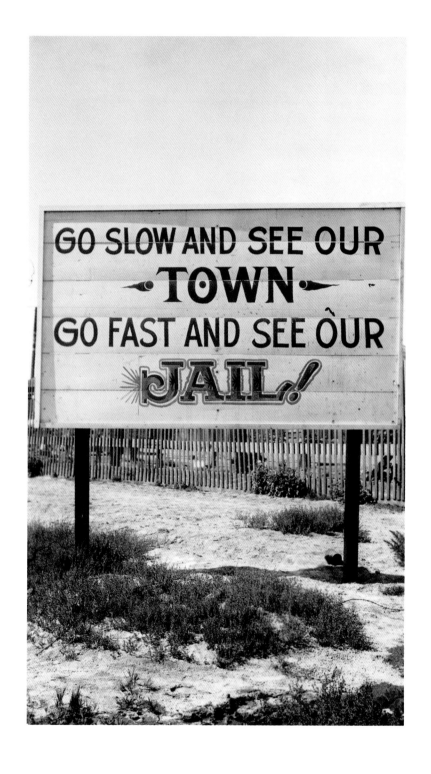

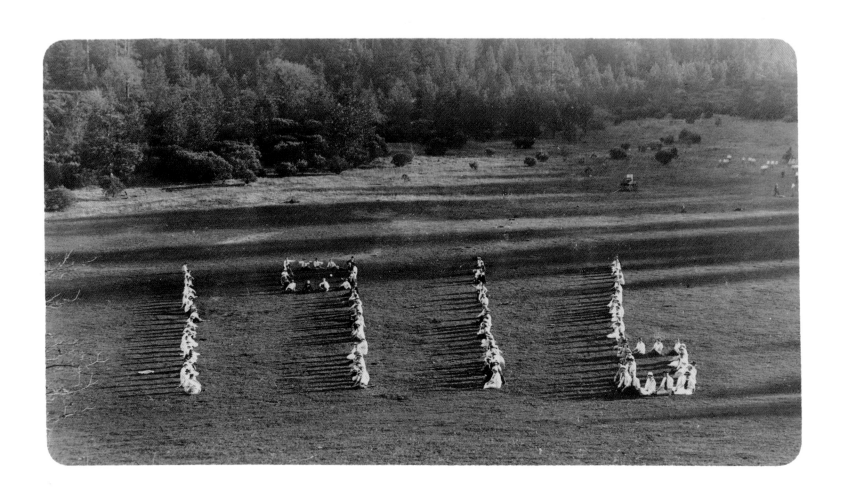

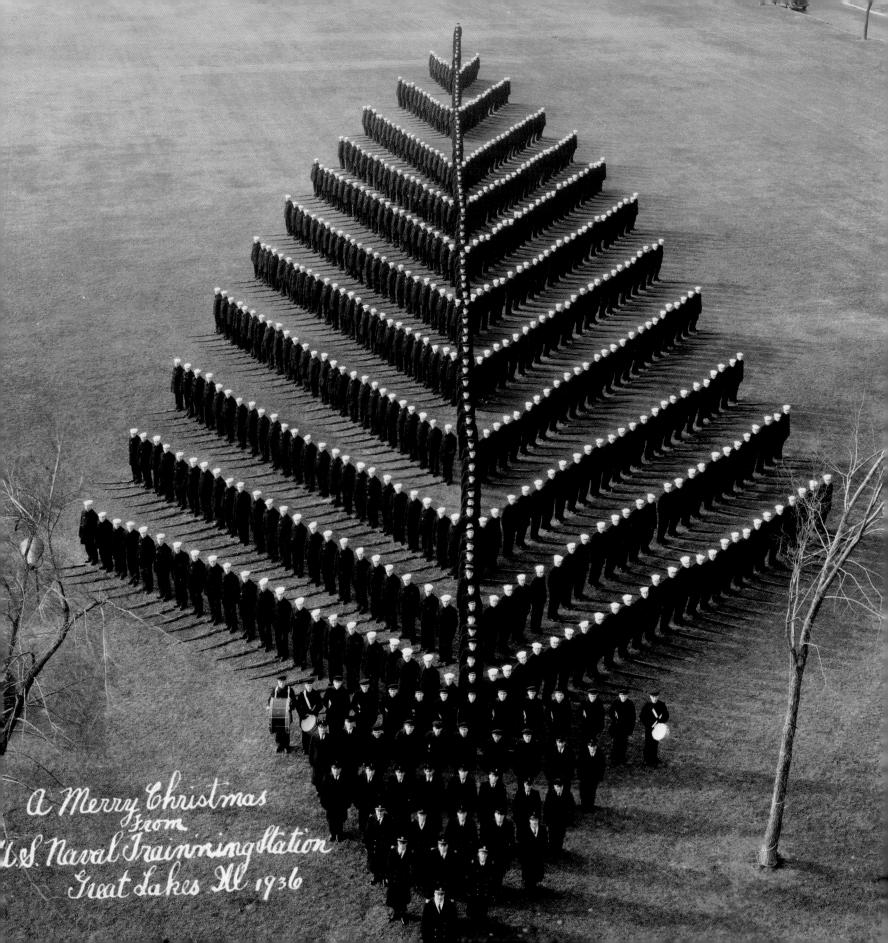

A Merry Christmas from U.S. Naval Training Station Great Lakes Ill 1936

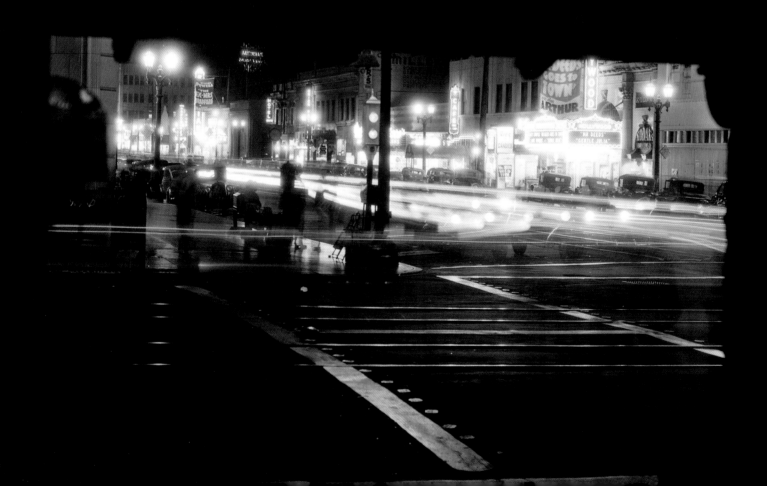

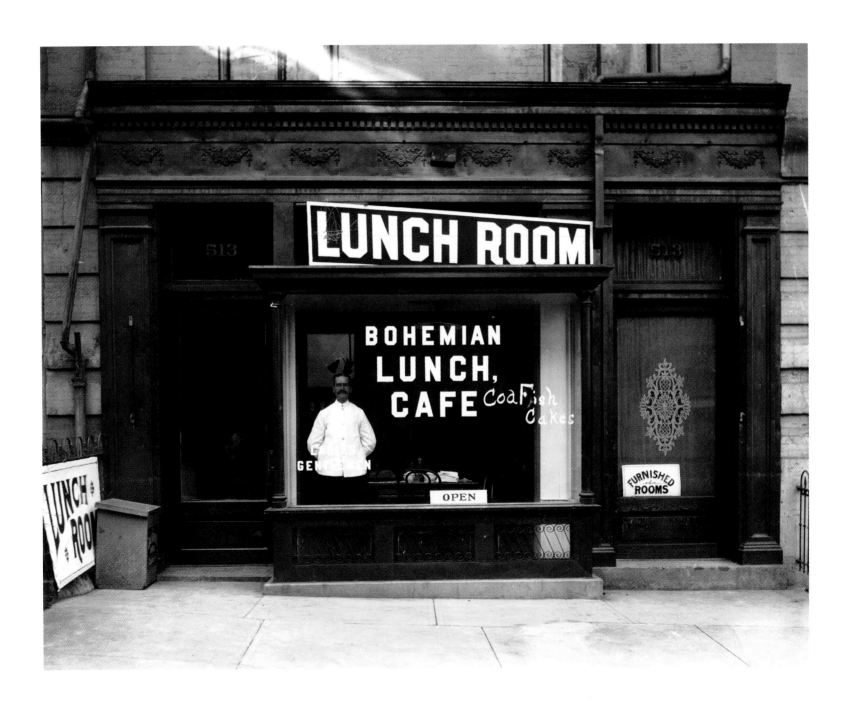

bizarre or beautiful

Photographs furnish evidence. Something we hear about, but doubt, seems proven when we're shown a photograph of it. Susan Sontag

The expression 'If I didn't see it, I wouldn't believe it' is particularly apt when considering the many bizarre and baffling images that exist in photography. Literature and art allow imagination and subjectivity to shape and embellish the truth. Photography, however, leaves little room for poetic ambiguity. In most cases, what you see did, in fact, exist or happen.

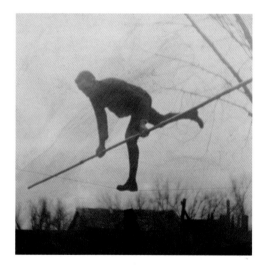

The degree of abnormal behaviour of which human beings are capable is truly breathtaking. There is a sense of proud accomplishment on many of the faces of those engaged in all manner of dangerous, repellent or weird undertakings. The camera bestows a curious immortality on such individuals. In fact, its presence not only tolerates, but encourages recklessness and extreme behaviour that otherwise might not have occurred. Some images, however, are not as unusual as they appear. Since the earliest days of the medium, there has always been a wide variety of trick or manipulated photographs. This was often accomplished by using multiple negatives. The desire to create fanciful, if not outrageous, images has always had appeal.

Some of the strangest and most wonderful anonymous photographs were not intentional. They were the happy accident of the finger clicking and the shutter closing at the right moment. These little photographic miracles have no place in the temple of premeditation that is art, yet they squeeze in anyway as unwelcome guests.

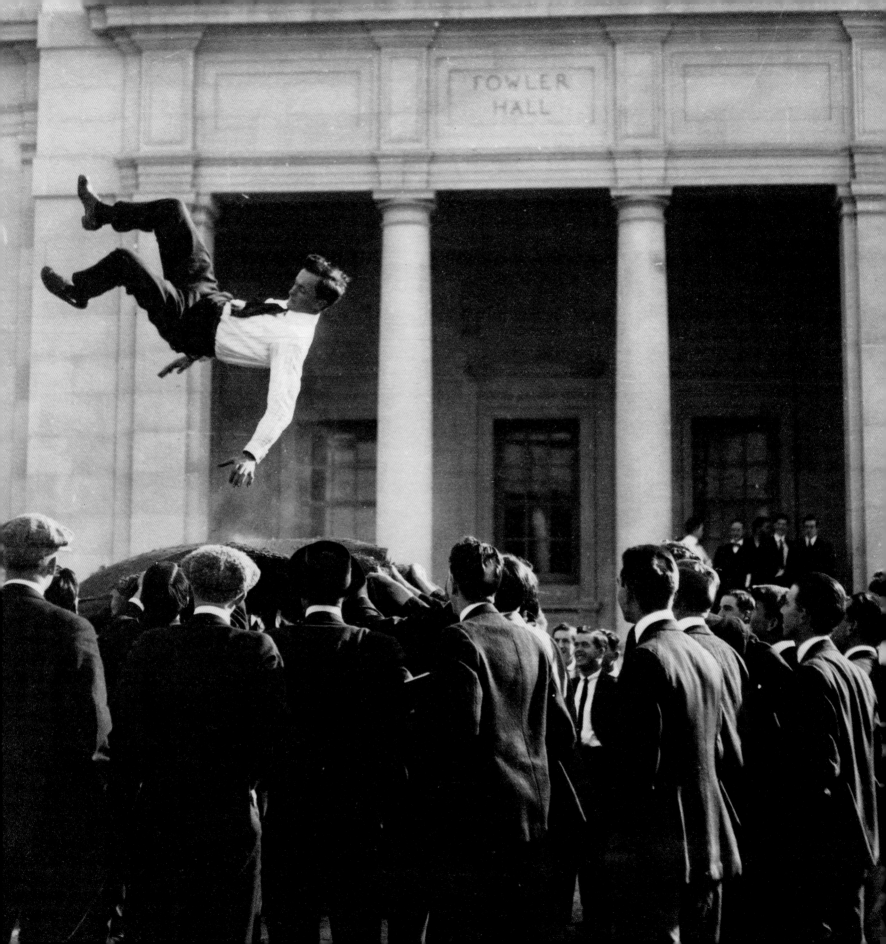

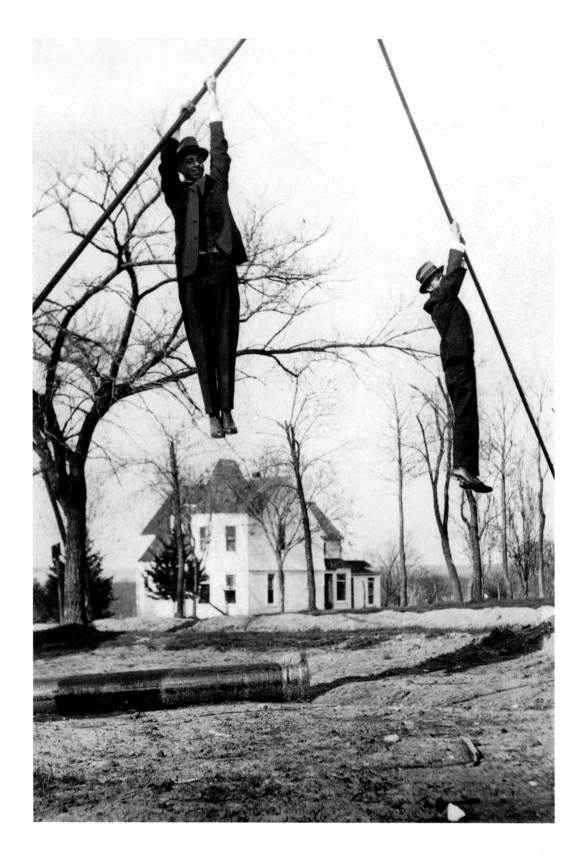

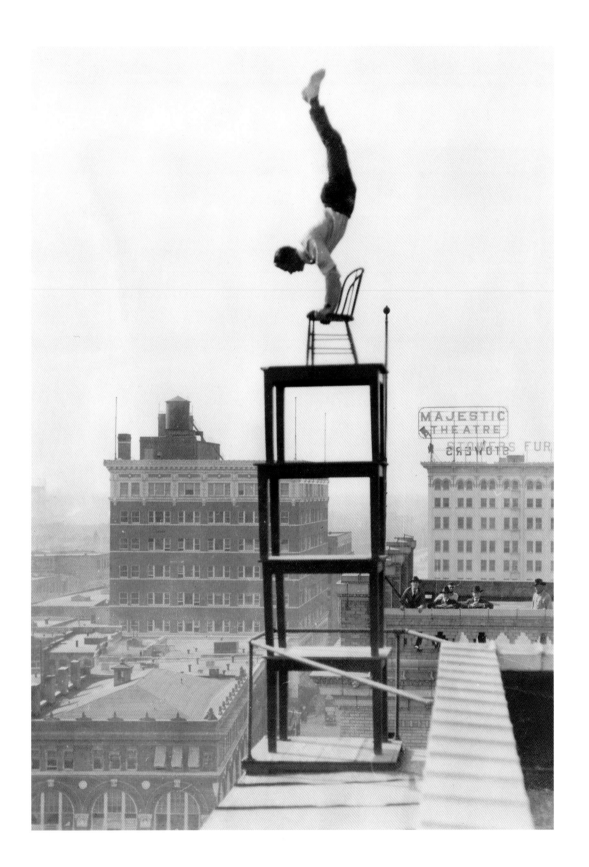

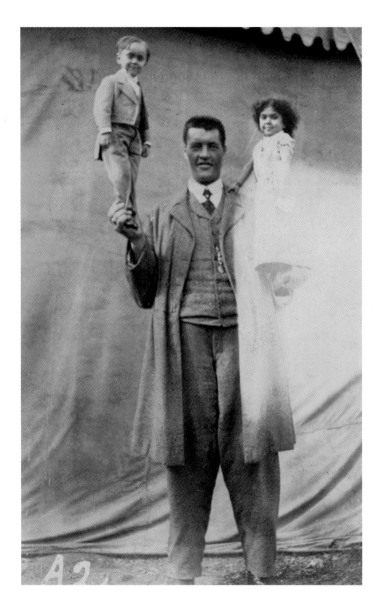

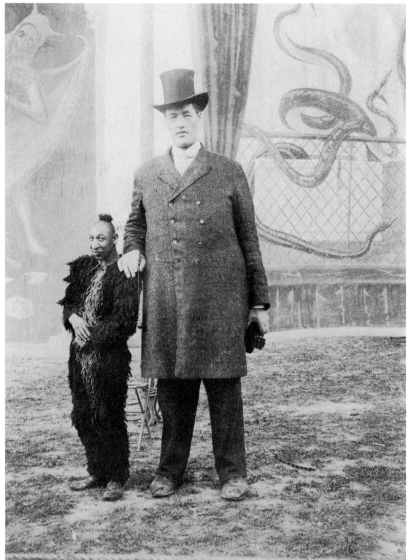

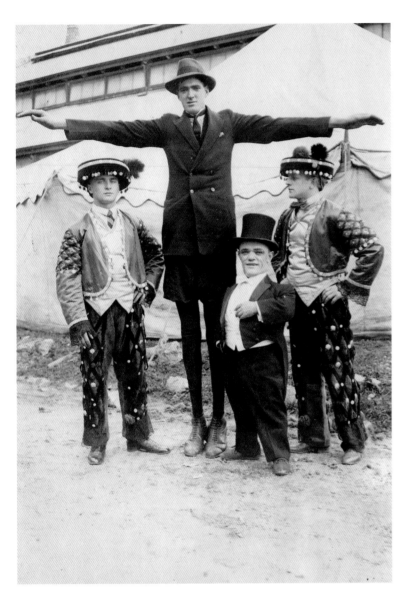

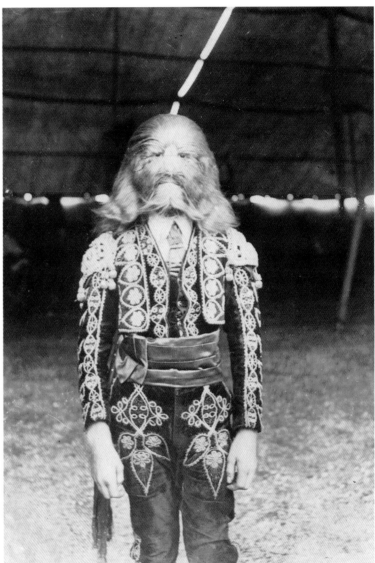

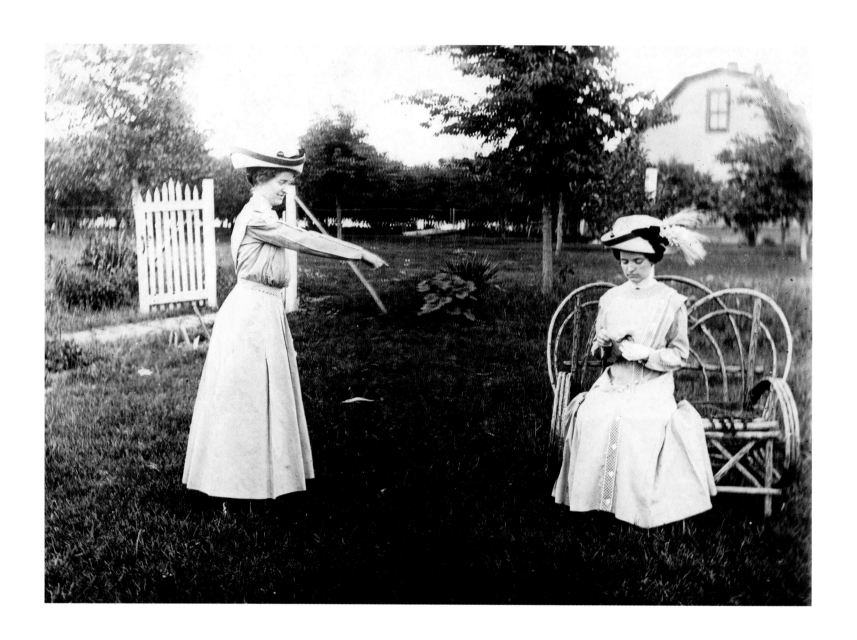

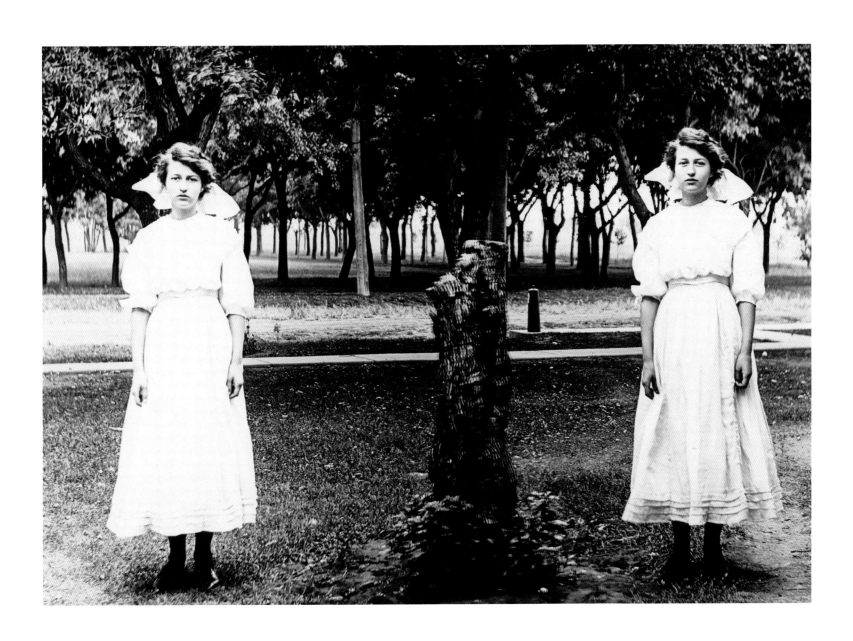

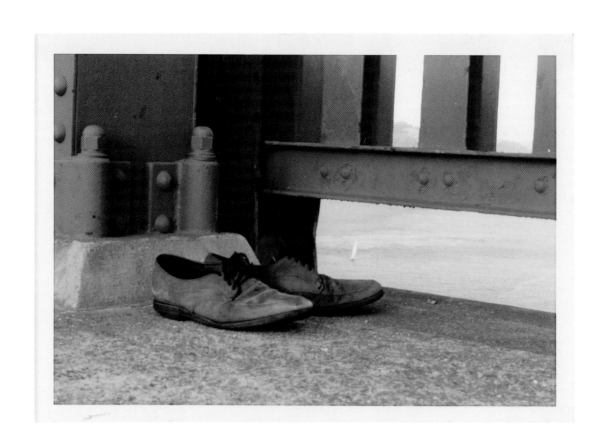

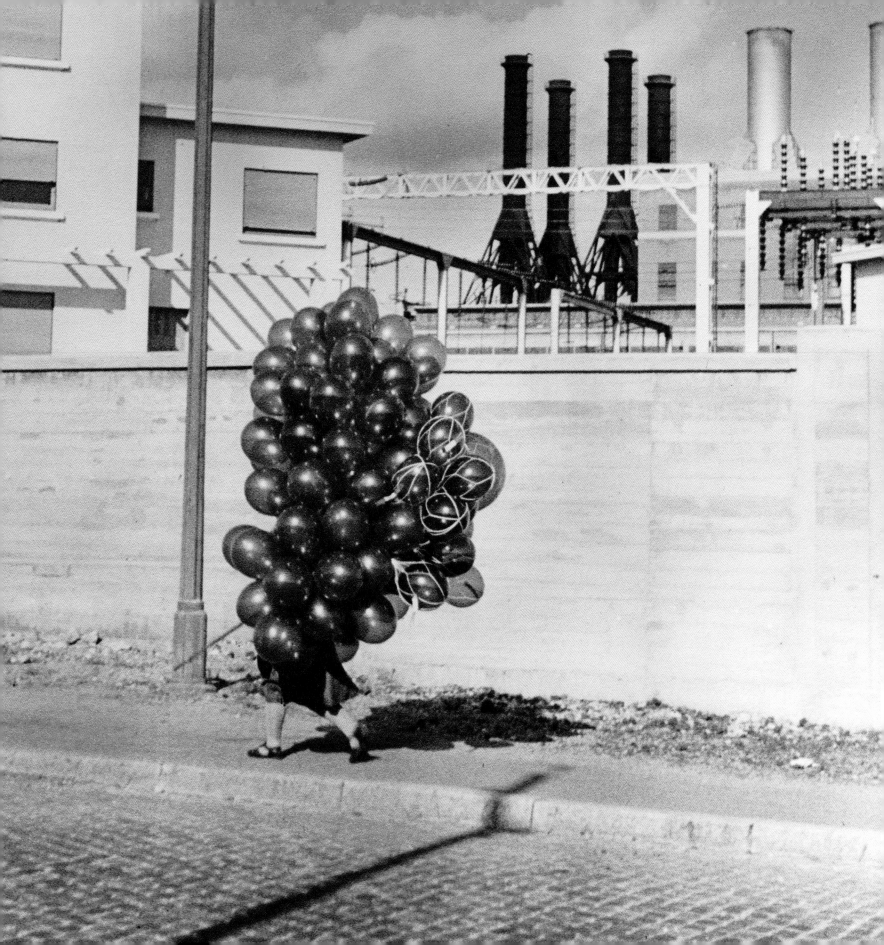

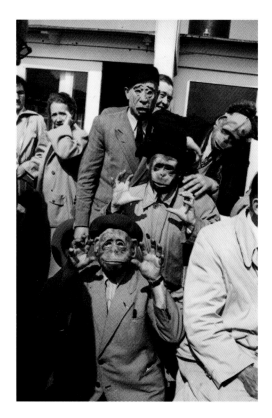
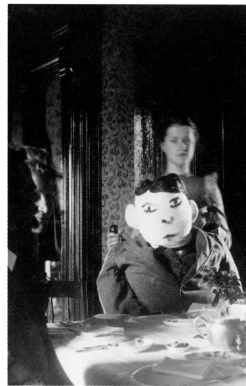
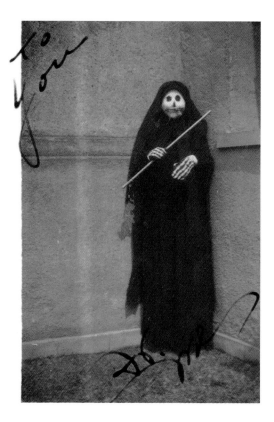

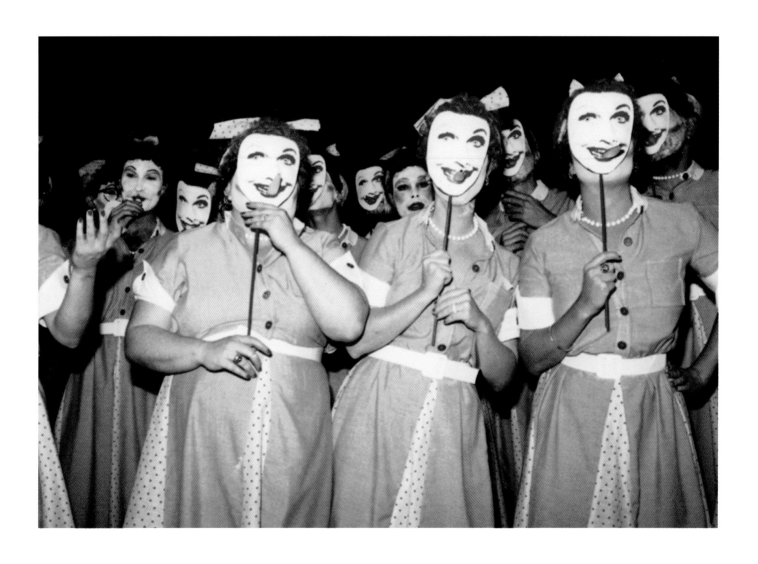

still life and structure

For me, an object is alive; this cigarette, this matchbox, contains a secret life much more intense than some humans. Joan Miró

When a potential purchaser is rummaging through old photographs, the typical question posed by a seller is, 'What are you looking for?' What usually causes a perplexed expression on the dealer's face is a request for photographs of things or, more specifically, still lifes.

Although there are relatively few images of things among the tens of millions of anonymous

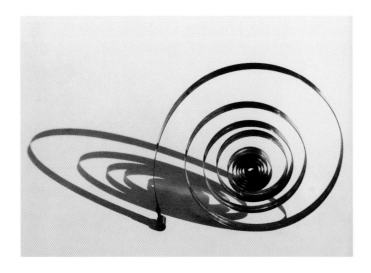

photographs, they are often starkly beautiful and well-composed. These works usually fall into two categories: those made with an aesthetic intent and those made with a businesslike sense of inventory or documentation. The range of subject matter is, of course, only limited to the imagination.

The geometry and mass of architecture have always found a sympathetic medium in photography. The ability to record details of buildings allows insight that would not otherwise be possible. Photography has often been used to document the planning and erection of edifices in painstaking yet fascinating detail. Photographs also furnish melancholy evidence of buildings that no longer exist. There is an extra poignancy, however, in photographs of lost architecture because, in many instances, their subjects did not have to be destroyed.

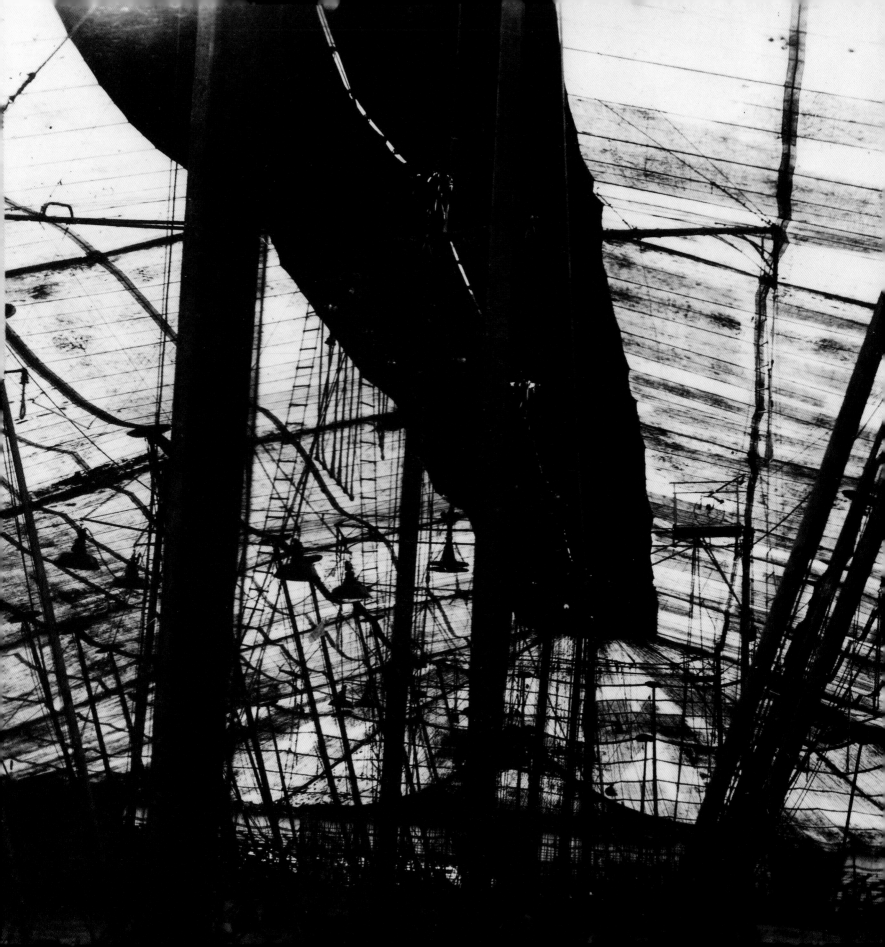

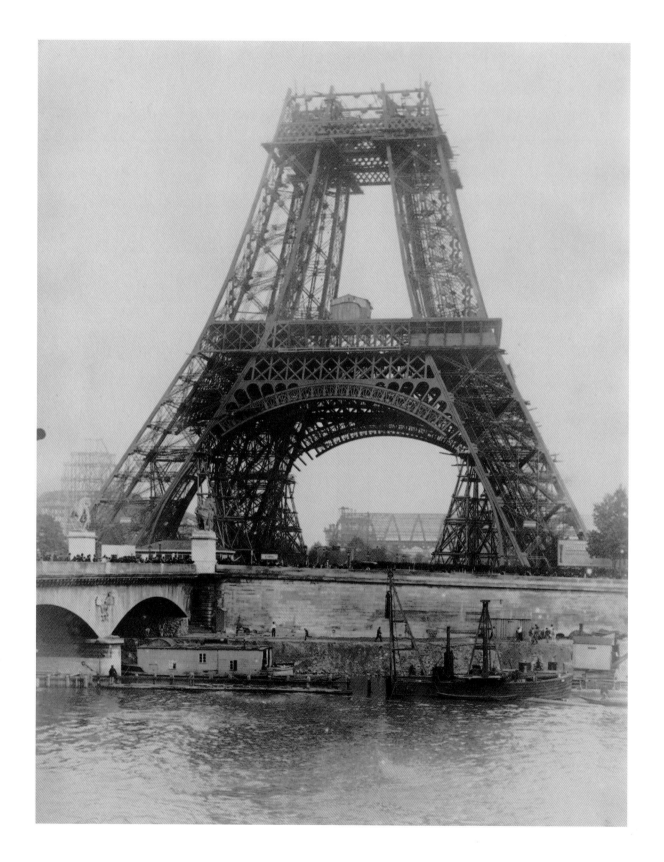

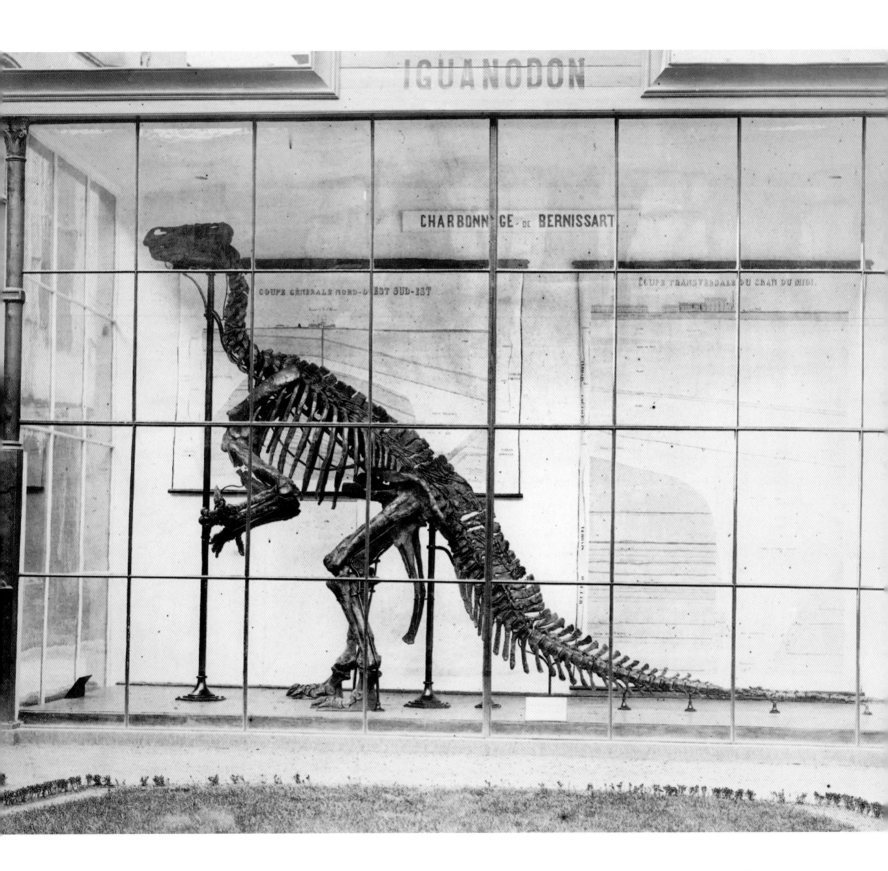

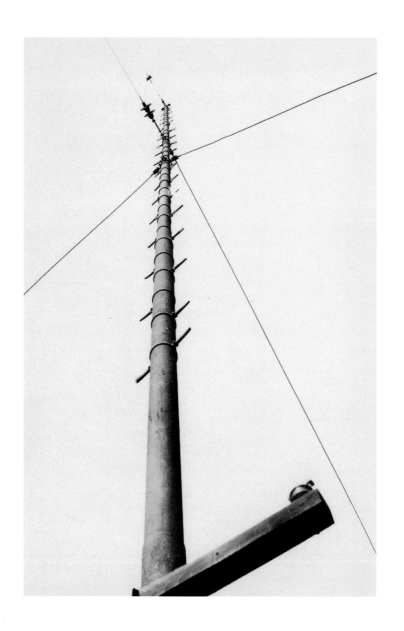

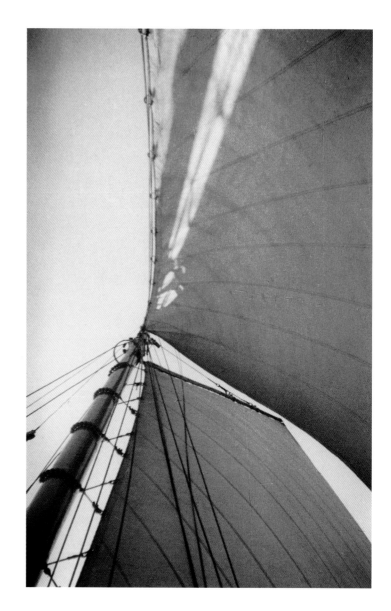

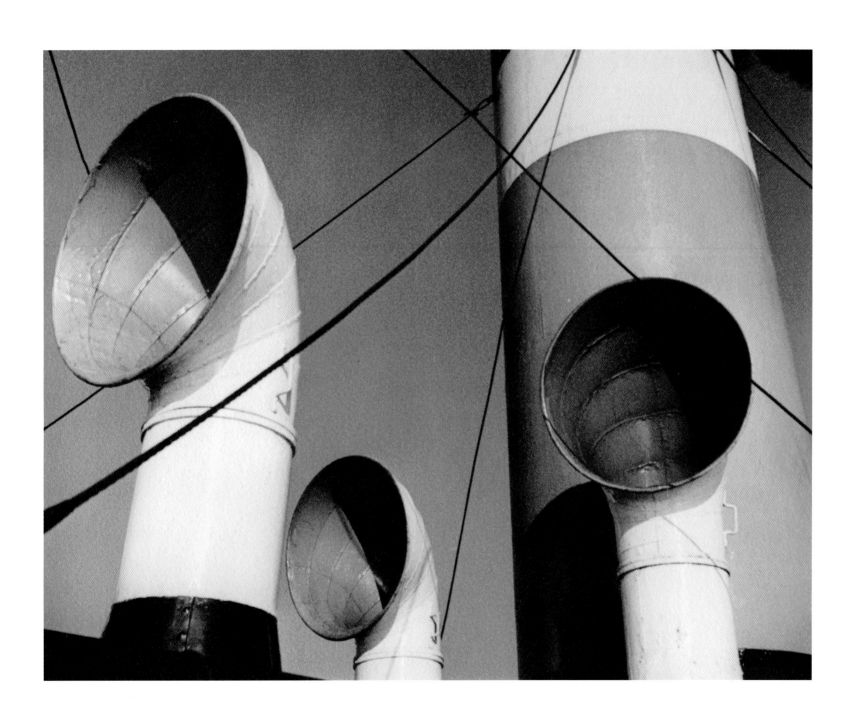

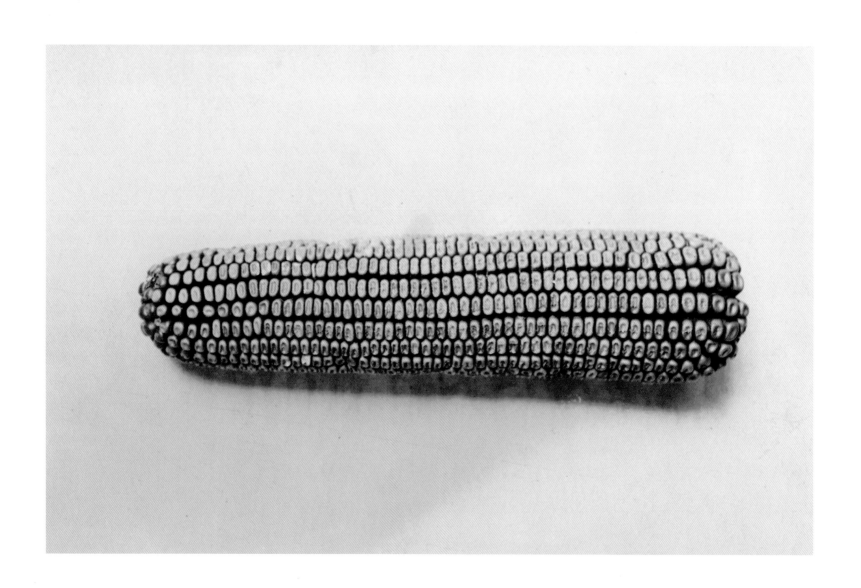

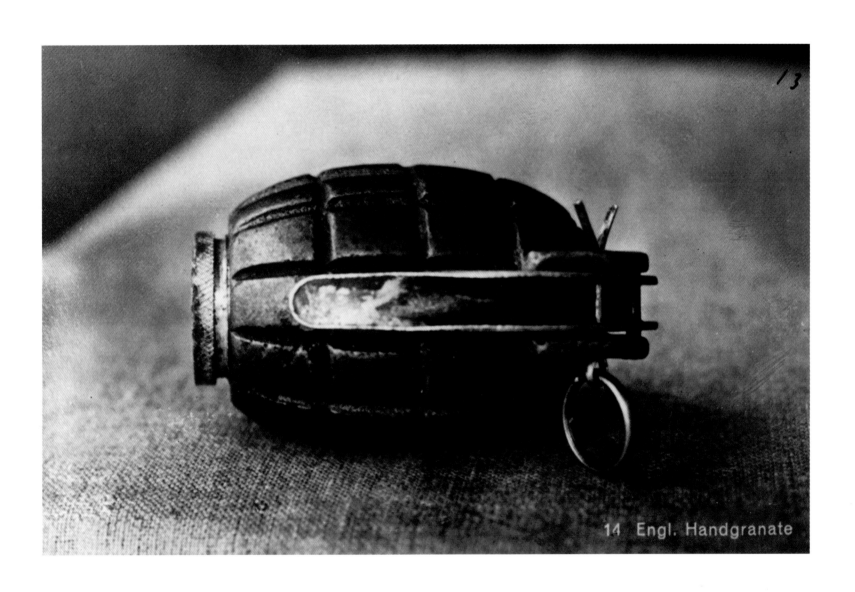

13

14 Engl. Handgranate

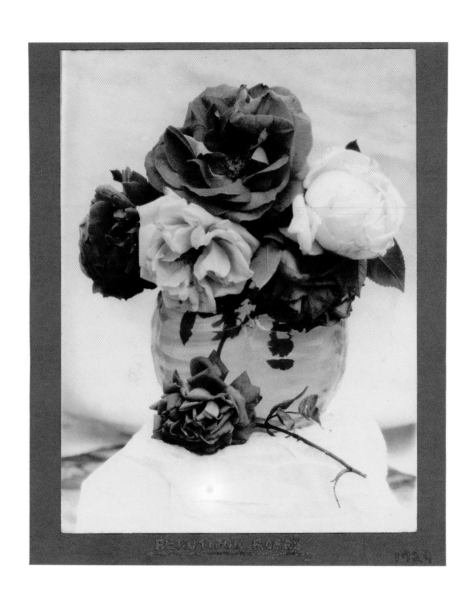

BEAUTIFUL ROSES 1924

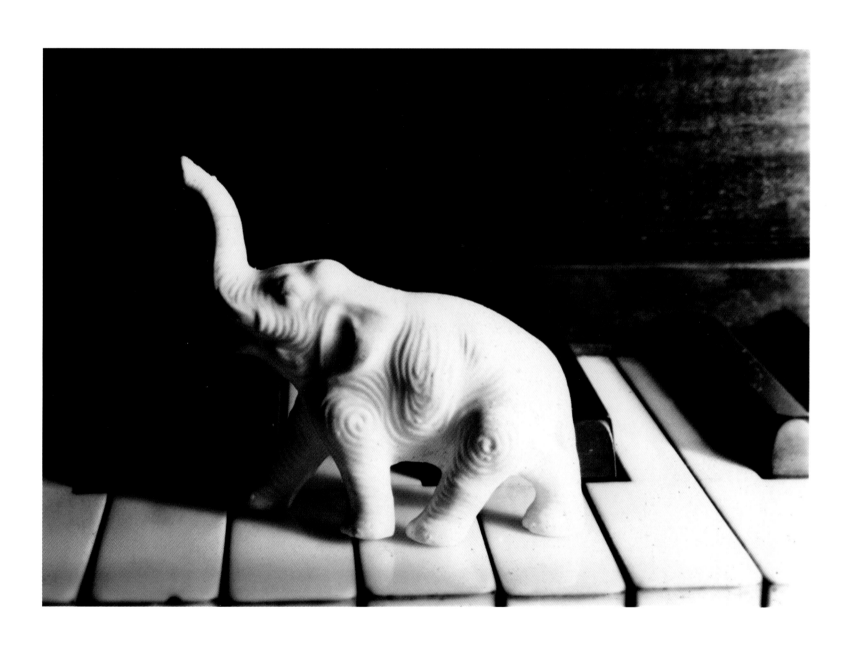

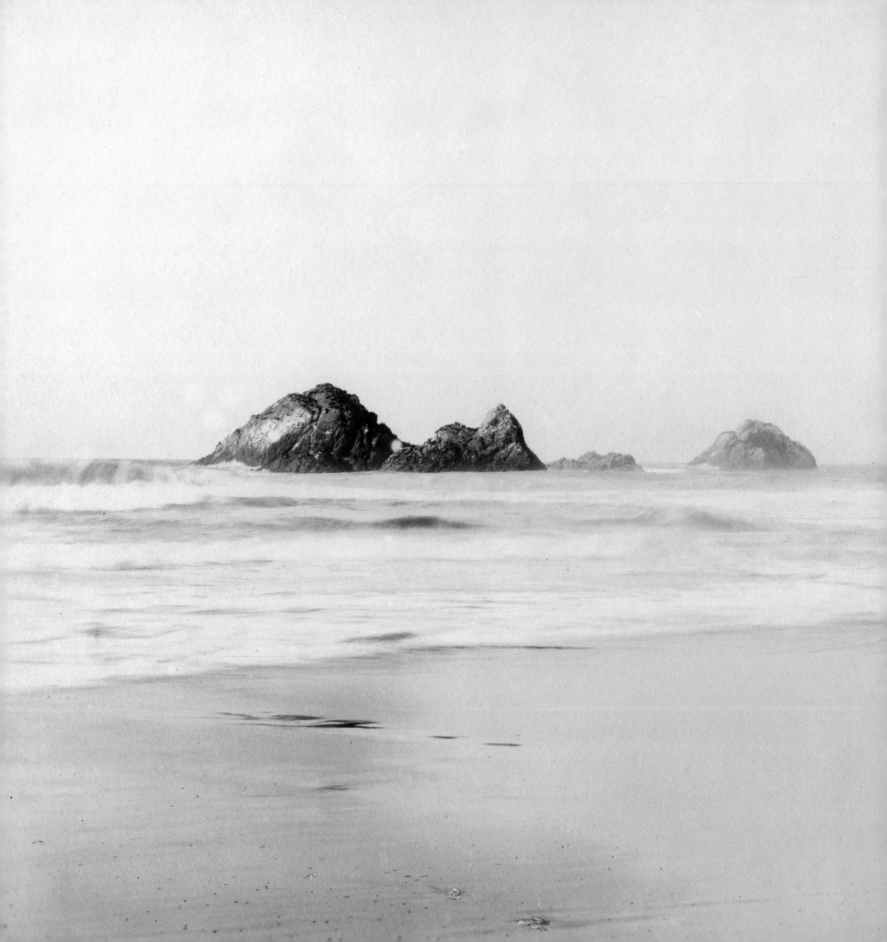

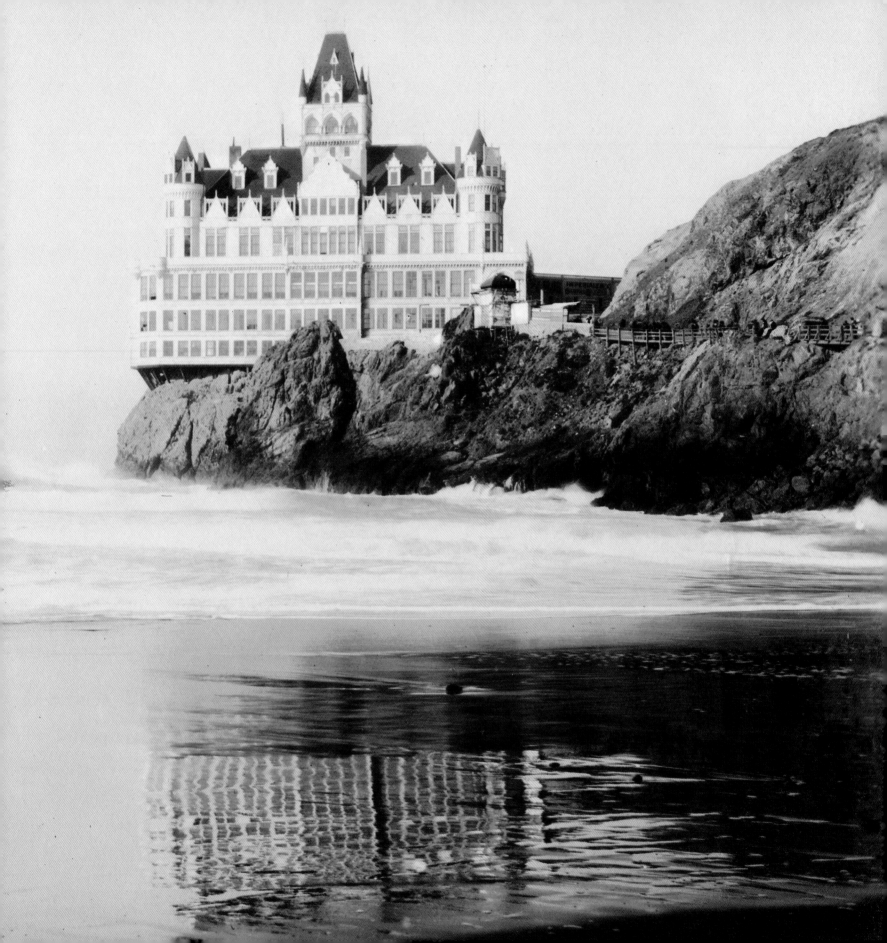

endings and infamy

Between grief and nothing I will take grief. William Faulkner

Post-mortem photography is the term used for images of deceased human beings. There are in existence an amazingly large quantity of daguerreotypes and other photographic images of the dead. It is not that our ancestors were morbid, but because in the 19th century, at the time of a person's death, especially in the case of children, the family often had no previous painting, drawing or photograph by

which to cherish or remember the departed. In despair, and in the haste before burial, a post-mortem photograph was taken. It might seem inappropriate to us today, but it was their last chance to capture a shred of the reality of that person.

Death also appears in photographs as factual documentation. It illuminates the tragic results of fate, the senselessness of crime and the methodology of criminal justice. Another use of photography chronicling death is to commemorate triumph. In war photography this means recording one's dead adversaries. A more common visual celebration, however, is the laying out of dead game or fish, often in grotesque profusion, to reinforce the strange achievement of man's continuing assault on nature.

There is an inherent melancholy in photography. Even lives as recorded by the camera as vital and present will, over time, become ghosts. The inevitability of death hovers gently over all photography.

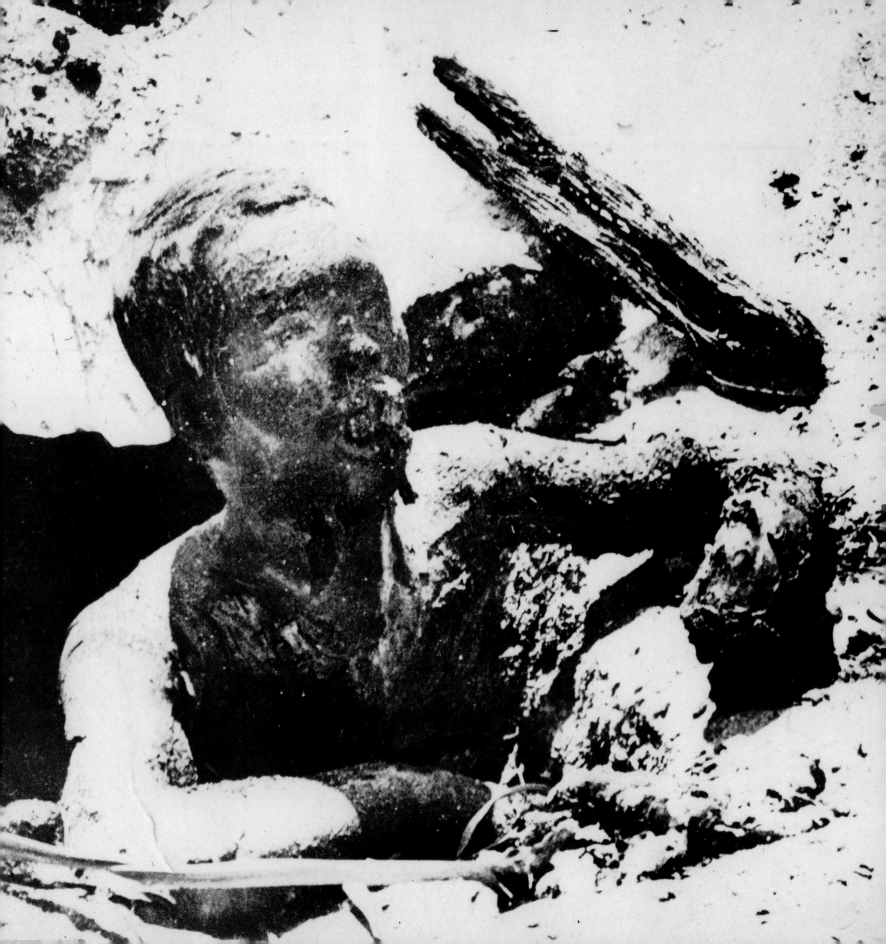

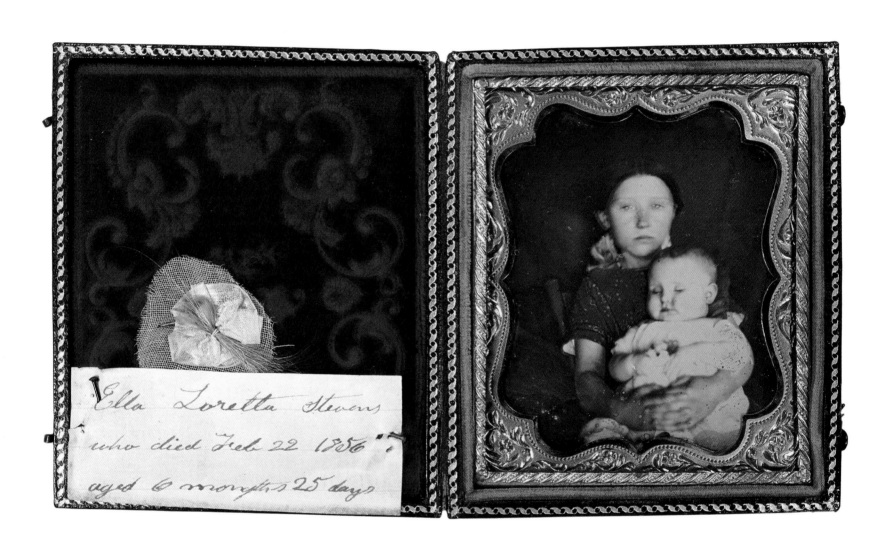

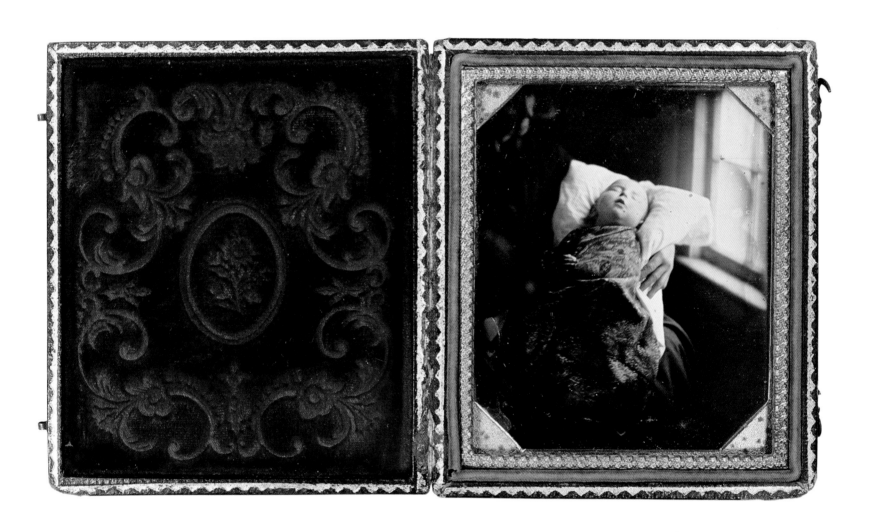

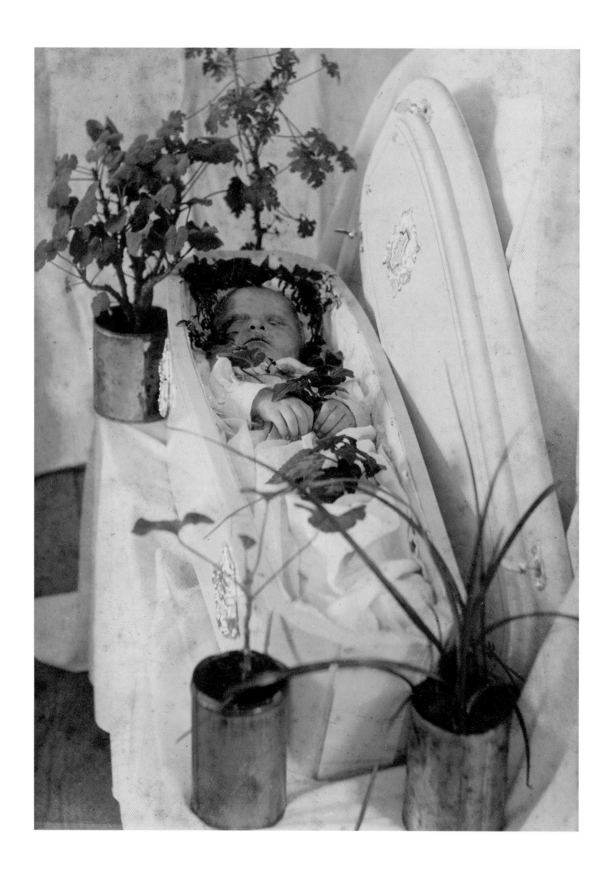

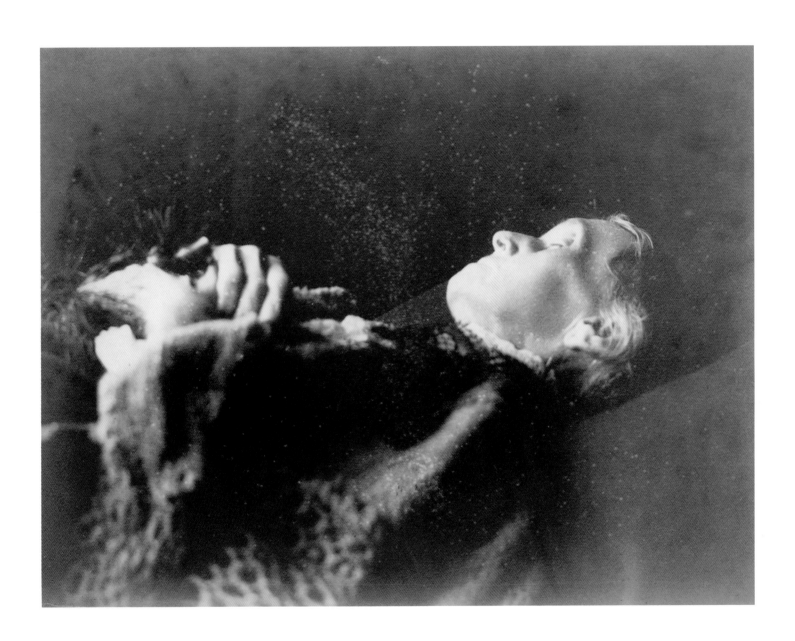

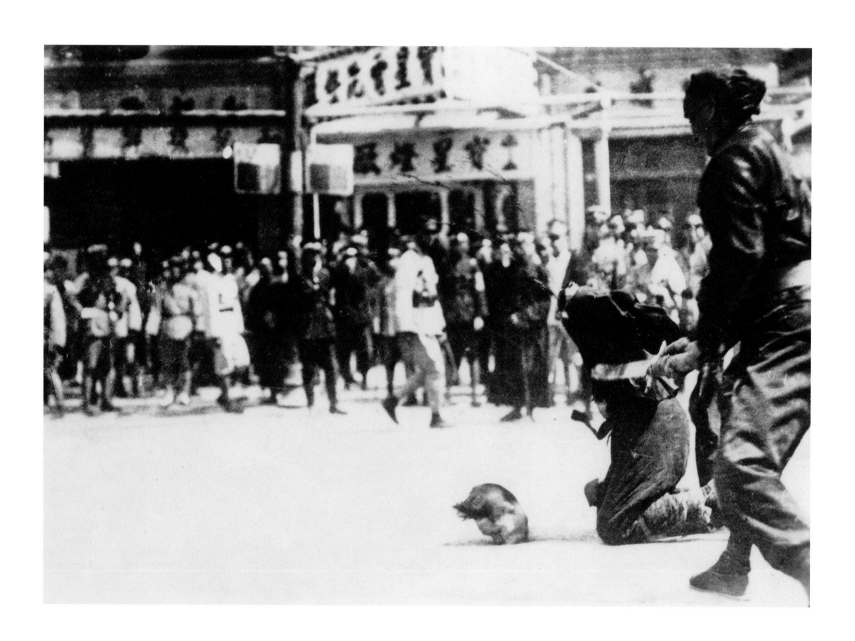

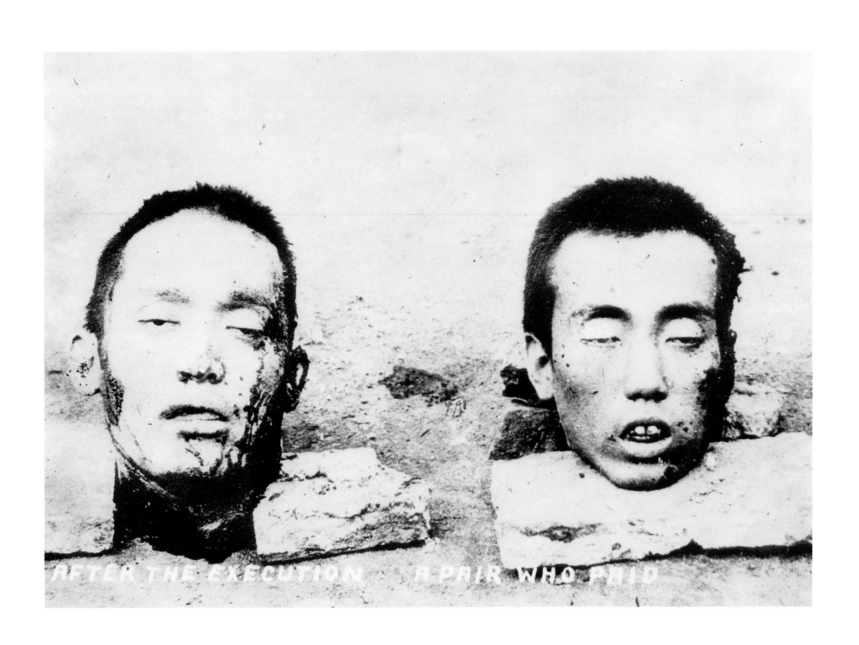

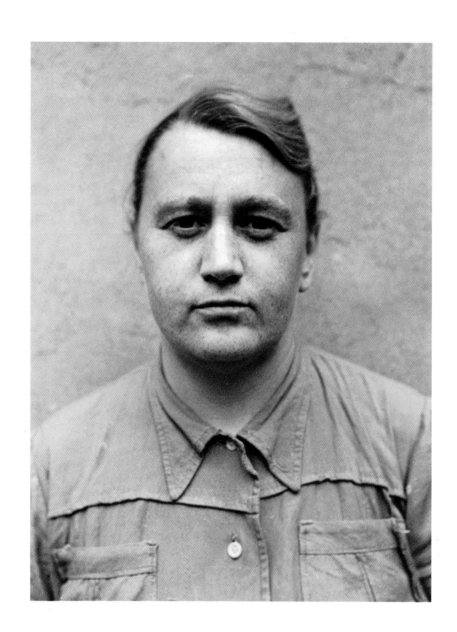

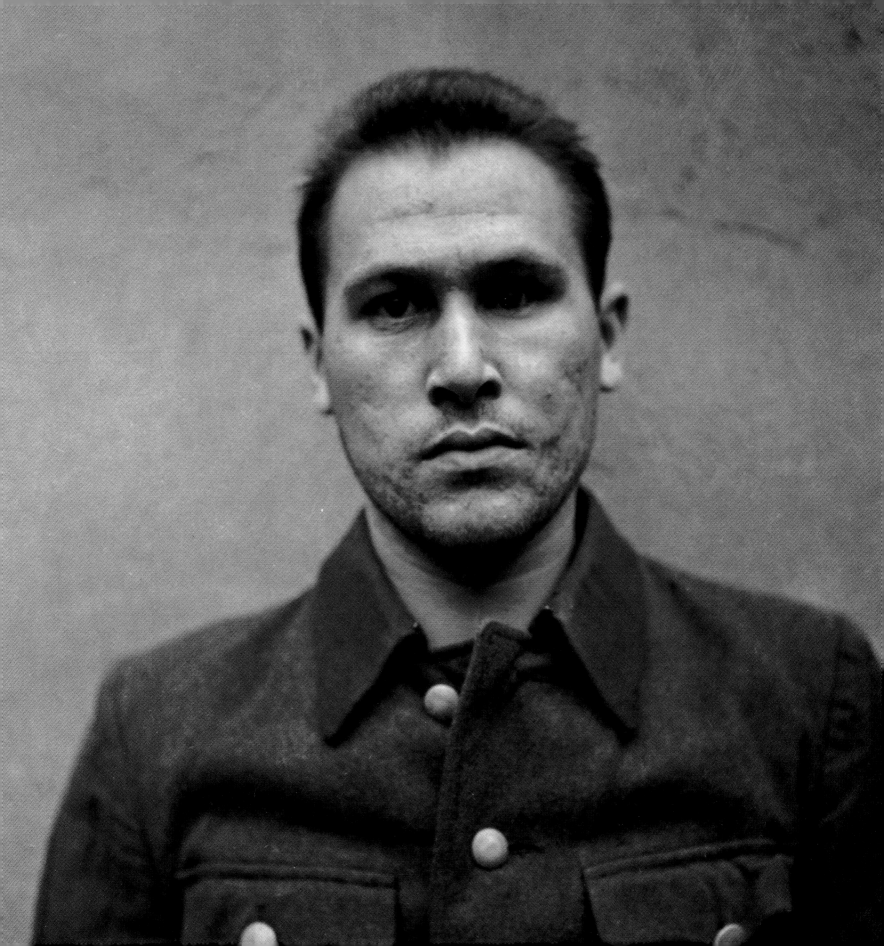

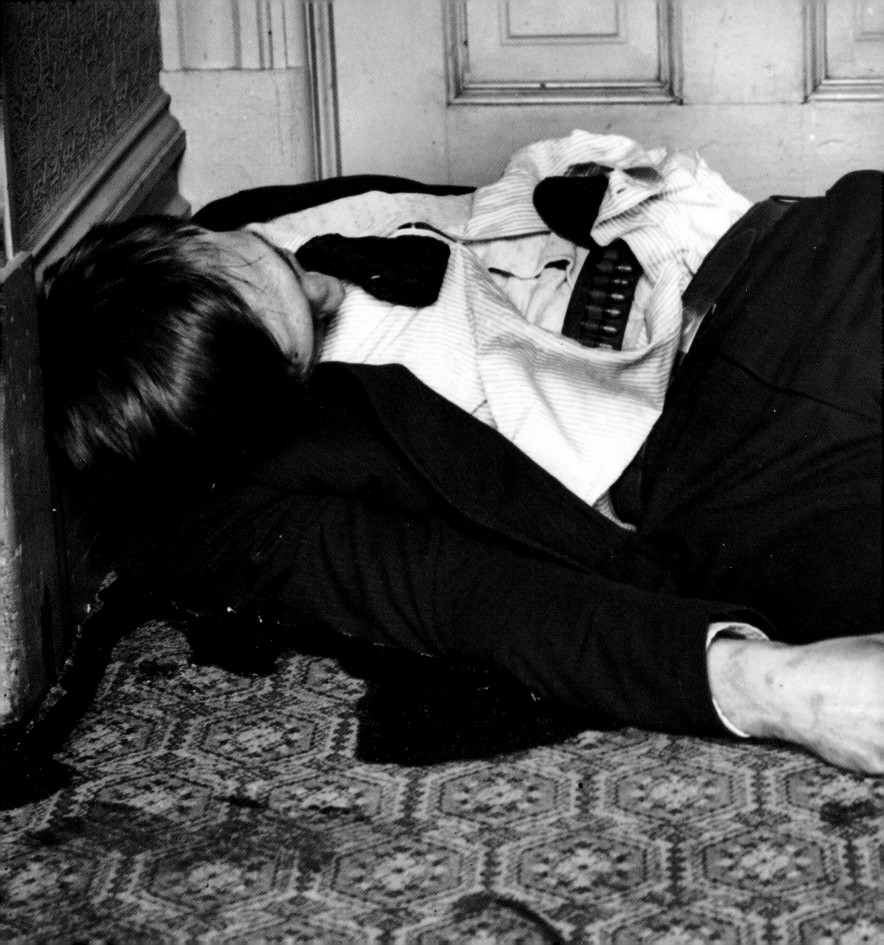

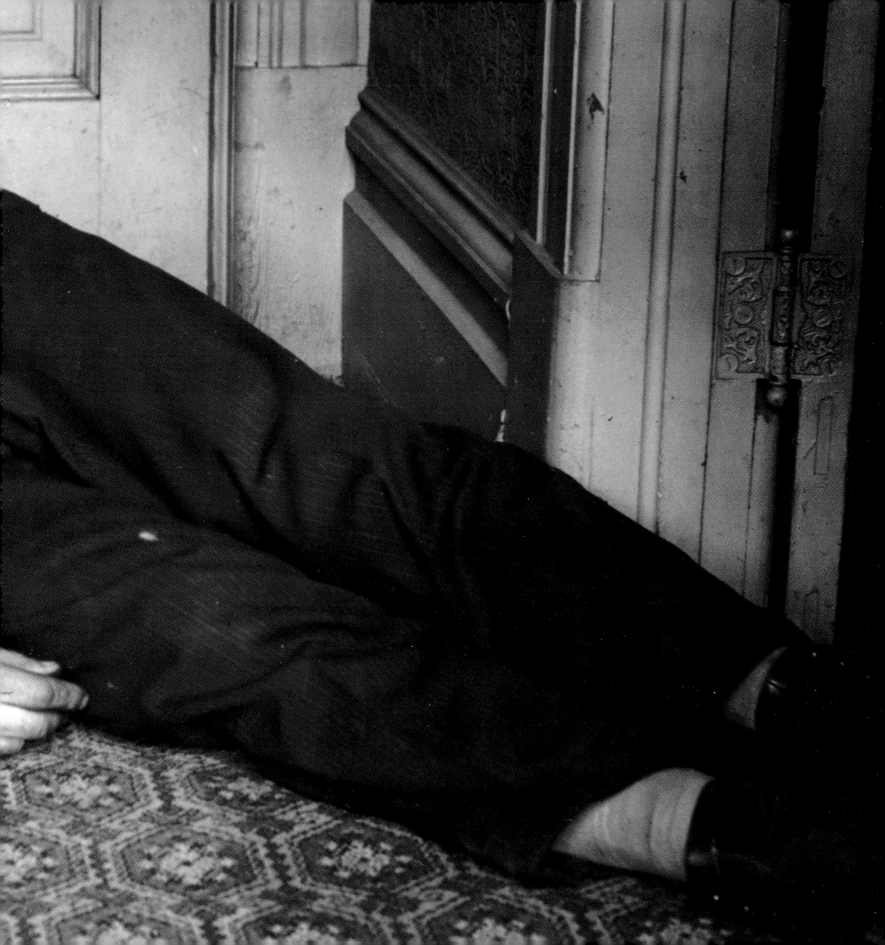

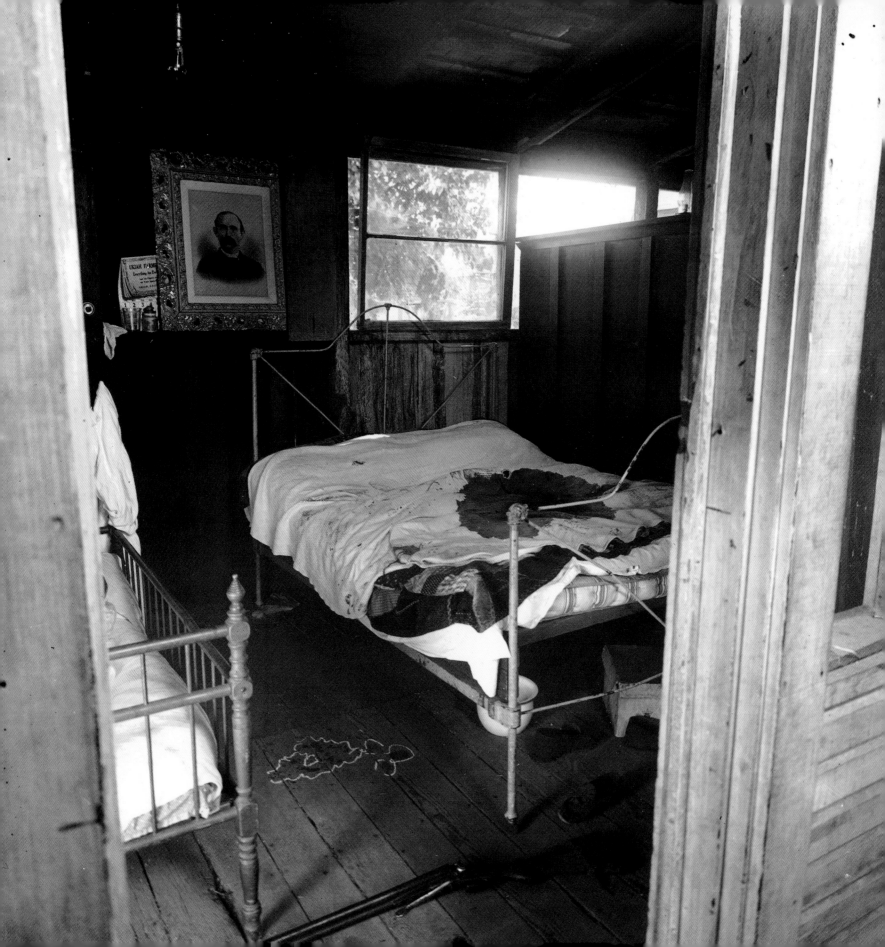

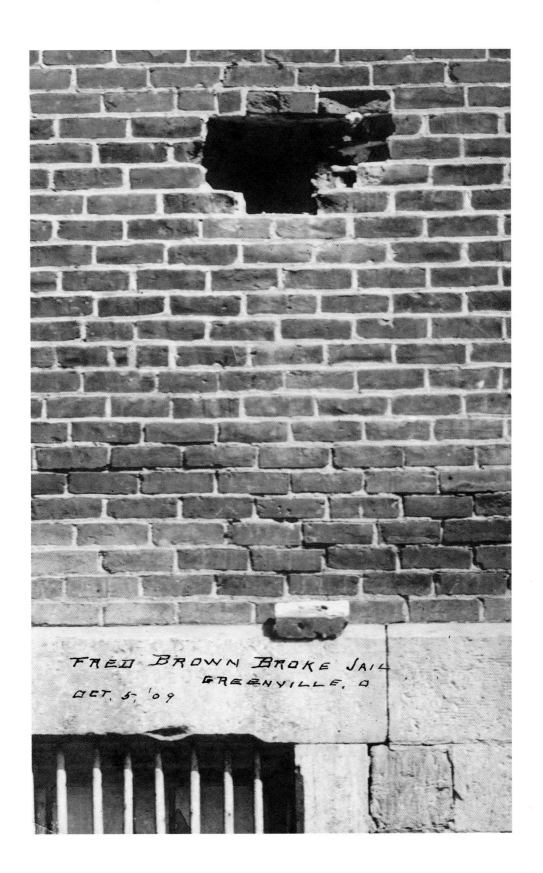

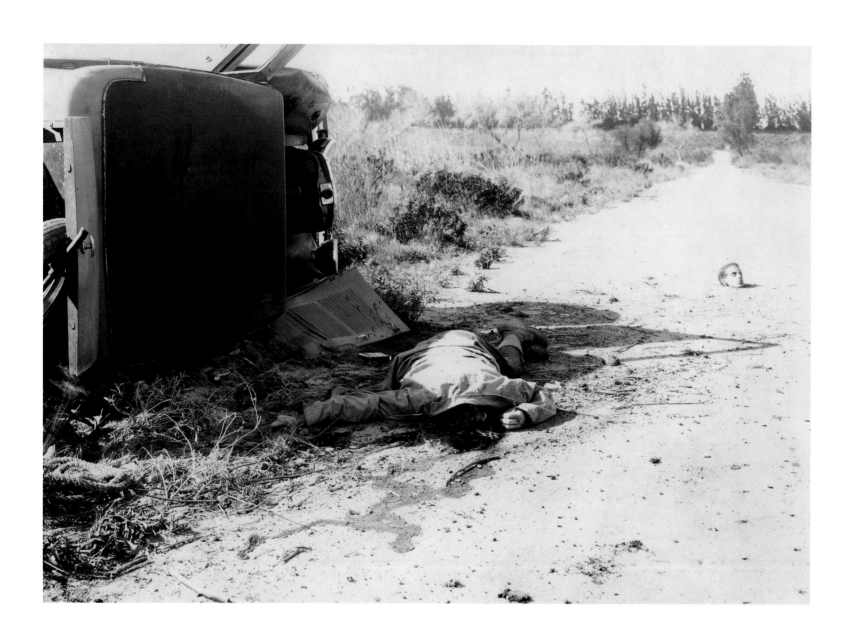

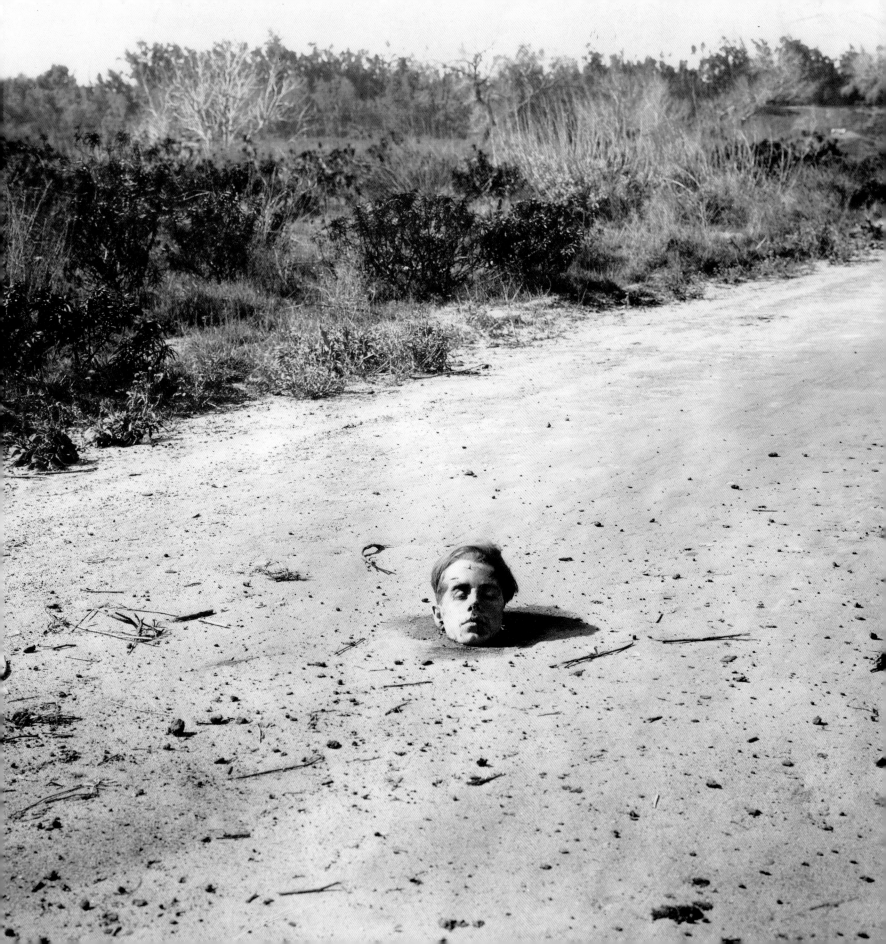

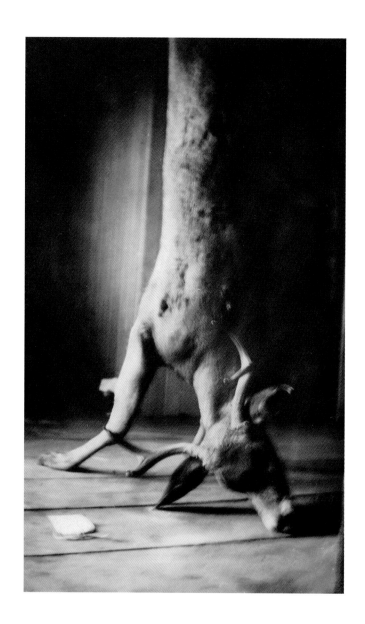

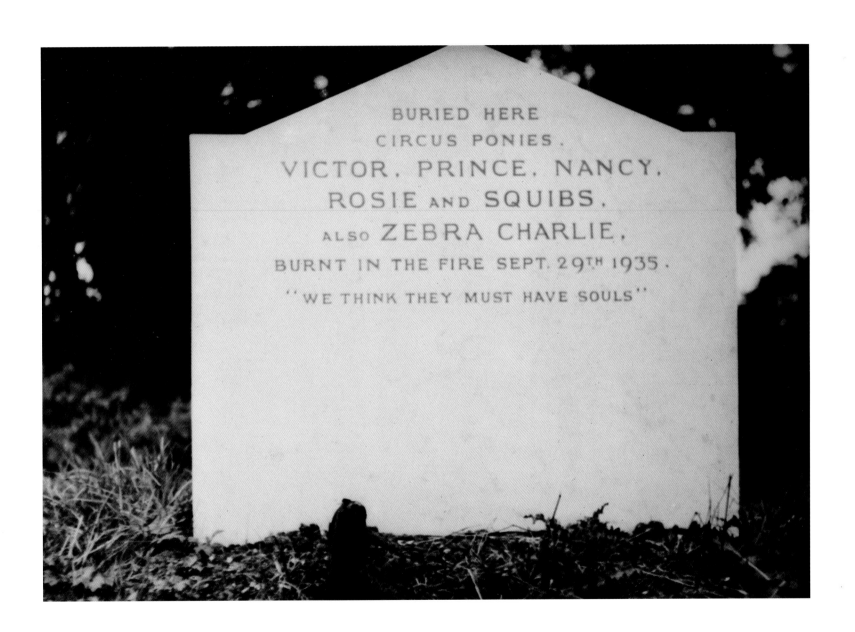

collecting anonymous photographs

Ninety per cent of success is showing up. Woody Allen

The anonymous photographs that are presented in this volume were selected from a much larger collection, which I have formed over a period of more than a decade. Time, not money, is the currency of collecting anonymous photographs. The seeking out, selection, consideration and, ultimately, acquisition of works has very little to do with money and everything to do with one's persistence, one's judgment and one's aesthetic taste. I can relate to a story told by a fellow collector, who once said that he pondered for an hour over the acquisition of an anonymous photograph priced at four dollars. It was not, of course, the price of the work that was important, but whether the photograph had those elusive yet personal qualities that would make it a worthy addition to his collection. Anyone reading this volume has the potential to form their own collection based on their own personal taste and vision – I hope it inspires many people to embark on their own voyages of discovery.

notes on the photographs

Dimensions of works are given in centimetres and inches, height before width. Unless otherwise stated, all photographs are gelatin silver prints.
a – above, *b* – below, *c* – centre, *l* – left, *r* – right

1 USA, *c.* 1885. 9 x 9.3 (3⁹⁄₁₆ x 3⅝)
2–3 Illinois State Prison. USA, *c.* 1890. 12 x 20.3 (4¾ x 8)
4 USA, *c.* 1890. 12.5 x 9.8 (4¹⁵⁄₁₆ x 3⅞)
6 France, *c.* 1900. 12 x 17.1 (4¾ x 6¾)
9 USA, *c.* 1940. 12.2 x 7.7 (3 x 4¹³⁄₁₆)
10 Bordello. USA, *c.* 1900. 12 x 17 (4¾ x 6¹¹⁄₁₆)
11 *a* USA, *c.* 1920. 8 x 11.7 (3⅛ x 4⁹⁄₁₆)
11 *b* USA, *c.* 1930. 7.7 x 13.4 (3 x 5⁵⁄₁₆)
12 USA, *c.* 1970. 24 x 18.6 (9⁷⁄₁₆ x 7⁵⁄₁₆)
13 Stand Rock, Wisconsin Dells. USA, *c.* 1920. 12.9 x 8 (5¹⁄₁₆ x 3⅛)
14 France, *c.* 1920. 17.2 x 12.1 (6¾ x 4¹³⁄₁₆)
16 Photobooth strip. USA, *c.* 1940. 20 x 4 (7¹³⁄₁₆ x 1⁹⁄₁₆)
17 France, *c.* 1930. 5.5 x 7.9 (2⅛ x 3⅛)
18 USA, *c.* 1890. 11.4 x 9.5 (4½ x 3¾)
19 USA, *c.* 1960. 16.5 x 11.4 (6⁷⁄₁₆ x 4½)
20 San Francisco Harbour. USA, *c.* 1900. 9.2 x 11.8 (3⅝ x 4⅝)
21 UK, *c.* 1880. Albumen print. 15.5 x 16.7 (6⅛ x 6⁹⁄₁₆)
22 Old Man's Cave, Hocking Forest. USA, *c.* 1880. 18.4 x 23.5 (7¼ x 9¼)
23 Niagara Falls. USA, *c.* 1900. 8.1 x 13 (3³⁄₁₆ x 5⅛)
24 'Silhouette'. UK, *c.* 1915. Gum bichromate print. 22.7 x 29.4 (8¹⁵⁄₁₆ x 11⁹⁄₁₆)
25 Germany, *c.* 1935. 8 x 10 (3⅛ x 3¹⁵⁄₁₆)
26 USA, *c.* 1920. 7.2 x 6.8 (2¹³⁄₁₆ x 2¹¹⁄₁₆)
27 USA, *c.* 1940. 24.2 x 18.3 (9½ x 7³⁄₁₆)
28 *l* '"A moonlight night" (through the branches of a plum tree).' USA, *c.* 1910. Cyanotype. 11.5 x 8.7 (4½ x 3⁷⁄₁₆)
28 *r* Comet. USA, *c.* 1920. 13.2 x 8.2 (5⁵⁄₁₆ x 3¼)
29 *l* Volcanic eruption. Mexico, *c.* 1930. 11.9 x 8 (4¹¹⁄₁₆ x 3³⁄₁₆)
29 *r* 'Electric storm, Brandon.' USA, 27 July 1917. 10.2 x 7.5 (4 x 3)
30–1 San Francisco earthquake. USA, 1906. 18.3 x 23.5 (7¼ x 9¼)
32 New York World's Fair. USA, 1939. 12 x 16 (4¾ x 6¼)
33 *al* Eiffel Tower, Paris. France, *c.* 1950. 5.4 x 5.2 (2¼ x 2¹⁄₁₆)
33 *ar* Place de la Concorde, Paris. France, 11 August 1950. 5.4 x 5.2 (2¼ x 2¹⁄₁₆)
33 *bl* Quai de la Concorde, Paris. France, 11 August 1950. 5.4 x 5.2 (2¼ x 2¹⁄₁₆)
33 *br* Tuileries, Paris. France, *c.* 1950. 5.4 x 5.2 (2¼ x 2¹⁄₁₆)
34 USA, *c.* 1940. 9.8 x 7.2 (3⅞ x 2¹³⁄₁₆)
35 USA, *c.* 1890. 12.1 x 9.7 (4¾ x 3¹³⁄₁₆)

36 USA, *c.* 1850. Quarter-plate daguerreotype. 11.7 x 8.3 (4¼ x 3¼)
37 USA, *c.* 1925. 8.2 x 13.3 (3¼ x 5¼)
38 Alice Lowrie Stenger and Robert Wilhelm Stenger, aged 1 year 7 months, Nellore. India, 28 August 1913. 14.7 x 10.7 (5¹³⁄₁₆ x 4¼)
39 USA, *c.* 1940. 9.2 x 14.1 (3⅝ x 5⁹⁄₁₆)
40 *l* USA, *c.* 1850. Sixth-plate daguerreotype. 8.4 x 7 (3¼ x 2¾)
40 *r* USA, *c.* 1850. Quarter-plate daguerreotype. 10.8 x 8 (4¼ x 3¼)
41 *l* USA, *c.* 1845. Quarter-plate daguerreotype. 10.8 x 8 (4¼ x 3¼)
41 *r* Two brothers, one suit. USA, *c.* 1850. Sixth-plate daguerreotype. 8.3 x 7 (3¼ x 2¾)
42 France, *c.* 1860. Albumen print. 11 x 9.5 (4⁵⁄₁₆ x 3¾)
43 Father Time. UK, *c.* 1900. 16.6 x 11.8 (6⁹⁄₁₆ x 4⅝)
44 *l* Carrie Bauer. UK, *c.* 1880. 14.6 x 10.2 (5¾ x 4)
44 *r* USA, *c.* 1880. 10.3 x 13.9 (4¹⁄₁₆ x 5½)
45 *l* France, *c.* 1880. 11.1 x 8 (4⅜ x 3⅛)
45 *r* USA, *c.* 1880. 14.8 x 9.8 (5¹³⁄₁₆ x 3⅞)
46 USA, 1928. 7 x 12.1 (2¾ x 4¾)
47 USA, *c.* 1920. 11.9 x 16.3 (4¹¹⁄₁₆ x 6⁷⁄₁₆)
48 *l* Girls with black dolls. USA, *c.* 1880. 14 x 10 (5½ x 3¹⁵⁄₁₆)
48 *r* UK, *c.* 1880. 15. 5 x 10.1 (6³⁄₁₆ x 4)
49 *l* 'Girls will be boys sometimes.' USA, *c.* 1900. 12.5 x 9.9 (4¹⁵⁄₁₆ x 3⅞)
49 *r* Wedding picture. USA, *c.* 1910. 13.7 x 8.7 (5⅜ x 3⁷⁄₁₆)
50 USA, *c.* 1900. 9.9 x 12 (3⅞ x 4¾)
51 USA, *c.* 1900. 9.6 x 14.3 (3¾ x 6⅝)
52 USA, *c.* 1920. 8.3 x 13.3 (3¼ x 5¼)
53 USA, *c.* 1920. 12.9 x 8.1 (5¹⁄₁₆ x 3³⁄₁₆)
54 'Thelma and Gertrude'. USA, *c.* 1915. 11.2 x 6.2 (4⁷⁄₁₆ x 2⁷⁄₁₆)
55 USA, *c.* 1915. 106 x 149 (4³⁄₁₆ x 5⅞)
56 *l* 'OBUS de 380, Bombardement de Nancy.' France, 13 August 1916. 14 x 9 (5½ x 3⁹⁄₁₆)
56 *r* USA, *c.* 1915. 9.6 x 5.3 (3¾ x 2¹⁄₁₆)
57 Germany, *c.* 1935. 8.1 x 11 (3³⁄₁₆ x 4⁵⁄₁₆)
58 UK, *c.* 1880. 9.8 x 11.5 (3⅞ x 5¼)
59 USA, *c.* 1950. 13.8 x 7.9 (5⁷⁄₁₆ x 3⅛)
60 'Marjorie Armstrong jumping.' UK, 1905. 11.1 x 15.2 (4⅜ x 6)
61 USA, *c.* 1960. 11.2 x 16.3 (4⅜ x 6⁷⁄₁₆)
62 Monkey. USA, *c.* 1950. 7.7 x 7.7 (3 x 3)
63 USA, *c.* 1920. 24 x 19.3 (9⁷⁄₁₆ x 7⅝)
64 USA, *c.* 1920. 11.9 x 15.8 (4¹¹⁄₁₆ x 6¼)
65 USA, *c.* 1890. 8.3 x 8.5 (3¼ x 3⅜)
66 Cawston Ostrich Farm, South Pasadena, California. USA, *c.* 1920. 8 x 11.4 (3³⁄₁₆ x 4½)
67 Italy, *c.* 1900. 6.3 x 10.8 (2½ x 4⁵⁄₁₆)

68 USA, *c.* 1920. 7.3 x 9.7 (2⅞ x 3¹³⁄₁₆)
69 USA, *c.* 1880. 11.5 x 9 (4½ x 3⁹⁄₁₆)
70 USA, *c.* 1920. 10.9 x 14.9 (4⁵⁄₁₆ x 5⅞)
71 France, *c.* 1870. Albumen print. 9.6 x 6.9 (3¾ x 2¹¹⁄₁₆)
72 'A "gopher" and a jack-rabbit.' USA, *c.* 1910. 12 x 8.9 (4¾ x 3½)
73 'It isn't easy to photograph a dog.' Albumen print. UK, *c.* 1870. 13.9 x 13.3 (5½ x 5¼)
74–5 Nara. Japan, 2 December 1928. 8.5 x 13.5 (3⁵⁄₁₆ x 5⁵⁄₁₆)
76 *l* Alligator on slide. USA, *c.* 1930. 10.2 x 7.7 (4 x 3¹⁄₁₆)
76 *r* 'Mrs Reese'. USA, *c.* 1920. 12.9 x 7.9 (5¹⁄₁₆ x 3⅛)
77 USA, *c.* 1930. 10.5 x 6 (4⅛ x 2⅜)
78 USA, *c.* 1920. 9.6 x 13.6 (3¾ x 5⅜)
79 USA, *c.* 1920. 9.6 x 13.6 (3¾ x 5⅜)
80 USA, *c.* 1850. Sixth-plate daguerreotype. 8.3 x 7 (3¼ x 2¾)
81 USA, *c.* 1920. 7.8 x 13.3 (3¼ x 5¼)
82 USA, *c.* 1920. 19.4 x 24.6 (7⅝ x 9¹¹⁄₁₆)
83 Germany, 23 November 1935. 7.7 x 13 (3¹⁄₁₆ x 5⅛)
84 USA, *c.* 1880. Albumen print. 15.8 x 20.8 (6¼ x 8³⁄₁₆)
85 'Snowball game, Leadville, Colorado, Camp McIntire, Co. E, 1st Reg.' USA, 1 January 1897. 7.8 x 8.5 (3¹⁄₁₆ x 3⅜)
86 France, *c.* 1900. 30.3 x 25.2 (11¹⁵⁄₁₆ x 9¹⁵⁄₁₆)
87 UK, *c.* 1910. 11.3 x 7.8 (4⁷⁄₁₆ x 3¹⁄₁₆)
88 *l* France, *c.* 1910. 13.2 x 8.3 (5³⁄₁₆ x 3¼)
88 *r* Japan, *c.* 1920. 13 x 8.3 (5⅛ x 3¼)
89 Transvestite. USA, *c.* 1920. 8.1 x 5.4 (3³⁄₁₆ x 2⅛)
90 'School days are over', Esther London, Mt. Vernon, Indiana. USA, *c.* 1900. 9.2 x 11.8 (3⅝ x 4⅝)
91 Influenza epidemic. USA, *c.* 1918. 12.9 x 7.7 (5¹⁄₁₆ x 3¹⁄₁₆)
92 UK, *c.* 1890. 11.8 x 9.6 (4⅝ x 3¾)
93 USA, *c.* 1900. 23.1 x 19.6 (9⅛ x 7⅝)
94 Brianza. Italy, *c.* 1870. Albumen. 13.1 x 9.6 (5⅛ x 3¾)
95 'Frau Hammann, probably tattooed in Hamburg.' USA, *c.* 1930. 16.6 x 10.6 (6½ x 4³⁄₁₆)
96 France, March 1928. 22.4 x 16.4 (8⅞ x 6⁷⁄₁₆)
97 USA, *c.* 1910. 13.8 x 8.7 (5⁷⁄₁₆ x 3⁷⁄₁₆)
98 France, *c.* 1890. 16.2 x 11.6 (6⅜ x 4⁹⁄₁₆)
99 'Otrux'. France, *c.* 1920. 13.6 x 8.6 (5⅜ x 3⅜)
100 *a* Bob Hope. USA, *c.* 1940. 5.1 x 7.9 (2 x 3⅛)
100 *b* President Kennedy. USA, *c.* 1962. 7.3 x 9.6 (2⅞ x 3¾)
101 *al* Colette. France, *c.* 1920. 10.6 x 11.2 (4³⁄₁₆ x 4⁷⁄₁₆)
101 *ar* Gloria Swanson. USA, *c.* 1960. 8 x 8 (3⅛ x 3⅛)
101 *bl* Amelia Earhart. USA, *c.* 1935. 11 x 7.5 (4⁵⁄₁₆ x 2¹⁵⁄₁₆)
101 *br* Jackie Kennedy. USA, *c.* 1962. 6.8 x 4.9 (2¹¹⁄₁₆ x 1¹⁵⁄₁₆)
102 France, *c.* 1925. 7.6 x 6.6 (3 x 2⁹⁄₁₆)
103 USA, *c.* 1940. 8.4 x 11.5 (3⁵⁄₁₆ x 4½)

104 USA, c. 1880. Albumen. 16.7 x 11.6 (6⁹⁄₁₆ x 4⁹⁄₁₆)

105 UK, c. 1920. 10.5 x 16.2 (4⅛ x 6⅜)

106–7 Prostitutes, Yoshiwara district, Edo. Japan,
c. 1870. Albumen print. 21 x 25.8 (8¼ x 10³⁄₁₆)

108 a Germany, c. 1925. 9.4 x 11.9 (3¹¹⁄₁₆ x 4¹¹⁄₁₆)

108 b USA, c. 1890. 8.2 x 8.2 (3¼ x 3¼)

109 a France, c. 1930. 8.4 x 13.4 (3⁵⁄₁₆ x 5¼)

109 b UK, c. 1930. 8.3 x 13.2 (3¼ x 5³⁄₁₆)

110 USA, c. 1940. 8.9 x 11.5 (3½ x 4½)

111 USA, c. 1940. 8.7 x 11.5 (3⁷⁄₁₆ x 4½)

112 l 'Paris Nights'. USA, c. 1920. 11 x 6.3 (4⅜ x 2½)

112 r USA, c. 1930. 9.9 x 6 (3⅞ x 2⅜)

113 USA, c. 1940. 22.2 x 16.2 (8¾ x 6⅜)

114 USA, c. 1940. 19.4 x 24.4 (7⅝ x 9⅝)

115 USA, c. 1950. 12 x 16.3 (4¾ x 6⁷⁄₁₆)

116 Fire-hose wagon, Chicago. USA, 1870. Albumen
print. 17.5 x 22.7 (6⅞ x 8¹⁵⁄₁₆)

117 UK, c. 1925. 9.9 x 8.4 (3⅞ x 3⁵⁄₁₆)

118 USA, c. 1920. 9 x 8.4 (3½ x 3⁵⁄₁₆)

119 l Venice in winter. Italy, c. 1920. 11 x 8.1 (4⅜ x 3³⁄₁₆)

119 r USA, c. 1920. 10.8 x 6.4 (4¼ x 2½)

120 Oceanside, California. USA, c. 1900. Cyanotype.
7.5 x 12.5 (2¹⁵⁄₁₆ x 4¹⁵⁄₁₆)

121 Pemaquid, Maine. USA, c. 1900. Cyanotype.
8.9 x 8.9 (3½ x 3½)

122 USA, c. 1925. 9.8 x 12.3 (3⅞ x 4⅞)

123 Circus parade. USA, c. 1920. 8.3 x 13.5 (3¼ x 5⁵⁄₁₆)

124 Germany, c. 1930. 10.4 x 7.5 (4¹⁄₁₆ x 2¹⁵⁄₁₆)

125 New York City. USA, c. 1900. 14.6 x 8.6 (5¾ x 3⅜)

126 UK, c. 1925. 11.1 x 15.8 (4⅜ x 6¼)

127 r China, 13 November 1928. 8.9 x 14 (3½ x 5½)

128 USA, c. 1930. 7 x 10.1 (2¾ x 4)

129 Cherokee, Oklahoma. USA, c. 1926. 10.2 x 5.9
(4 x 2⁵⁄₁₆)

130 J. B. Marquis Sunbeam racer, Vanderbilt Cup,
Santa Monica. USA, 1914. 9.1 x 12.9 (3⁹⁄₁₆ x 5¹⁄₁₆)

131 USA, c. 1930. 11.2 x 16.8 (4⁷⁄₁₆ x 6⅝)

132 'Akron – 10 days before it went down. Chas and
Gilbert went up in the control room.' Miami, Flor-
ida. USA, 21 March 1933. 12.2 x 25.3 (4¹³⁄₁₆ x 9¹⁵⁄₁₆)

133 France, 1925. 14 x 9 (5½ x 3⁹⁄₁₆)

134 'Fly past of Viskers Valentias.' UK, 1925. 8.1 x 13.4
(3³⁄₁₆ x 5¼)

135 USA, c. 1960. 10.1 x 11.7 (4 x 4⅝)

136 USA, c. 1945. 8 x 5.5 (3⅛ x 2³⁄₁₆)

137 USA, c. 1945. 8.1 X 12.2 (3³⁄₁₆ x 4¹³⁄₁₆)

138 USA, c. 1880. 14 x 10 (5½ x 3¹⁵⁄₁₆)

139 USA, c. 1900. 8.5 x 13 (3⅜ x 5⅛)

140 l Spain, c. 1910. 13.8 x 8.8 (5⁷⁄₁₆ x 3⁷⁄₁₆)

140 r USA, 1912. 14 x 8.9 (5½ x 3½)

141 USA, 1896. 9.9 x 7 (3⅞ x 2¾)

142 USA, 1907. 13.9 x 8.8 (5½ x 3⁷⁄₁₆)

143 USA, c. 1900. 15.4 x 11.9 (6¹⁄₁₆ x 4¹¹⁄₁₆)

144 La Honda, California. USA, 1927. 5.4 x 8.1
(2⅛ x 3³⁄₁₆)

145 USA, c. 1930. 8.6 x 13.8 (3⅜ x 5⁷⁄₁₆)

146 USA, c. 1930. 13.2 x 22.6 (5³⁄₁₆ x 8⅞)

147 USA, c. 1930. 10.6 x 6.1 (4³⁄₁₆ x 2⅜)

148 USA, 1916. 6.2 x 11.2 (2⁷⁄₁₆ x 4⅜)

149 'A Merry Christmas from U.S. Naval Training Stat-
ion, Great Lakes, Ill.' USA, 1936. 24 x 18.9 (9⁷⁄₁₆ x 7⅜)

150 'Glamour Street – Hollywood Boulevard by
night.' USA, c. 1935. 23.4 x 18.9 (9¼ x 7⁷⁄₁₆)

151 USA, 1930. 19.2 x 24 (7⁹⁄₁₆ x 9⅜)

152 Tightrope walker. USA, c. 1890. 9.6 x 12 (3¾ x 4¾)

153 College initiate. USA, c. 1920. 13.6 x 7.9 (5⅜ x 3⅛)

154 USA, c. 1925. 12.8 x 7.9 (5 x 3⅛)

155 USA, c. 1915. 11.5 x 8.9 (4½ x 3½)

156 l Giant and two midgets. USA, c. 1900. 9.9 x 7.9
(3⅞ x 3⅛)

156 r Giant with William Henry. USA, c. 1900. 9.8 x 7.9
(3⅞ x 3⅛)

157 l Giant, dwarf and two performers. USA, c. 1900.
10.8 x 8.2 (4¼ x 3¼)

157 r Fedor Jefrichew (Jo-Jo the dog-faced boy). 9.7 x 7.9
(3¹³⁄₁₆ x 3⅛)

158 Trick photograph of a woman. USA, c. 1910.
8.1 x 12.1 (3³⁄₁₆ x 4¾)

159 Trick photograph of a girl. USA, c. 1910.
8.7 x 13.8 (3⁷⁄₁₆ x 5⁷⁄₁₆)

160 Golden Gate Bridge, San Francisco. USA, c. 1960.
7.9 x 11.7 (3⅛ x 4⅝)

161 'Jour de Fête'. France, c. 1930. 20.3 x 19.5
(8 x 7¹¹⁄₁₆)

162 l USA, c. 1940. 11.3 x 7.3 (4⁷⁄₁₆ x 2⅞)

162 c USA, c. 1890. 8.7 x 6.8 (3⁷⁄₁₆ x 2¹¹⁄₁₆)

162 r USA, c. 1910. 7.8 x 5.3 (7¹⁄₁₆ x 2¹⁄₁₆)

163 Women with Lucille Ball masks. USA, 1981.
8.8 x 12.3 (3⁷⁄₁₆ x 4¹³⁄₁₆)

164 Germany, c. 1930. 9.9 x 12.4 (3⅞ x 4⅞)

165 Circus tent. USA, c. 1930. 7.9 x 13.8 (3⅛ x 5⁷⁄₁₆)

166 Eiffel Tower under construction, Paris. France,
1888. Albumen print. 18 x 14.2 (7¹⁄₁₆ x 5⅝)

167 Iguanodon. Belgium, c. 1870. Albumen print.
26.5 x 35.4 (10⁷⁄₁₆ x 13¹⁵⁄₁₆)

168 l USA, c. 1930. 10.3 x 7.9 (4¹⁄₁₆ x 3⅛)

168 r France, c. 1930. 12.7 x 7.9 (5 x 3⅛)

169 France, c. 1930. 9.1 x 11.4 (3⁹⁄₁₆ x 4½)

170 USA, c. 1920. 8.9 x 13.9 (3½ x 5½)

171 'Engl. Handgranate' (English hand grenade).
Germany, 1915. 8.5 x 13.9 (3⅜ x 5½)

172 USA, c. 1890. 19.4 x 10.2 (7⅝ x 4)

173 'Beautiful roses'. UK, c. 1915. 21.6 x 16.6 (8½ x 6⁹⁄₁₆)

174 USA, c. 1940. 7.7 x 11.8 (3 x 4⅝)

175 'Elephant on the piano keys.' USA, c. 1950.
11.5 x 16.3 (4½ x 3⅛)

176–7 Cliff House, San Francisco (destroyed by fire
on 7 September 1907). USA, c. 1900. 11.5 x 16.3
(4½ x 6⁷⁄₁₆)

178 USA, c. 1900. Cyanotype. 10.2 x 14.3 (4 x 5⅝)

179 Westminster Abbey. UK, c. 1870. Albumen print.
14.4 x 19.5 (5¹¹⁄₁₆ x 7¹¹⁄₁₆)

180 Japan, c. 1930. 13.6 x 7.8 (5⁷⁄₁₆ x 3¹⁄₁₆)

181 Laguna Beach, California. USA, c. 1910. 11.3 x 8
(4⁷⁄₁₆ x 3⅛)

182 Euston Station, London. UK, c. 1930. 36.4 x 30
(14⁵⁄₁₆ x 11¹³⁄₁₆)

183 Los Angeles, California. USA, c. 1930. 13.8 x 8.7
(5⁷⁄₁₆ x 3⁷⁄₁₆)

184 UK, c. 1880. 15.9 x 9.9 (6¼ x 3⅞)

185 Dead Japanese soldier incinerated by an American
flame-thrower. USA, c. 1944. 8.8 x 10.6
(3⁷⁄₁₆ x 4³⁄₁₆)

186 'Ella Loretta Stevens who died Feb 22 1856
aged 6 months 25 days.' USA, c. 1856. Sixth-plate
daguerreotype. 8.4 x 7 (3¼ x 2¾)

187 Mother with dead child. USA, c. 1850. Sixth-plate
daguerreotype. 8.4 x 7 (3¼ x 2¾)

188 USA, c. 1880. 14.1 x 9.8 (5⁹⁄₁₆ x 3⅞)

189 Cynthia Loomis. USA, c. 1880. 10.2 x 13.5 (4 x 5⁵⁄₁₆)

190 Execution by beheading. China, c. 1900. 7.4 x 11.6
(2¹⁵⁄₁₆ x 4⁹⁄₁₆)

191 'After the execution – a pair who paid.' China,
c. 1900. 7.8 x 12.9 (3¹⁄₁₆ x 5¹⁄₁₆)

192 Belsen Trials – Klara Opity, S.S. guard at camp.
USA, c. 1945. 14.5 x 11 (5 11/16 x 4 5/16)

193 Belsen Trials – Georg Krafft, S.S. guard at camp.
USA, c. 1945. 15.3 x 15.3 (6 x 6)

194–5 Dead policeman or gunman. USA, c. 1930.
12.2 x 23.5 (4¹³⁄₁₆ x 9¼)

196 Murder scene of Frieda Knaesche, killed 11 July
1919, Ukiah, California. USA, 1919. 21.2 x 16
(8⅜ x 6⁵⁄₁₆)

197 'Fred Brown broke jail', 5 October 1909,
Greenville, Ohio. USA, 1909. 13.7 x 8.7 (5⅜ x 3⁷⁄₁₆)

198 Fatal automobile accident. USA, c. 1930.
19.6 x 25.1 (7¾ x 10)

199 Fatal automobile accident. USA, c. 1930.
19.3 x 25.2 (7¹¹⁄₁₆ x 10)

200 USA, c. 1920. 12.9 x 7.9 (5¹⁄₁₆ x 3⅛)

201 Chessington Zoo. UK, c. 1935. 7.3 x 10.6
(2⅞ x 4¹⁄₁₆)

208 USA, c. 1910. 8.8 x 13.8 (3⁷⁄₁₆ x 5⁷⁄₁₆)

acknowledgments

There are six individuals who were crucial in the forming of my ideas about the nature of anonymous photography and were instrumental in encouraging my pursuit of collecting in this, until recently, disparaged area of photography. John Szarkowski, former curator of photography at the Museum of Modern Art, New York, has always recognized the important role anonymous photography has played in the history of the medium. As long ago as 1966, Szarkowski made the then audacious decision to put an image by an unknown American photographer, *c.* 1910, on the cover of his influential publication *The Photographer's Eye*, which was otherwise filled with the works of world-famous photographers. The curator and collector, Sam Wagstaff, was evangelical in his belief in the importance and beauty of photography. He repeatedly told me and others to forget the labels of authorship and look at the images themselves to determine their significance. His superb collection, now at the Getty Museum, full of the famous and the unknown, is testimony to his following his own advice. The former dealer, and now vintner, Sean Thackery was the one who first directed me to the beauty of daguerreotypes and ambrotypes. It was the highly personal nature of these mainly portrait images that attracted him. The fact that they were usually anonymous was of no concern. The presentation of 19th-century photography in an almost surreal format of cased imagery, reminiscent of Joseph Cornell, intrigued him and he transferred that fascination to me. Over a decade ago, I was introduced to the artist and collector, Gordon L. Bennett. A shy and thoughtful individual, he showed me a large body of anonymous photography that he had patiently and meticulously collected over the years. It was a revelation to me. To say that Gordon had discerning taste would be an understatement. He opened up the possibilities of a new world of collecting that, at the time, was far below the radar screen of collecting fashion. I thank Gordon for his vision, but I sometimes regret that his inspiration became, at times, my obsession. Over many years at Swann, and now at Sotheby's, Denise Bethel has emphasized scholarly professionalism without ever losing her infectious enthusiasm for both the great and obscure in photography. Her sense of humour has often re-energized long auction sales. The mutual connoisseurship of the absurd in photography cements our friendship.

Finally, I want to acknowledge a dealer and friend, David Winter, who has dedicated a significant portion of his business to the acquisition and sale of unusual anonymous photography. There are, of course, other dealers that have contributed to this field, but none that have done so with such marvellous iconoclasm and irony.

The excitement of discovering compelling anonymous imagery does not take place without the presence of passionate and knowledgeable dealers. I have greatly benefitted from their friendship and advice over the years. I would especially like to thank: Stephen Anaya; Jack Banning; Bruce Barton; Larry Baumhor; John Benjafield; John Boring; Frish Brandt; Susan Burks; Sylvian Calvier; Jeff and Pat Carr; David Chow; Stephen Cohen; Daniella Dangoor; Gary Edwards; Robert Eckhardt; Michael Fairley; Adam Fogash; Jeffery Fraenkel; Louis Gutierrez; Jane Handel; Thomas Harris; Richie Hart; Lenny Helischer; Paul Hertzman and Susan Herzig; Bill Hunt; Norman Kulkin; Hans Kraus; Mack Lee; the late Harry H. Lunn, Jr.; Frank Maresca; Michael Maslin; Carl Mautz; Richard Meara; Alex Novak; Marc and Brigitte Pagneux; Kevin

Randolph; Fern Rickman; Estelle Rosen; William Schaeffer; Sean Sexton; Newell Snyder; Robert Tat; Jo Tartt; Carol Thompson; David and Jane Thompson; Keith Tower; Geffory Turner; Christopher Wahren; Dennis and Carol Waters; Casey Waters; Erin Waters; Stephen White; and Thomi Wroblewski.

To see art through the eyes of an artist provides unique insight into creativity. The artists with whom I have discussed anonymous photography over the years that I wish to thank include: Robert Benton; Robert Crumb; Joseph Goldyne; the late John Gutmann; DeWitt Hardy; Leo Holub; Henry Hornstein; Alex Kanevsky; Yuri Kuper; Peter and Edith Milton; Valentin Popov; Ed and Paul Ruscha; Jennifer Sauer; Robert Stivers; John Waters; and Terry Zigroff.

I cannot express enough my appreciation to my friends for the patience they have shown over the years in putting up with my preoccupation with anonymous photography. I wish to thank: Gordon Baldwin; the late Bruce Bernard; Aldis and Maria Browne; Irene Brückle; Sven and Sabine Bruntjen; Amie Clute; Josephine Coniglio; Barnaby Conrad III; Roy Davis and Cecily Langdale; Stuart and Beverly Denenberg; Shelly Dowell; Emily Fine; John Flather and Jacqueline Roose; Anne Grant; Charles Grant; Florence Holub; Robert Jackson; Hans Kraus; Reva and David Logan; Lourdes and Kimball Livingston; Christopher Mahoney; Martin Muller; Weston Naef; Doug Nickel; Sandra Phillips; David and Marcia Raymond; Sally Robertson; Paul and Prentice Sack; Jean-Pierre Selz; Dr Robert and Marion Shimshak; Heida Shoemaker; Serge and Tatiana Sorokko; Farrah Spott; Christine Taylor; Thomas Walther; Stephen and Connie Wirtz; and David and Constance Yates.

In the early stages of the development of this book, Allison Arieff was one of the first to understand what I was hoping to accomplish. Her advice at a critical moment was of great importance. A number of individuals were there when I needed them to offer advice concerning both the selection of images and the editing of the text. I wish to thank Eileen Petersen, Maxine Rosston, David Winter, and my brother, Richard Johnson, for all their efforts on my behalf. Andrea Young has been a constant source of inspiration and constructive advice in the evolution of this book. It would not be the same without her. The staff and management of Thames and Hudson Ltd. are to be recognized for having the courage to introduce a fascinating yet unfamiliar area of photography through a major publication. My editor, Jamie Camplin, has been enthusiastic, supportive and practical throughout. His assistants, Helen Farr and Laura Workman, have handled the numerous publication issues with great efficiency. Finally, a special word of thanks to Nigel Soper for his dynamic and creative design and layout of this volume. Working with Constance Kaine, he has taken a large group of fascinating, but disparate images and fashioned them into a flowing and unified whole.

Robert Flynn Johnson

That All.

G. R.